# RELIEF PRINTING

MICHAEL ROTHENSTEIN

# RELIEF PRINTING

*With contributions by*

TREVOR ALLEN

BERNARD CHEESE

SELMA NANKIVELL

AGATHE SOREL

*Photographs by* JOHN HUNNEX

*Diagrams by* DUNCAN MILL

WATSON-GUPTILL PUBLICATIONS, NEW YORK

*For Julian and Anne*

© 1970 by Michael Rothenstein

Published by Watson-Guptill Publications, New York, New York

No part of the contents of this book may be reproduced

without the written permission of the publishers.

All rights reserved.

Manufactured in U. S. A.

Library of Congress Catalog Card Number: 73-98988

Edited by Donald Holden

Designed by James Craig and Robert Fillie

Unless otherwise credited, all photographs are by John Hunnex,
except for those of artists' work

Composed in ten point Univers by Wellington-Attas Inc.

Color offset in Japan by Toppan Printing Co. Ltd.

Black and white offset by Halliday Lithograph Corp.

Bound by Halliday Lithograph Corp.

# ACKNOWLEDGMENTS

I have been very lucky in my choice of associates; my warm thanks are due to each of them. They were responsible for giving me most of the information contained in the following sections. . .

Caustic etching: Trevor Allen
Relief and transfer lithography: Bernard Cheese
Relief and screen printing: Selma Nankivell
Metal relief: Agathe Sorel

I am also much in debt to the following schools, colleges, and other organizations, for providing students' work: Bournemouth and Poole College of Art, Brighton College of Art, Camberwell School of Arts and Crafts, Falmouth Art School, Goldsmiths College, Haystack Mountain School of Crafts, Teeside College of Art, National Exhibition of Childrens' Art, Ohio University Art Department, Redbridge Art Centre, Stoke on Trent College of Art, Voss Summer School, Wanstead School.

I would like to make a special mention of the teachers on whose cooperation I have been dependent in assembling the student material shown here: Trevor Allen, Michael Barrett, Gordon Bell, Bernard Cheese, Graham Clucas, Harvey Daniels, Jennifer Dickson, Abner Jonas, Charles Lloyd, Elizabeth Nolan, Peter Olley, Donald Roberts, Alan Sargent, Waldemar Stabell, Gerald Woods. Bernard Cheese and Gordon Bell, in particular, have given help on a number of different occasions.

Grateful thanks are due to the artists who gave permission for their work to be reproduced: Trevor Allen, Edward Bawden, Tadek Beutlich, Robert Broner, Harold Cohen, and Agathe Sorel.

Thanks are also owing to the following museums and galleries for supplying photographs: Alecto, The British Museum, The Cleveland Museum, of Art, The Curwen Gallery, London Graphic Arts, Marlborough Fine Art (London) Ltd., The Munch Museum.

Further acknowledgments are due to the Chief Librarians of Camberwell School of Arts and Crafts, and of Brighton College of Art, for help in lending books; to Miss Leona Prasse, Kenneth Kaplowitz, John Wilkinson, Kenneth Randle, and Edward Bawden for having material specially photographed; to Mrs. Peggy Rickwood, who originally helped with typing, and to Mrs. Staples, who took on the main part of this work at a later stage. The work of writing the text was materially helped by the close attention given to typing the manuscript by Mrs. Staples.

Very warm acknowledgments are owing to John Hunnex, who undertook the main part of all the photographic work contained in this book. For the care he took in carrying out this work over a period of many months, I am specially grateful.

I should also mention the trouble taken by Don Holden, the editor, in the final stages of preparing the text for publication. His close concern has proved consistently helpful and encouraging.

I should also discharge a debt to William Ivins: his fine book, *Prints and Communication*, is one I have drawn on for a number of details in the section entitled "Background."

# FOREWORD

In introducing the present book, I should like to define at once the general direction of my comments — apart, that is, from the purely technical matter. To some extent, this direction is taken in defiance of an existing tradition, for I think we should recognize that the influence of some of the leading teachers of printmaking is still firmly tied to a system that recognizes only the gestural techniques of hand tools. However revolutionary and advanced this teaching would have appeared in Paris, London, or New York twenty or thirty years ago, the evolution of print-making, in the meantime, has taken a further decisive step, putting into new perspective the part played by the manual repertory of techniques. Today, the effective teaching and practice of printmaking must take full account of the enormous potential conferred by the appearance of photo-technology. This does not mean that hand gesture has become less valid, less authentic for the needs of human expression. On the contrary, in the light of photo-technology, it may well be taking on added dimensions of depth and meaning.

To be sure, we should regard the photo techniques as an immense plus — an addition to existing methods, bringing to printmaking an immense potential, undreamt of until a few years ago. In any case, it appears difficult to deny the value of these techniques, since so many of the finest prints of recent years — those of Paolozzi and Rauschenberg for example — have to a large extent depended on such new and sophisticated methods.

The instruments of photo-technology already exist. In any foreseeable future, far more advanced equipment will be available to the artist; in this situation, its influence is certain to become more widespread. A new generation of printmakers is already being trained to integrate these techniques with older ones, and to integrate them without self-consciousness. A natural dialogue between eye and camera lens is rapidly coming into existence.

In this context, relief printing allows the artist certain advantages: with the employment of this method, he is able to work in the gap between industrial technology and manually constructed art, while drawing on the remarkable potential of both. A

main reason, here, is that relief printing brings us close to the character of actual materials — with the interaction between tools and substances of many kinds, and with the use of processes that carry with them the resonance of causal reality. Perhaps of all techniques, we may fairly consider that relief printing has the fullest claim to being the intermediary between materials that are concrete in their presence — wood, metal, and found materials and objects in infinite variety — and the expanding world of the photographer's darkroom, where the reach of reference is so enormous in its sweep, but so shadowy in its substance.

In any case, present day technical facilities are so rich in their implication, and possess such varied potential, that the artist may well want to reach beyond the capacities offered by any one method.

My own studio, for example, though based mainly on relief printing, and chiefly equipped with hand presses, stands, in a sense, at the center of a varied operation. Sheets, only partly printed, may go to an outside printer, where the necessary editioning is carried forward with the use of equipment I don't myself possess; or work comes in from the commercial platemaker, when a part of the image is to be processed with halftone letterpress plates.

This dialogue between the manual techniques, carried out in the artist's studio, and the more technically sophisticated ones, carried out with help outside, has at present considerable value. Relief printing has tended to lag behind other methods — notably photo-lithography and photo screen printing — in availing itself of new technical developments. Yet this adaptation to the new is always necessary to survival. Wherever a given method fails to respond to the call of evolutionary change, the current of a living art form is diverted, and starts flowing through another and more suitable channel.

The educational uses of relief printing hardly need underlining. In schools, in colleges, and in the universities — wherever printmaking is taught and practiced, whether by young student groups, or by groups and individuals of any age who have no access to sophisticated printmaking facilities — the hand worked, hand printed block finds uses that remain unchanged. These uses are essential ones and are likely to survive into the foreseeable future, particularly in technically backward countries and in poorly endowed universities, wherever they may be.

In much of my comment, I have attempted to serve the need of such purposes — whether educational or professional — and to explore and explain the methods and equipment such work requires.

# CONTENTS

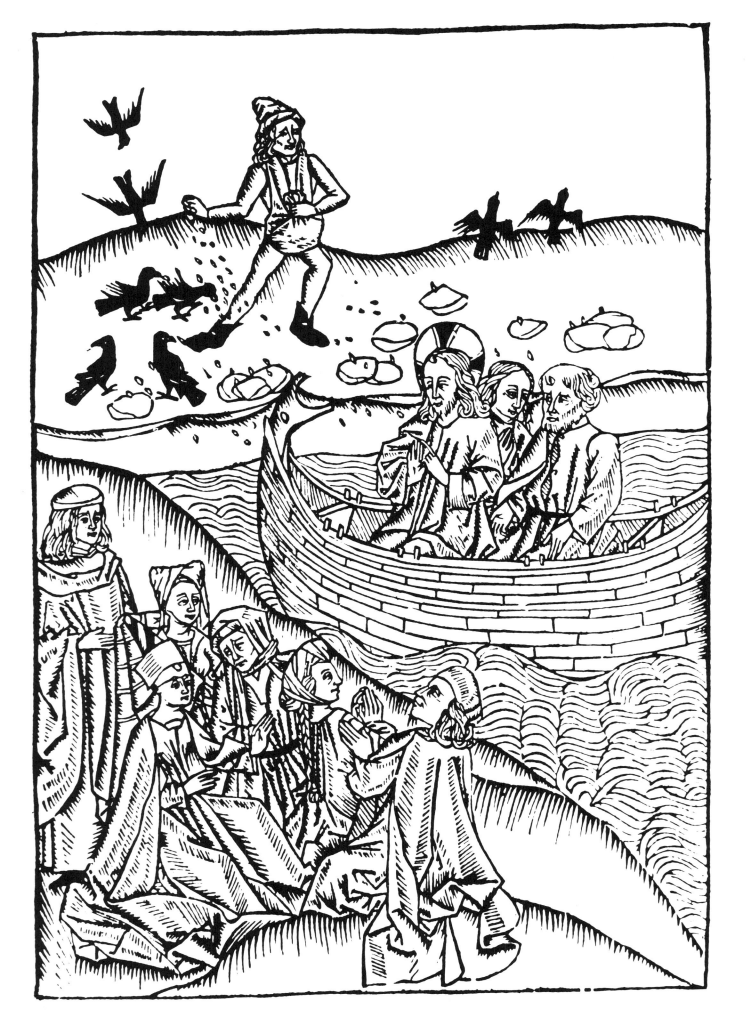

# 1
# BACKGROUND

Relief methods of graphic presentation have been used for many thousand years. On slate and stone, gold and steel, on the hardest and softest materials, men have attempted to outline the imagined faces of their gods and to placate their fears. For primitive man (millennia before the invention of paper), carving, scraping and incising lines from a dense, resistant substance formed a main outlet for his graphic powers.

Thousands of years later, the Sumerians made cylindrical seals and "printed" them, rolling them over a soft clay slab to impress a signature upon its surface, or producing a series of images that appeared as a continuous frieze as the cylinder was turned. This operation we may well consider one of the earliest forms of printing; the use of a cylinder to carry the image prefigured the modern high speed rotary presses that produce a million copies of our daily paper in the space of a few hours.

In the Book of Exodus (28:36) there is an early reference to engraving on gold for decorating the Ark of the Covenant. Again, centuries later, the metal-workers of Europe, the goldsmiths and armorers in particular, must be counted among the first makers of prints. Their skill with burins and punches was turned to producing engraved (and, later on, etched) plates, from which these images were taken.

## Earliest Woodcuts

The woodcut, however, is probably the oldest of the relief processes. It was used originally (or so it appears) for printing repeat designs on cloth more than a thousand years ago. Some of the earliest examples come from Egypt, originating in the sixth and seventh centuries A.D., while the oldest known, authentic hand-rubbed prints were made in Japan at about the same time; they were taken from carved woodblocks, used for printing text. The earliest preserved picture taken from a woodblock is also Japanese; this is an image of lions, printed on white leather in 740 A.D. The earliest woodcut to come from Europe is a Madonna, dated 1418. The appearance of this art, in the west, coincided with the introduction of paper from the east.

Christ Preaching from the Ship and the Parable of the Sower, *woodcut from* Levens ons Heeren, *Ludolphus, Antwerp, 1487.*

Very little is known about where or when, in Western Europe, images were first taken from woodblocks or metal plates. Before 1400, such prints were unknown, yet by the middle of the fifteenth century, the art was already widely practiced. At first, Germany appears as the most active center, but printed woodcuts soon spread from there to Austria, France, Italy, the Netherlands, and finally to England and Spain. The woodcutter was quick to see that the presses devised for book printing could be turned to his own use. Hence, such cities as Ulm and Mainz, where these presses were being constructed for use with movable type, were also the places most forward in producing woodcuts.

As the art of woodcut spread, its expanding commercial possibilities brought it within the strict control of the various guilds. Between rival organizations in different cities, a militant jealousy existed; and this, as we should expect, repressed and discouraged inter-city trade. A woodcutter, trained in Mainz, would probably have found it impossible to produce and sell his wares in another town. No doubt the worst excesses of present day trade unionism were far exceeded by mediaeval practise. But in spite of such difficulties, we know that the city of Ulm, already famous for its hand colored, woodblock printed playing cards, built up a vigorous international trade in this commodity.

The popularity of pilgrimages in the fifteenth century was a factor of some importance to the woodcut trade. The yearly migrations of pilgrims swarming into Rome, Assisi, and other holy places, brought hosts of travelers anxious to take home a woodcut momento of a revered saint. As a matter of fact, such images were sold chiefly at the particular shrines of these saints, while convents and monasteries, all over Europe, handled such easily salable subjects as scenes from the life of the Virgin, or the passion of Christ. In the main, such images would have served the mood of solitary devotion, often, no doubt, of intensely private sorrows; for more relaxed and social purposes, New Year greeting cards were given. The infant Christ was a favorite subject, and here, oddly enough, the figure was often associated with a cuckoo — a bird noted for its certain gift of prophecy.

Although these images were chiefly designed to awaken pious emotions in the breast of the beholder, they were also intended to be used as a protective measure against particular dangers, such as the plague or some other form of sickness. Such speculations are amply supported by the woodcut pictures that have been found pasted inside deed and traveling boxes. Most likely, travelers put them there, just as they sewed them into their clothes, as amulets to ensure their personal safety and survival, offering, in this case, an economic alternative to an original painting.

Prints as substitutes for hand painted originals, however, would doubtless have been rejected by more conservative minded people. We know that the early woodblock illustrations used for books were looked on as cheap and worthless substitutes for hand painted illuminations, much as photo silkscreen prints have sometimes been frowned upon by traditionalist museum curators of today.

On the whole, these woodcuts were simple images directed at simple people. The figures shown were often crude, broadly cut, and very generalized. Once the identification of a particular saint was achieved, no doubt the artist's purpose had been fairly served. This was often accomplished merely by the use of a recognizable attribute belonging to the person represented: a model cathedral for St. Peter; or the stigmata in the case of St. Francis.

William Ivins points out that well before the end of the fifteenth century, the commercial exploitation of the woodblock image had already begun. "The cloven hoof of manufacture showed itself in these prints, for there are some that have changeable heads ... printed from little blocks dropped into little slots left for the purpose in the bigger blocks. Thus different saints would have identical bodies, clothes, backgrounds, and accessories, all printed from one identical block."

## Early Methods

Before the development of the printing press, paper was laid on a hard plank, and the inked block placed face down upon it. The back of the block was then pressed, stamped, or hammered to produce the impression. Hand rubbed prints were made by placing the inked block face upwards with the paper on top: the back of the sheet

The Birth of Tristram, *woodcut from* Morte d'Arthur,
*Malory, Westminster, 1494.*

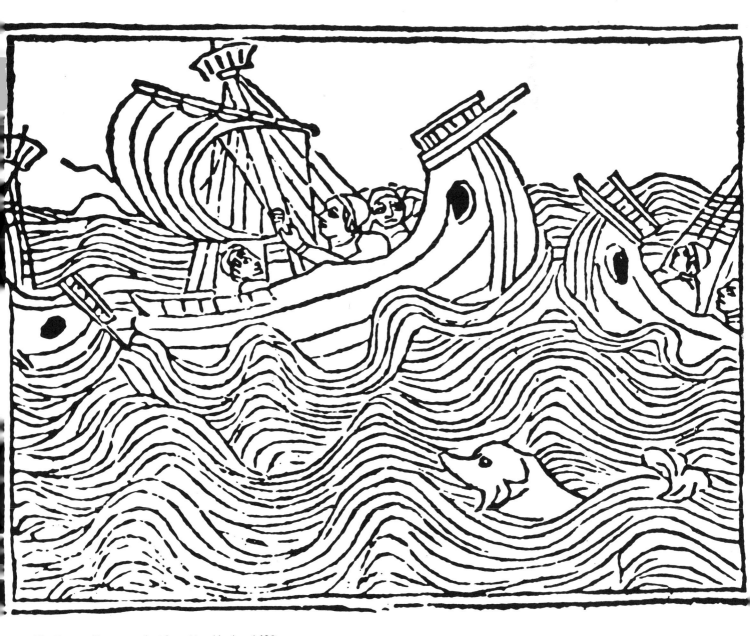

The Roman Navy, *woodcut from* Livy, *Venice, 1493*.

was then rubbed with a flat piece of wood, a hard pad of some kind, or a leather froton, much as hand rubbed prints are taken today.

These early woodcuts consist of images in broad outline; shading is absent and the line is typified by a graceful curvature. The folds and details of drapery tend to fall either into hairpin bends or loops. A style of shading was later added to break the plainness of the line, light and shade, in this case, being considered as a substitute for color. Where woodcuts were colored, they were colored by hand in the first phase of this art, but the patches of color were freely spotted on the page, and made no attempt to conform to the printed outline. At a later stage, color was added with the use of stencils, and finally blocks were cut and the color printed. A book on astronomy, produced in Venice in 1485, is reputed to be the first instance where printed color was used. In this case, blocks had been cut for red and yellow, as well as for black. This must have been a most exciting moment for the publishers of printed books in Western Europe.

Woodcutting came low in the hierarchy of the crafts. While the engraver would most likely have belonged to the more splendid guild of goldsmiths or silversmiths, the woodcutter's affiliations would have been to the humbler guild of carpenters; and doubtless the early practioner made butter stamps and wooden kitchen utensils, as well as blocks for playing cards and other printed images. The traveling craftsman would have carried his stock of prints with him, strapped to his back, or under his arm, in what must have been an early form of improvised portfolio. It is certain that he peddled his prints all over Europe, going from country to country, and from city to city, wherever a likely outlet existed for his wares.

## Woodcuts and Engravings Compared

At a much more sophisticated level, Dürer, Burgkmair, Holbein, and others produced a number of woodcuts. This medium was a much favored technique, since the artist was able to draw directly on the woodblock, and once his image was complete, a professional craftsman of great skill took over the work and carved the block. To get elaboration of design and wealth of detail, however, many of Dürer's more ambitious prints had to be carried

out on a large scale. There was good reason for this. Even the most skillful woodcutter could not carve the upstanding ridges of wood (from which the lines were printed) too close together. Had he done this, and carved them beyond a certain point of fineness, the network of ridges would have broken down under the enormous pressure of the press. Furthermore, any lines that ran across the grain of the woodblock would have a tendency to split away during the actual work of carving.

These difficulties made it almost impossible for the craftsman to carve highly detailed blocks on a sufficiently small scale for use in books; yet the publisher needed images that were both an accurate and detailed account of his subjects, in order to win an effective market for his wares.

The papers then used for printing, moreover, were rough by modern standards. When small, finely cut blocks were printed, such as Holbein's *Dance of Death*, the impressions were often poor; the ridged surface of the paper failed to pick up some of the tiny detail of the original. Nor, at that time, had printing rollers been devised. Blocks were still inked by the primitive method of pounding with an ink-charged leather ball, which often gave a spotty, uneven impression. Poor surfaced paper and irregular inking combined to the great disadvantage of the woodcut image once it was compared to the sharp, detailed impressions offered by the etched or engraved plate.

From 1550 onwards, etchings and engravings appeared more and more frequently; by the end of the century, the woodcut had been driven from the page of the printed book. The metal plate, however, wore out more quickly than the woodblock, providing smaller editions or "runs" of any given image; but in spite of this, the higher definition offered by these techniques satisfied the urgent craving for detail that the public then demanded.

Towards the end of the 16th century, the first publishers and dealers concerned with prints entered the commercial field. These men were manufacturer merchants who might not themselves be practicing craftsmen. They employed others, to make drawings, and to carry out the engraving of any subjects they believed they could sell. Among other artists, Rubens was

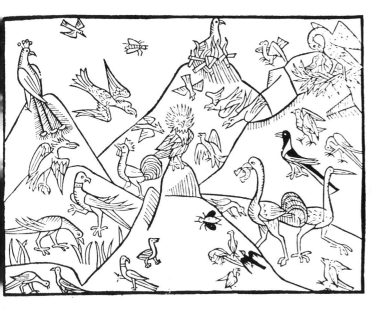

The Birds, *woodcut from* Proprietaire des Choses,
*Bartholomaeus Angelicus, Lyon, about 1485.*

involved in this trade. Perhaps he was the first artist to have a direct financial interest in promoting the facsimile reproduction of his paintings, and the first to found a school of engravers employed in such work. In this case, Rubens himself was either the publisher, or a partner in a publishing firm that handled woodcut or engraved reproductions of his more popular paintings.

In 1766, the French artist, Papillon, wrote a treatise on woodcutting, in the hope of reviving a dying craft. He describes the use of a long handled knife, held in one hand, while the other hand held the woodblock on a leather bound book. This made it easy for the woodcutter to change the position of the block, swinging it round, or rotating it against the edge of the knife, in cutting a curve.

In England, the woodcut survived, to some extent, well into the 18th century. Ballad headings, billheads, trade cards, and children's books, illustrated with bluntly cut, crudely colored pictures, were sold in the print shops of all the main cities.

## Technical Advances

At the end of the 18th century, a discovery of great importance to the future of blockcutting was made. It was found that the engraver's tool could be used on the end grain of wood, instead of the knife used on the side or long grain. This made it possible to produce blocks from which the finest systems of lines could be printed in great quantities, since the boxwood used for these blocks was a material of extreme toughness. The English illustrator and ornithologist, Thomas Bewick, was the first artist to fully exploit the reach of this method, and to bring it great public acclaim through the publication of his *British Birds* in 1797. The new technique made an immediate and sensational impact on the treatment of books and magazines, and brought back the use of wood for illustration with surprising suddenness.

But much else was happening to change and improve both the technical quality of print and its wider distribution. Between 1800 and 1810, the first wood engravings appeared on really smooth paper; clear and detailed impressions that would have been impossible to make on the older and rougher papers. The smooth material used was imported China and India paper, a material that already had the qualities of smoothness and opacity, combined with evenness and thinness, needed for books and periodicals. The new technology of machine made paper was soon to rival, and overtake, these imported materials — certainly for the general purposes of commerce — though the fineness of the oriental product remained in many ways unsurpassed. In any case, paper was needed in greater and greater quantities, and paper makers were now eagerly searching both for new materials, and for new processes of manufacture to enable them to keep abreast of a voracious demand for printed books. The biggest single factor here was the introduction of paper made from wood pulp, manufactured in a continuous web by power driven machines. The immense pine forests of the new world provided the source of this material.

By 1815, a steam press had been devised: the first printing machine to run by power and not by the sinews of men's arms and backs. From this time on, iron presses were used, and metal replaced wood as the main material for the manufacture of printing presses. In 1820, Clymer of Philadelphia introduced the Columbia hand press to England; but this was soon supplanted by rather more sophisticated presses, such as the Albion. By the

end of the century, in any case, the hand press had seen its day; it was left far behind by the onward rush of the new engineering technology that now served the main purpose of the industry, though, as a matter of fact, a number of hand presses stayed tucked away in odd corners of many printing works in England until very recently. Those few presses that remained in working commission were used mostly for printing auction sale notices from the large wooden letter forms still held in stock by the printer — thus preserving a tiny area of usefulness, and continuing a line that began with the presses used by Gutenberg some 500 years before.

About 1860, Bolton, an English wood engraver, succeeded in getting a photograph on his woodblock by coating the surface with a light sensitive emulsion. He was now able to make his engraving directly through the photograph, without the intervention of a hand drawn image — an event of the utmost consequence to the future development of engraving and to various other forms of printmaking.

Until the end of the century, similar methods of engraving through photographs (printed on the block) remained standard practice for most commercial reproduction. By this time, engraving was used almost entirely as a facsimile medium for the mass production of printed material of every kind. With the rise of popular journalism, newsworthy and documentary engravings appeared regularly in the daily and weekly papers: images of bridges collapsing beneath express trains, of furious military encounters, of climbers toppling over Alpine precipices or trapped in the fatal surge of an avalanche. Engraving, too, was a favorite medium for books and periodicals reflecting the happier interests of travel, religion, and the family. Old scrapbooks are still found filled with engravings of favorite scenes preserved from these works: the sedate progress of a family on a Sunday walk; the calm splendors of a cathedral close at sunset; or smiling laborers, aproned and gaitered, returning from the fields.

These images were often executed by specialist engravers of quite remarkable skill. To produce large magazine illustrations in the shortest possible time, work on different sections of the image was frequently carried out by a team of engravers on separate blocks. These were later keyed and bolted together for printing. Areas around the edges of the different blocks were deliberately left unengraved, and here the most skilled engraver of the team would set to work to knit together the network of lines — joining the broken contours together with tiny, skillful cuts — so that the onlooker would be unaware of the mosaic origin of the original block. Only a few proofs would have been pulled from a block of this kind. The magazines, themselves, were printed from metal electrotype facsimiles of the hand engraved originals.

In the 1880's and 1890's, the ruled, cross-line screen appeared, which made halftone reproduction possible. This invention, as we know, enabled the printer to reproduce photographs for the first time without recourse to the help of either draughtsman or engraver. Within a few years, the new method overran the world. We shall return to the subject of the halftone reproduction later in this book.

## Japanese Prints

We should now turn to the sensational achievements of the Japanese print. Until the end of the sixteenth century, the only printing works in Japan were those of the monasteries, and here the woodcut was mainly used for crude, stereotyped devotional pictures — outline images printed in black — made by Buddhist monks. Woodcut also had a limited use for fans and other purposes connected with court life — scroll pictures, albums, and single sheet woodcuts — but, on the whole, the medium suffered from the oppressive narrowness of a static tradition. The middle of the seventeenth century, however, saw rapid change; independent presses were set up in Edo (now Tokyo), Kyoto, and Osaka, and a more popular form of woodcut, the Ukiyo-e print, arrived with comparative suddenness.

The Ukiyo school of artists, who originated this form of picture, made an open and conscious break with tradition. By illustrating themes drawn from daily life, these artists appear to have been in active sympathy with other free thinking men, both in the worlds of theater and literature. The word, Ukiyo, itself signifies 'the floating world', or the 'pageant of passing life', it was bound up, too, with the concept of transience — the transience of

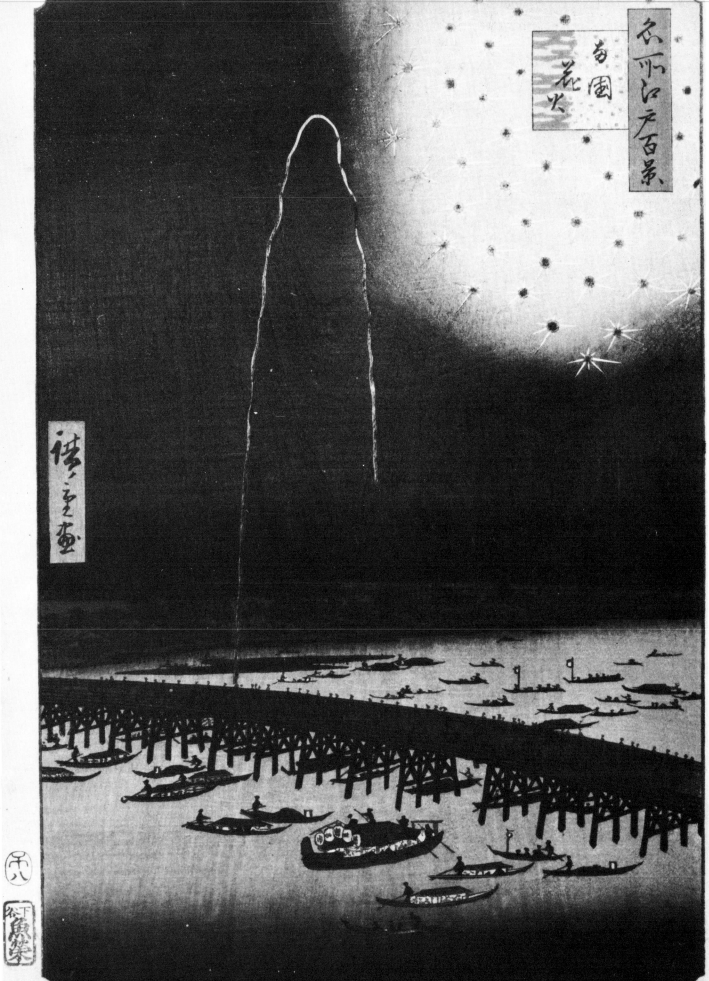

Fireworks over Riogoku Bridge,
*color woodcut from* The Hundred Views of Edo
*by Hokusai, 1858.*

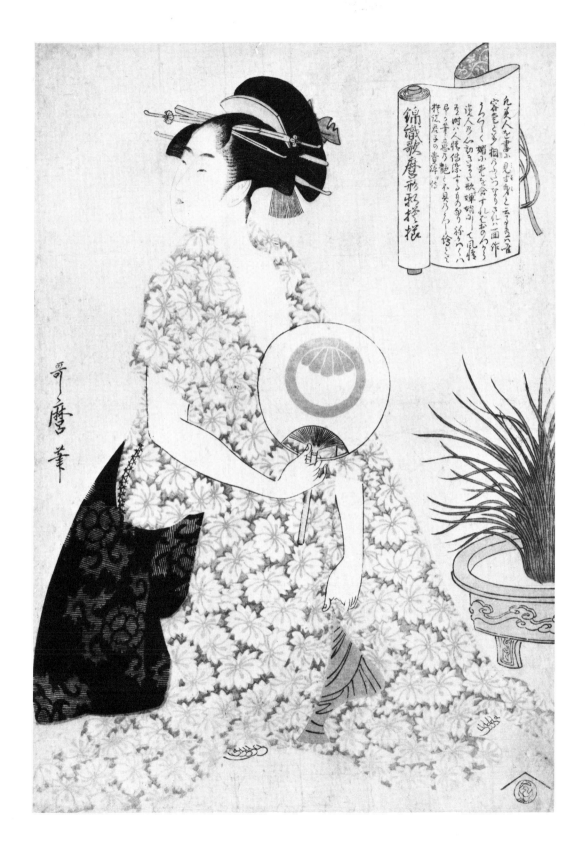

The Brocade Dress, *color woodcut by Utamaro (1753-1806).*

Women on the Potsdamer Platz,
*woodcut (19 11/16" x 14 9/16"), 1914-1915,*
*by Ernst Ludwig Kirchner.*

all human life. The Ukiyo-e print reflected a world in the process of continual change, a 'vanishing world'. 1660 to 1700 were the crucial years when the Ukiyo-e print burgeoned with extraordinary force.

An active dialogue existed between the Ukiyo school of artists and the Kabuki Theatre. Both won wide popular support, in particular among modern minded men, and both were radical movements, contrasting sharply with older traditions. The Ukiyo school of painters stood in much the same relation to the classical traditions of the Tosa (Chinese) and Kano (Japanese) schools of painting as Kabuki stood in relation to the ancient traditions of Nō drama. The best Kabuki actors had crowds of followers. Hence they were feted, much as pop stars are today. Their admirers demanded portraits and these the artist supplied, the woodcut likeness revealing a look appropriate to their more famous roles; an expression of unbridled passion or lowering ferocity is common enough.

Together with actor prints, came warrior prints. These showed antique heroes in the wild panoply of horned, plated, and scaly battle dress. Numbers of books were also produced. These could be cheaply done, since the text, consisting of titles or brief poetic allusions, could be cut on the same blocks as the pictures, and printed with them. They illustrated themes of violence and love; of incidents drawn from civil wars, centering on various national heroes; and of 'spring drawings,' a euphemism for erotic pictures. A vast output of woodcuts served the sensual fantasies of this ebullient society, from portraits of rich courtesans, idolized at a distance like the film star of today, to female portraits published in guidebooks, designed to facilitate romantic or sexual contacts between geisha and customer.

The well known courtesan became the very repository of fashion, the model upon whom the leading dress designers displayed their newest, most exotic and dazzling styles. To some extent, the artists themselves were involved, for many produced albums of kimono patterns based on their own designs. In any case, they were careful to follow female fashion. "It was the period when women put combs in their hair", Shiba Kōtkan wrote, "I took good care not to overlook that, and the public was greatly taken with my prints."

By the early 19th century, the landscape print became immensely popular. This taste arose, no doubt, from a repressed aspiration to know something of the world beyond the small, densely populated islands of Japan itself. Since foreign travel was forbidden, scenes of the parks of Edo and Osaka, views of mount Fuji, the Yodo rivers, Lake Omi, or the plumed and plunging currents of the Nikko waterfalls served to satisfy this longing. Hokusai and Hiroshige between them produced many hundreds of woodcut landscapes, bridges, waterfalls, and mountains were each the subject of a series of color prints. With these fine artists, the popular woodcut virtually ended; by the end of the century, little was produced beyond a mass of meaningless, stereotyped, and insipid images, designed largely for the tourist trade: a pagoda between willows, a young girl feeding goldfishes, petals blowing from an outstretched branch of cherry blossom.

The fully polychrome Japanese print developed by stages. The earliest woodcut prints were black and white, though color was often applied by hand. Two colors were later added to the black — pink and green — and separate blocks were cut to edition these colors. From 1762, the fully polychrome image appeared, using five or more different pigments. The water based inks were brushed on the blocks by hand, producing a flat field of color, but as the technique grew in sophistication, effects of graded color were obtained by the progressive dilution of the pigment directly on the block.

If we exclude the publisher, the printed woodcut resulted from a group of three, working closely together: artist, woodcutter, and printer. The artist either drew his image directly on the block, or onto a sheet of thin paper pasted to the block. In this case, the woodcut was a reverse image of the original, but if the drawing was pasted face down, on paper thin enough for the lines to show from the back, the woodcutter could produce a block that printed the same way round as the original. Some of the more successful artists left the detail of their drawings incomplete; the woodcutter himself filled out the pattern of a dress material, or the foliage of a tree. Apprentices were always trained to produce exact facsimiles of the master's work.

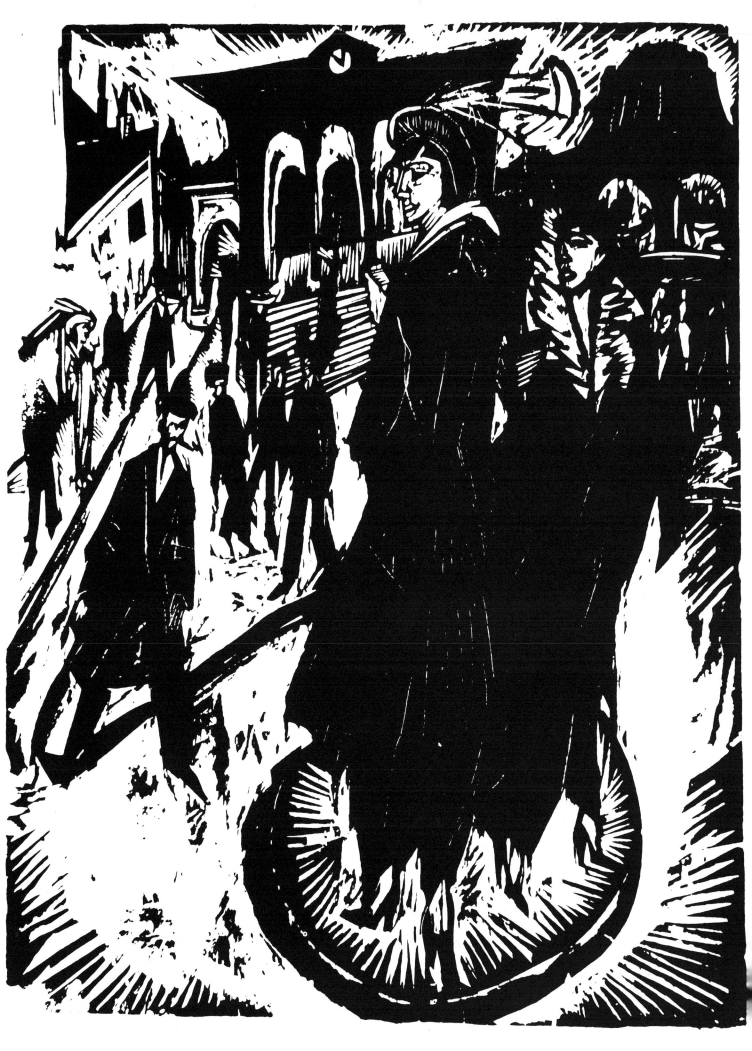

Angst,
*color woodcut (18  1/2'' x 14  7/8''), 1896,*
*by Edvard Munch.*

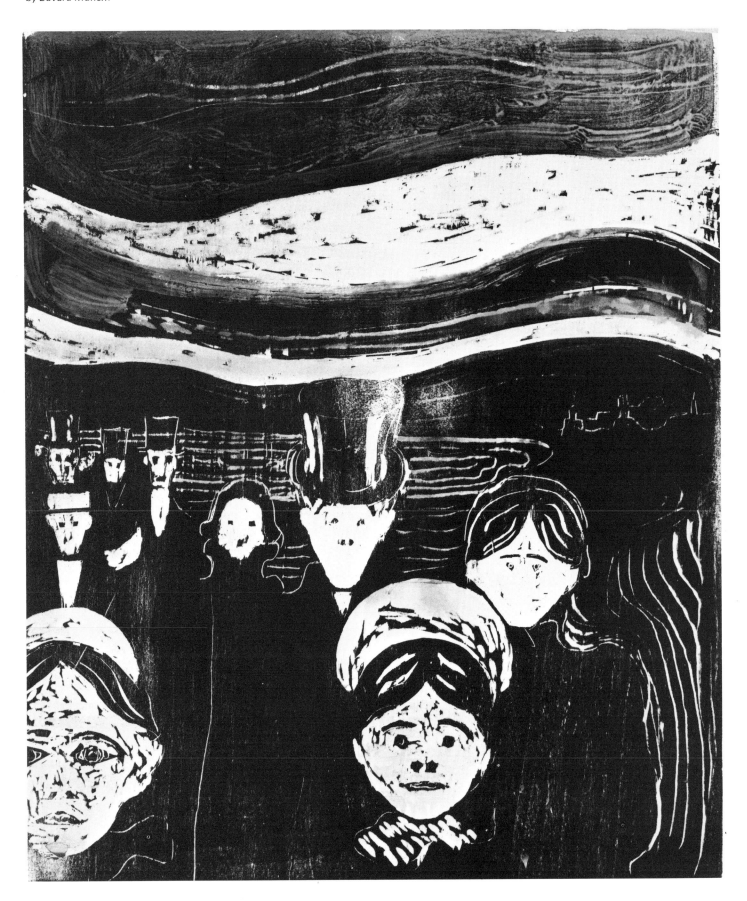

To Piker pa Broen,
*woodcut (10 1/2" x 8 1/8"), 1905,*
*by Edvard Munch.*

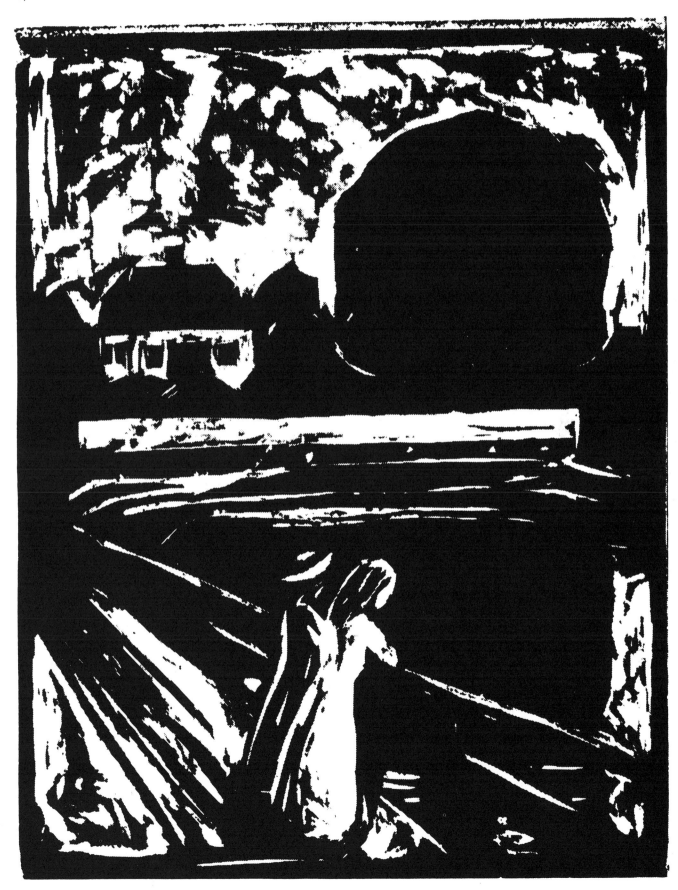

Life Class No. 7,
*lithograph (22" x 14"), 1968,*
*by Allen Jones.*

## Printmaking Revival

About the year 1856, Japanese woodcuts, used merely as wrapping to protect imported china ware, began to appear in Paris. The arrival of this remarkable art form in Europe was thus quite accidental. The best of these prints, however, were quickly recognized by Lautrec, Gauguin, and Van Gogh, as having particular relevance to the strong, vividly colored, planar images they were themselves evolving. This was an event of some importance, since the printmaking revival of the last eighty years may be ascribed, at least in part, to the impact of Japanese woodcuts on the artists of the eighties and nineties of the last century.

Gauguin and Munch, together with Nolde, Kirchner, and other members of Die Brücke school, were among the first to reactivate relief printing in the form of woodcut. These artists, in particular, used woodcut in a very pure form. They succeeded in heightening the power of line and mass by exploiting the dramatic character inherent in the timber grain itself. As practiced today, however, relief is essentially a hybrid process, partly a revival, partly an original phenomenon, evincing many novel connections with the arts of collage and assemblage.

But the biggest change by far has been brought about by the intervention of photo-technology. The introduction of photo aids to printmaking followed (or so it would appear), the introduction of the silkscreen image onto canvas by certain American painters, notably by Rauschenberg. My own first encounter with the "creative" use of photo-silkscreen took place in Paris, in 1958. After a late supper, I was taken by my host to what was then a new gallery (The Galerie Ileana Sonnabend), a midnight visit occasioned by his eagerness to show some new work lately arrived from New York.

The door of the gallery was unlocked; we were taken to an upper room.

Here were shown to me the first "black" Rauschenbergs that I had seen, and the first, I suppose, to arrive in Europe. They were all dark images, partly silkscreened directly onto canvas, and partly painted with big, loose marks of the brush. The subjects shown were a huddle of white helmeted football players; a crashed train — a side view of buckled carriages — and helicopters lifting against a graded sky — space age insects with spidery menace in their forms. The veiled blackness of certain kinds of news photography had invaded these images, giving them a smoky, mysterious presence. And although his subjects were those of daily life, Rauschenberg, by his use of the photo image, had somehow given them the deep perspective of memory. They did not belong to the sharply contoured world of seen and recorded fact. There was an ambiguity. The flying figures of the football players involved you in an immediate event — in a sense you were there watching these men — yet the presentation gave the helmeted players a remote, nostalgic, even ghostly, presence. In Rauschenberg's hands, the silkscreen image had become the vehicle of a kind of perception that was entirely new.

Viewing these images at midnight, in an alien city, formed for me a significantly dramatic introduction to a theme that now appears central to the development of printmaking. Shortly afterwards, one often saw photo imagery used for editioned prints. The hard encounter between the hand drawn mark and the photographic statement had begun.

**Throughout a long history, printing and printmaking have undergone change. They have reflected continually the different cultures of a hundred peoples; but the present moment may well provide their most marked and dramatic transformation.**

**In the workshop of the modern college or art school printmaking department, old hand presses (derived originally from the wine press devised two thousand years ago) stand within easy reach of the photographer's darkroom. Workbench hand tools of very ancient origin lie beside boxes of photosensitive film. We now appear to have reached the frontier of the hand crafted print; beyond this line, an entirely new territory lies open to our inspection. This account of relief printing is written against the fully acknowledged backdrop of decisive change.**

## The Relief Process Now

The new materials available for prints, such as plastic, rubber, plywood, and hardboard sheeting, together with an extended tool kit — the powered tools in particular —

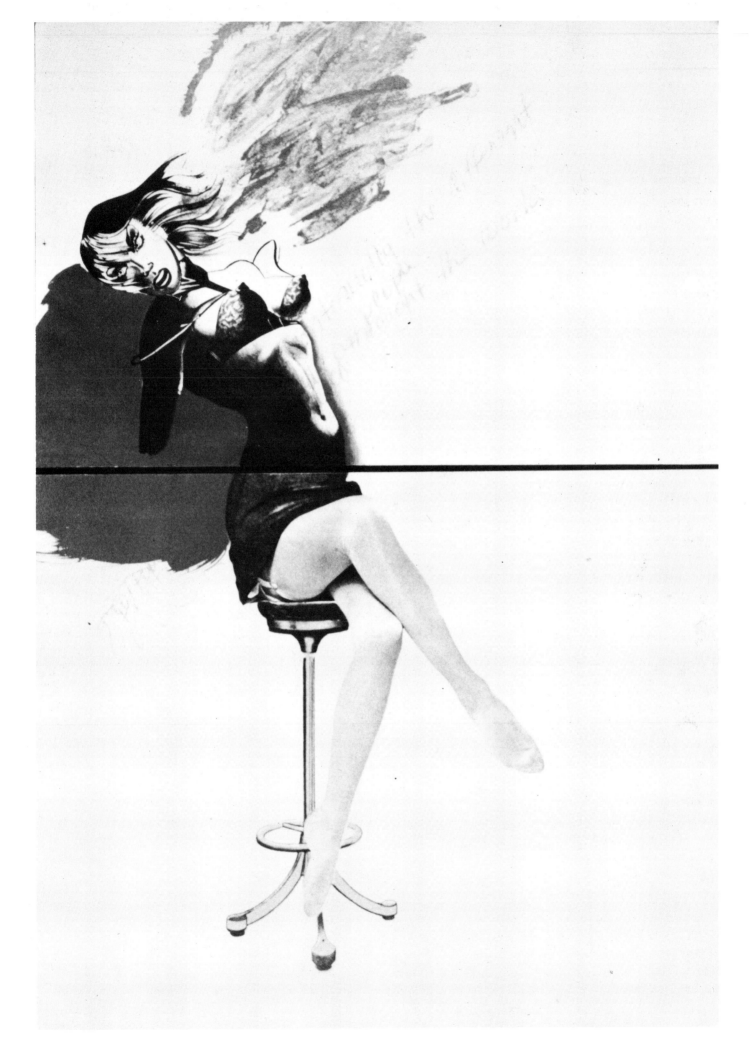

have all contributed to changing methods in the print workshop. Finally, the arrival of photographic aids has placed entirely new areas of expression in the print-maker's hands. This situation has made us look again at the part played by hand gesture, and indeed at all the manual techniques that have held so preeminent a place for hundreds of years.

As a matter of fact, all the hand crafted print processes, relief printing among them, have been overtaken to some extent by developments in photography. Photographic facilities exist already in art schools; in the future, more of them will exist. Wherever technology intercedes, the hand content of labor (including all the specialized crafts) has shown a marked tendency to drop. It is certain that many remarkable professional prints and student projects in our own day, have been partly or wholly dependent on photomechanical aids, and to this extent, they exhibit the recognizable pattern of reduced gestural content. Indeed, manual mastery, in terms of a restricted system of carved and engraved marks, is already giving way to photographic technology. This technology, moreover, can be expressed in more universal terms than could the older forms of craft, where traditional methods were inseparable from regional differences.

But here a paradox exists. Whatever facilities the camera offers, certain prerogatives will continue to be sought, prerogatives which alone enable us to maintain an active balance between the needs of direct individual expression and a dependence on photomechanical or other aids. Wherever creative work is done, hand gesture is likely to remain with us in the foreseeable future, for once this is totally withdrawn, the whole machinery of empathy will slowly disappear; on this basis, we should be left only with programmed propositions, and this is never likely to happen. It is more sensible to reckon with the strenuous dialogue that already exists between camera technology, on the one hand, and the manually created mark, on the other.

In this connection, the relief print may well make a special contribution; for one of the chief arguments in favor of this method is the richness of experience that goes with the use of materials that are solid and actual in their presence. With their use, we participate in their life.

Apart from hand crafted blocks of wood, metal, and various other materials, the relief method is unique in enabling the artist to get images from a great variety of different surfaces — almost any flat object that can be covered with ink and that is tough enough to withstand the necessary pressure for printing: a section cut through a tree, a face of eroded stone, a fragment of tortured metal found on the beach. We may well consider such images capable of greatly extending the printmaker's art. Together with my students, I have taken impressions from hundreds of different objects: pierced furniture mouldings, printed electronic circuits, pieces of embroidery, fragments of slate, floorboards, the rippling surface of a nylon stocking.

If the camera lens alienates us from direct experience, placing within reach unlimited sources of "second hand" imagery, the active involvement with processes and materials, each of which makes its own claims on our skill and energy, brings us again in balance with physical reality. There is certainly no lack of drama in this situation; for here, in the practice of printmaking, a basic, grass roots activity can be brought into active relation to the enormous shadow world of darkroom and process camera.

The implications of the change outlined above are large indeed. Doubtless, it will be many years before we can properly discern its meaning, or trace its line of development. In the meantime I have hazarded the above suggestions, though I am well aware that comment on this general level is always dangerous.

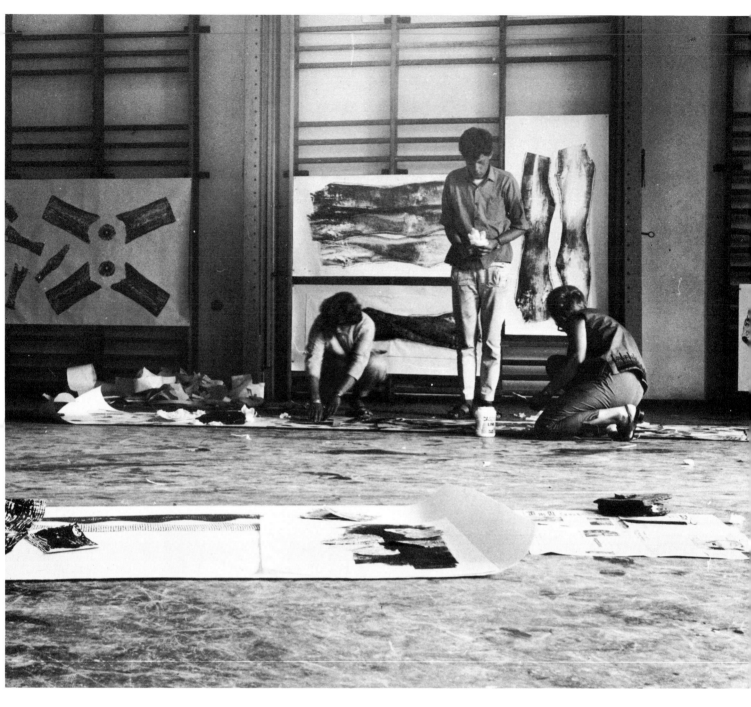

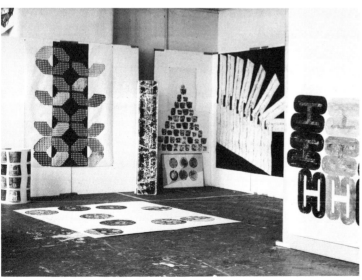

Voss Summer School. *This is one of the workshops of Voss Summer School in Norway, organized under the direction of Waldemar Stabell. These students are at work on large scale prints, chiefly based on found materials. A summer school offers quite novel problems to the teacher since he must attempt to open an effective dialog with both the committed career student and the middle aged amateur, anxious for the most elementary advice. The teacher is dealing with a group mixed in both age and experience, and all or most of those taking part are likely to be quite unfamiliar with the presses or other equipment in use. Hence the summer school graphic workshop is likely to fall into confusion and disorder with insufficient help from the class monitor or technical assistant.*

Prints are displayed for group discussions *at Goldsmiths College School of Art, London. The results of a one week program are shown here, designed to open up discussion of printmaking between first year students drawn from different study areas; hence, painters and sculptors were involved as well as printmakers.*

# 2
# TEACHING

As technology advances, it leaves the creative act as one of the few remaining prerogatives of the individual personality. One reason, no doubt, why more and more students crowd into the art schools year by year. Since many of these students are likely to spend at least part of their time making prints, it becomes increasingly clear that the graphic studio should now expand its activities, moving away from specialized study to a more open dialogue with mainstream ideas. I doubt whether the student of today any longer responds to the idea of print study as craft. He seeks a much more total scene, where different forms of study become merely a series of bases from which he can explore outwards, setting up a long frontier between print research and the pursuit of color, movement, optical or other values. This pushes the teacher very much into the center of the stage; he must now act as the intermediary between different activities, setting up connecting areas of study that finally make sense of the art course as a whole.

The day is past when these courses were broken down on the basis of different techniques — oil painting, watercolor, pencil drawing, charcoal drawing, and so on — though, in my grandfather's time, art was indeed taught strictly on this system. Up to now, the movement away from this confined approach has shown itself most clearly in the schools of sculpture and painting. Many fine sculpture departments, for example, have encouraged an active dialogue between all available techniques; plastics, carving, modeling, and wood and metal construction.

In the study of printmaking, however, this open minded and active posture is less usual. Perhaps a main block to a forward move has been the sectionalization of the job, the boxing in of each printmaking technique in a separate compartment. On the whole, we tend to think of doing a "lithograph," an "etching," or a "silkscreen." And this notion of a particular technical approach may take precedence over exactly what we mean to do with these media. We tend to find some special virtue in mastering a series of techniques — silkscreen one semester, engraving the next. In this absorbtion with means, we are easily led to neglect more fundamental questions

concerned with the ends likely to be attained.

Rightly taught, printmaking can be a large and effective arena for learning, not merely the learning of this or that process or skill, but the learning of something about the hard and real confrontations that turn us finally into worthwhile artists. If, within the art school today, prints play a narrow role, we must inquire how that role can be widened, deepened, made altogether more effective. We must persist in this pursuit; persist until the answer — or some part of the answer — is uncovered. We must discover, within the context of printmaking, ways of confronting the student with problems that are fundamental to his development as an artist: the call and answer of color, the flow or disruption of movement, the referential validity of a stated image.

Prints are best looked at in the total context of a student's achievement. Each work will bear witness, in its own way, to the quality of his latent talent, to the generosity or meanness of his natural endowment. The current tendency toward intensive specialization, however, may encourage the teacher to assess a given student's development in terms of the excellence, or otherwise, of his printed work alone — sometimes quite out of context with his main area of study. It makes little sense to encourage developments in a student's printed work that find no answering call in his drawing, painting, or sculpture.

In the study of drawing, painting, and sculpture, at the present time, a particular difficulty exists. A central factor here is the condition of cultural overload that puts a severe pressure on the student, providing, as it must, a complex mosaic background to all his activities. The level of diversified stimulus offered by books, articles, television features, lectures, films, exhibitions, etc., is unique to our time. A cultural explosion (of perhaps an unreal kind) is keeping pace with the explosion of information. As a result, the student may be torn between conflicting claims, finding this "richness" of available — indeed inescapable — influence overdetermines his feelings in any given direction he cares to take, towards optical art, post-painterly abstraction, or any other kind of art.

An intelligent head of studies is well aware of this confusion, seeing that the sheer wealth of ideas — of

"cultural fallout" to use McLuhan's expression — may easily generate a highly toxic atmosphere, destructive, in particular, to the more sensitive student.

One answer, here, is to raise the threshold of choice: to set the student working in a sharply profiled area, where his options are more limited — and can be met more fully. In this context, printmaking has a very valuable role to play: it offers fewer choices and firmer options. I know of certain fine students who thrive on printmaking, who find an almost biological satisfaction in the exercise of engraving, for example, where the physical act of cutting a line is in itself demanding, and needs a direct form of concentration, that both frees their energies, and acts as a cutout to the "unnecessary" content of artistic responsibility that worries them.

## Printmaking Projects

What is the teacher's aim in setting up a project? To provide a new growth point for the experience of structure or movement? To clear away possible obstructions, easing thereby the process of renewal? To suggest ways of deepening and extending experience already begun? No doubt, the teacher attempts all these things, trying different projects for different students, and different projects for different stages of work.

In some of the exercises we have tried, no attempt has been made to produce a piece of finished printed work. We have aimed rather to encourage the student to experience in depth the quality of some particular situation, or the character of some particular object. To this end, we have often used the technique of print collage, as in the following example. A student studied the form of a heavy metal plate picked up on a building site. He began by taking a dozen or more direct black impressions by directly inking the metal fragment and hand printing it. Next, he cut out and moved these separate images around, exploring the way they reacted upon each other as they were positioned and repositioned on the sheet. He tried an arrangement of horizontals, piled up like the laminations of rock or slate; he tried fanning them out, he made them leap backwards and forwards from certain chosen centers; he placed them upright and tried the effect of a continuous falling

*Surface print,*
*white ink on black paper.*

*White relief image,*
*uninked surface print.*

*Intaglio print.*

*Surface print,*
*black ink on white paper*

Pierced metal plate, control image, *Haystack Mountain School of Crafts. This exercise, using a pierced metal plate picked up on a building site, was carried out by a student with no previous printmaking experience, and with no printing facilities beyond a wooden spoon and a combination printing press. A longer series of a similar kind, but one that included photographic tone processes, could be carried out in any well equipped printmaking department. The point here is that students who are taught different print techniques separately often remain unaware of the remarkable potential of any particular block. If some such exercise was occasionally carried out in the art college, this might help to bring together some of the different aspects of printing and would surely indicate the value of closely integrated study.*

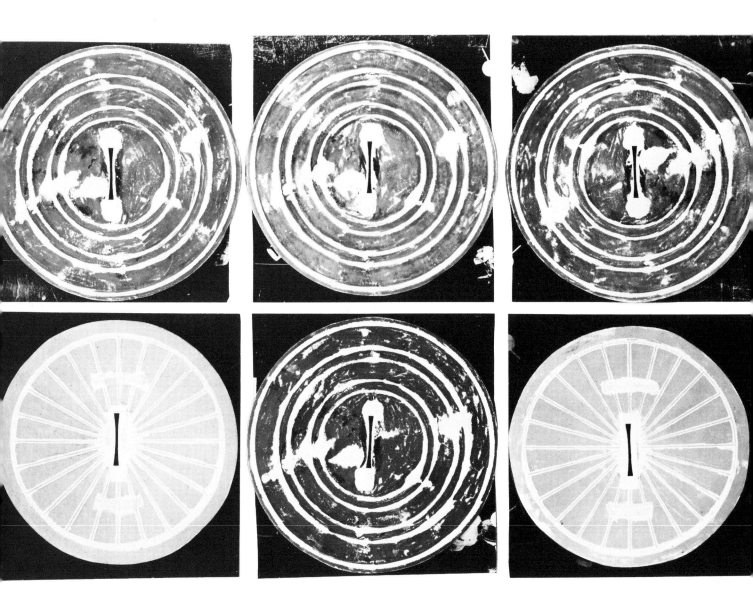

Trashcans, *direct relief print from trashcan lids by Nick Potter,*
*Brighton College of Art. The printed lids, mounted on circles of*
*hardboard with handles attached, were placed over the screen images*
*shown opposite. They were displayed lying flat on the workshop floor;*
*the "lids" had to be lifted before the screen prints could be seen.*

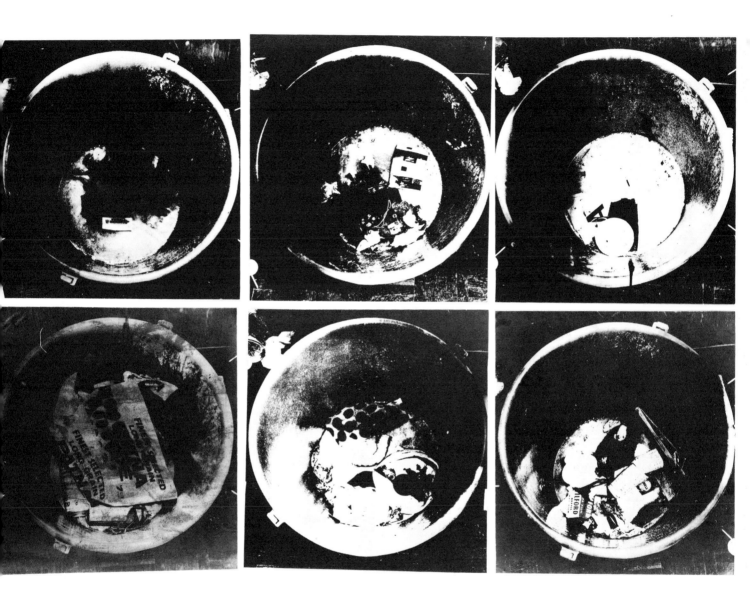

Trashcans, *with covers removed, photo silkscreen by Nick Potter,*
*Brighton College of Art. A photographic negative was made from this*
*image, and from this a positive was made on Kodalith, which finally*
*produced the photo stencil for screen printing.*

movement, running from one end of the series to the other. Finally a choice was made. He collaged the pieces together on a large sheet of paper, matching the idea he considered the best.

Collaging together separate printed elements has proved its value for the extension of print study. Merely made up of pieces stuck together to articulate the full reach of a student's ideas, the resulting image makes no particular claim to be a print. Collage print techniques, moreover, are clearly of special value where the available time for print study is limited.

## A Combine Print of Trashcans

In another instance, the programmed project had a simple enough starting point. The students at Brighton College, in the south of England, were asked to find for themselves a single object likely to generate close personal involvement — the chosen object to form the growth point for an ambitious printed consequence.

One student set out to search the school buildings and their surroundings — a search that ended on the school waste heap. Here he discovered an old and battered trashcan, half filled with rubbish. Evidently this set him thinking about the silent trickle of pathetic, smashed up objects flowing continually from every household to merge, finally, into the huge lakes of rubbish that one finds on the outskirts of every town. He emptied out the trashcan, turned it up, and set inside it different groups of objects: a crushed cereal package, a bedraggled stocking, paint covered rags, and various objects dirty and broken beyond recognition, which signified for him this drab, pathetic aspect of the world of waste.

These were photographed, directly from above; photo silkscreens were prepared and six different images printed in the sad, low toned colors — the dirty greens and grays — that belong so particularly to objects in decay. Finally, the pressed steel lid of the trashcan was covered with ink and a set of impressions taken. These were mounted down on hardboard and a mocked-up handle fixed to each. These "prints" of the bin interiors were finally displayed lying flat on a plinth, covered with their respective lids. Before the images below could be seen, these lids had to be lifted up.

This particular work was a quite remarkable instance of a print project producing a total, "wrap around" experience, and made a great impression on both students and staff. Many other instances of work, equally far out, could be given, and of work equally bound up with the concept of total commitment to experience.

After a series of these exercises had been carried out over a period of several months, it was decided that the students themselves should now set up a project of their own choice. The work, in this case, was noticeably inferior to work based on some of the teachers' former projects. But no value judgments were made; it was felt that the exercise had justified itself in effectively exposing the students to the feedback of their own ideas.

Within practical limits, the various technical services of the print rooms at Brighton College, where these projects were done, are all placed at the students' disposal, to be used at their considered discretion. The staff, in the meantime, give tough group tutorials in which each student's work is discussed in detail. But the feeling here is that teachers are "on the floor" with the students, and criticism takes the form of constructive "feedback" rather than paternal advice.

## A Printed Block of Wood

A three dimensional black and white print of a block of wood was produced by the following method. The pinewood block was first rolled up with black ink and a hand burnished print taken from each of its six faces in turn. The six prints were then mounted back upon the block, and secured with glue, producing a three dimensional "unwrapping" of the original form. A remarkable feature of this study consists in the "reality" of the transformation: the inner structure of the timber reveals itself on each of its faces, with the consequent interaction of the structural figure between them.

The print of an organic surface always tends to possess a "landscape" character — in wood, the marks, cracks, indentations, and whorls of its structural figure — but metal, hardboard, textiles, the plaster coating of a wall, are all embedded in time, equally subject to erosion and accident, and all will finally reveal on their surface the marks of their past history.

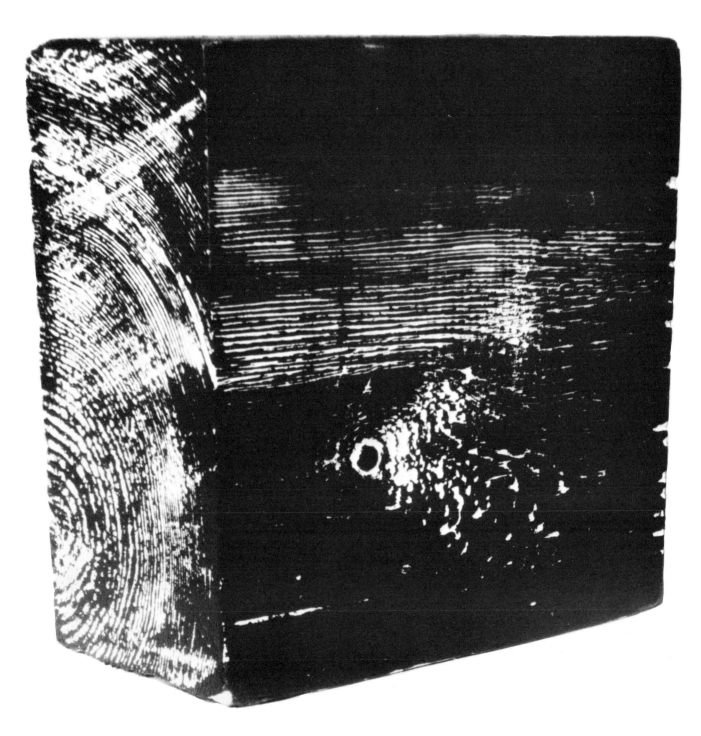

Three dimensional printed block of wood, *hand rubbed relief print by second year student, Falmouth School of Art. We have grown too accustomed to the notion that printed impressions should be flat images made on flat surfaces by woodblocks, metal plates, or whatever. But since paper is flexible and can be curved and bent and fixed to an inked surface — with weights, tape, and other adhesive devices — we can take prints from inward and outward curves, or even from surfaces that go around corners. We have occasionally made these impressions from found materials taken from the lumber yard, the carpenter's workshop, or the sculptor's studio. In the case of this printed block of wood, six separate prints were taken of the six surfaces of the block, and each print was finally mounted back on the block, gluing the paper to the surface from which it was originally taken. Having something of the character of "still life" — since it concerns itself with the study of objects close at hand — this form of study may have considerable value.*

Untitled relief print *(62" x 45") from found material (strips of wood and pierced architectural molding) by Cheri Reif, Ohio University.*

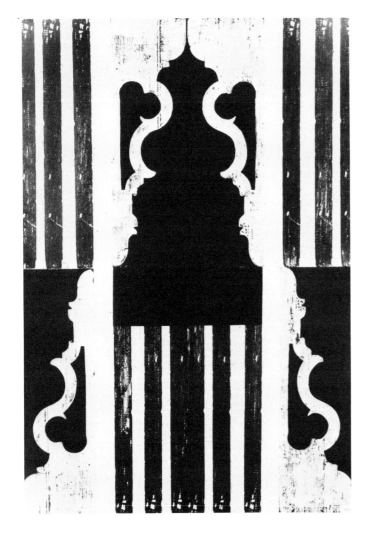

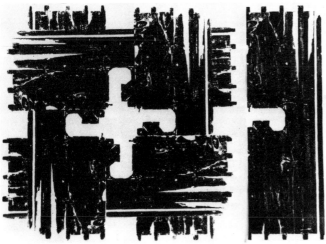

Relief and screen print *by Richard Dack, Camberwell School of Art and Crafts.*

This exercise, the printed block of wood, was the first project we initiated in printing from three dimensional objects. It was followed by a series of studies that took two rather different forms: first, the examination of solid objects by printing them directly, and second, the printing of objects which had been taken apart expressly for this purpose; in the latter case, an "opened out" or exploded image was produced.

Our first trials were made in the summer of 1966, at Haystack Mountain School of Crafts in Maine. This type of work was then so new — and the results it gave so unexpected — that a good deal of excitement was quickly generated around it.

The most ambitious project we tried was printing a disused desk found in an outbuilding of the school. The desk was first taken apart and the various sections printed in turn on separate sheets of paper. Ken Kaplowitz, a young student from New York who undertook this project, persuaded each of us to carve our name or initials on the desk top before printing it, in recognition, I suppose, of the appropriateness of such marks when revealed on the timber of an old classroom desk. The consequence of this curious study was an "opened out" image of great complexity and vitality. Since then, three dimensional prints of shoes, car tires, tools, gear wheels, and many other objects, have all been tried.

Some fine examples of this work have been carried out in the art department at Ohio University (in Athens) under the instruction of Donald Roberts and Abner Jonas.

### Effects of Sophisticated Equipment

In the art school or large university art department, many thousands of dollars may well be spent on providing photographic and other equipment for the students' use; process and vertical cameras, enlargers, light boxes, etc. However, each sum of money spent by the department may be said to widen the gap between work done in the school, with the use of these facilities, and work done by the student on leaving school, without them. Alone in his studio, the student — now become artist in embryo — cannot avail himself of the very equipment that lately

Crushed Cans,
*intaglio print by second year student,*
*Goldsmiths College,*
*School of Art.*

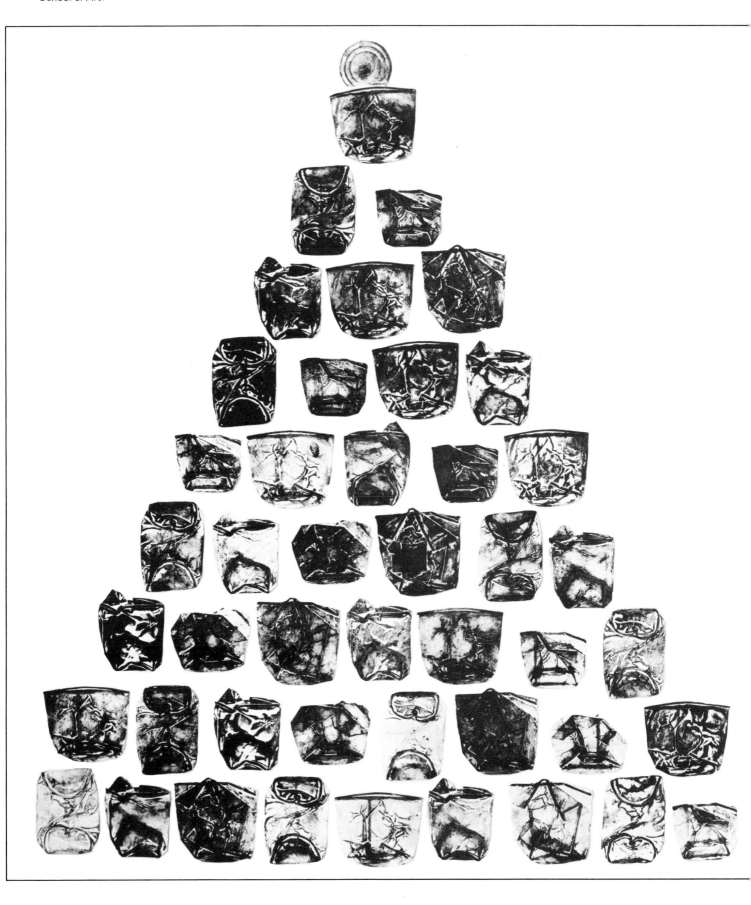

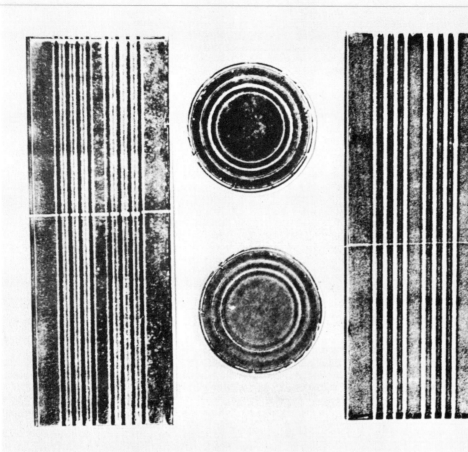

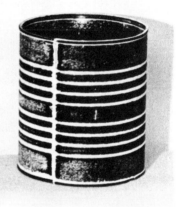

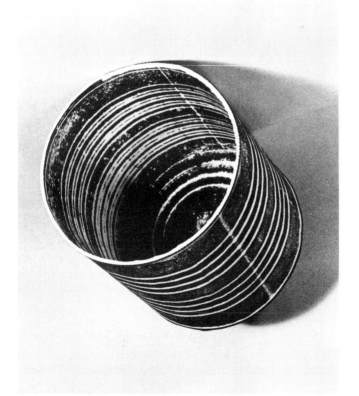

"Printed" bulk food can, *three dimensional relief print, Haystack Mountain School of Crafts. This was one of a group of "prints" involving the study of objects close at hand, in this case the bulk food cans found outside the school's kitchen door. A can was taken apart, the sides were flattened out, and the outside and inside of each section printed separately; finally, the separate prints were mounted on a second can. Time and again, this form of study has proved its worth, both in the summer school and in work with groups of young students unaccustomed to printmaking. It quickly involves the student in the study of actual objects, and sets in motion a series of practical problems that need practical solutions — how to print the inside or outside of a curved surface, for example. These problems are in themselves interesting and often highly relevant to the job of printmaking. This is a form of study in which esthetic choice is almost entirely excluded (non-choice activity) and the interest of the final result lies largely in its complete unexpectedness. None of us knew, for example, how this can would look until we had actually printed it. Once printed, we found that the original object was entirely changed — its values of surface form interpreted only in black and white. This transformation is always found exciting and arresting, since transformation itself invokes one of the basic esthetic principles. Often, too, it produces results of unexpected quality, particularly as in the present case, where the print is three dimensional in character; and here a photographic reproduction can give little notion of its actual presence. (Photo by Kenneth Kaplowitz.)*

surrounded him; and should his talents have become closely geared to their help, he may well find his abilities frustrated.

A grass roots situation, where the student is thrown on unsupported native talent, should be balanced by the teacher against one where the use of sophisticated graphic equipment is placed naturally within his reach.

By the same token, work in specialized printmaking studies (such as graduate degree programs or post diploma courses) should be regularly supported by other forms of study. Printmaking, with its high content of specialized discipline, may narrow the students' viewpoint, and so encourage an unnecessarily high regard for this discipline. Painting, drawing, sculpture, collage, assemblage, construction, and photographic research are all disciplines capable of widening and deepening the student's *total* experience in undertaking any particular peice of work. The various projects undertaken should form a related series and, insofar as they are programmed by the teacher, this sequential relationship forms an important part of the teacher's aim.

Art schools can easily disrupt the sequence of printmaking studies by arranging courses that insist on a series of brief excursions into various methods; etching, lithography, silkscreen, etc: but the limited time normally allowed for print study suggests a much more sustained pursuit of a single technique (always allowing the student the option of change where this appears necessary). As a matter of fact, this would not only be likely to produce more solid experience on the student's part, but an experience sustained enough to relate his printmaking more securely to his painting, sculpture, graphics, or his other main area of study. The argument that the student should "try everything" introduces a disturbing pattern of unnecessary diversification when his position in the art school is already overexposed to a mosaic of conflicting claims.

## Large Scale Prints

At present, students of painting and sculpture tend to work large. Where this big scale has meaning, it is often conceived as a direct exchange with the values of movement, color, height, reach, pace, etc., set up by the work itself. It was natural enough that my students should consider making prints that were equally capable of forming an arena for these preoccupations.

The availability of paper manufactured in continuous rolls, together with the silkscreen printing method, made this desire a practical possibility. Since we initiated the concept of the "big print" for art school study in 1967, a number of these jumbo images have been produced, such as the 18' long Arrowhead print. The motif in this case was taken from a pierced architectural molding. This was directly inked and a series of hand burnished prints were made. These separate images were then set out and collaged together. Next, a photo screen was prepared from the basic unit, which was finally printed according to the system set out in the original collage. The color scheme consists of various shades of black and gray to vary the pace, accent, and movement of the image.

## Repeatability

Repeatability is a characteristic of all print media. The matching and multiplication of an original may indeed be considered, above all else, the reason that these media were called into existence: the main line of their evolution has been firmly centered around two characteristics — accuracy of interpretation and ease of reproduction.

So long as the image was taken from a "continuous" surface — a metal plate or woodblock matched to the size of the original — the concept of repeatability was severely limited. But the moment the collage or combine print arrived (and with it the open block method later described), it became obvious that this narrow interpretation was likely to be extended. The methods of photo stencil and lithographic transfer have placed many new recourses in the printmaker's hands. Robert Rauschenberg, for example, has fully demonstrated the structuring of an image by the use of repeated insets. In many art college projects, images have likewise been based on the use of a repeated unit. This has lent itself, in particular, to the large scale print where an impressive field of movement can be created by the multiplication of an identical shape. Some of these images have been developed on a masterful scale: in some of them, the

identity of the individual unit loses itself in the complexity of the total field. Here a situation of optical vertigo may be set up — in looking at them, a process that calls for continual scanning, we tend to "fall" into them, losing entirely our normal posture of "seeing."

## Teaching Children

In regard to work with young children, my own experience has been limited. It is certain, however, that a central purpose here is to open an active dialogue between the tools and materials used, on the one hand, and the child's response to his environment, on the other. Here, in his immediate surroundings, the most vigorous source of his experience will be found, and here the teacher can offer effective help by giving the child an understanding of the remarkable potential of the technical means by which this response can be ordered and shaped.

Compared to drawing, print study contends directly with the physical presence of the object studied; therefore the tactile experience may be as immediate as the visual one. The surfaces used for printing are constantly touched with the hand; rubbed, smoothed, scraped, or flattened out. Finally they are covered with ink and paper pressed upon them.

For this reason, a special value is placed on the use of plasticene in the early stages of printmaking. It is a material that can be easily pressed into the conformation of a relief surface, and by this simple means a cast can be taken. Plasticene can also be wrapped around a suitable form, pressed into its surface, and then unwrapped, transforming a three dimensional object (such as a cheese grater) into an "opened out" relief. Such casts, which are a negative image of the chosen form, can of course be inked up and printed by hand pressure in the ordinary way.

Plasticene, rolled out into an even slab, will also form a printing block. With a sharpened stick, a ballpoint pen, or the needle of a compass, the child can draw by incising lines upon its surface. Peter Green considers that "the scratching of a surface with a sharp point appears a more natural action than pushing a tool into, or through, a tough material." It is certain that drawing with a point allows a gestural freedom impossible in using edge tools, since these must always be pushed or pulled in a more or less set gestural repertory, according to the tool and the material used.

With the use of plasticene, found materials, and built up collage, together with the carving and cutting of wood and linoleum, a wide choice is open. When the child attains success, his success will be the outcome of a process with its own logic. The discipline of printmaking need not be an oppressive struggle. When the child builds up enough interest and excitement, correct ways of work arise almost of themselves by virtue of the very concentration so generated. It is surely better for the child to discover the most effective and natural way to work each block — the right tools and methods for each material — than to impose a particular discipline, such as linoleum cutting, in isolation. A "closed" method may well limit the child's response to his materials (and to all those environmental sources where these materials are found) and impose, in the meantime, unnecessary and avoidable restraints.

Having written this, I am forced, in all fairness, to admit that one of the best juvenile printmaking groups I know (Wanstead School for Deprived Boys in north London) is based almost entirely on linoleum cutting. But in this exceptional case, the method is carried out in an atmosphere of extraordinary sympathy and understanding of the boys concerned. The vigor and expressiveness of the fine work done makes nonsense of some of the arty "experimental" collage prints coming from many more sophisticated schools. Good teaching always wins out, even when, as in this case, particular circumstances impose restraints on the methods applied.

Vest *by second year student, Brighton College of Art. The image is based on the etched impression of an actual vest. The vest was spread out and run through the press on a plate coated with soft ground, which was subsequently etched.*

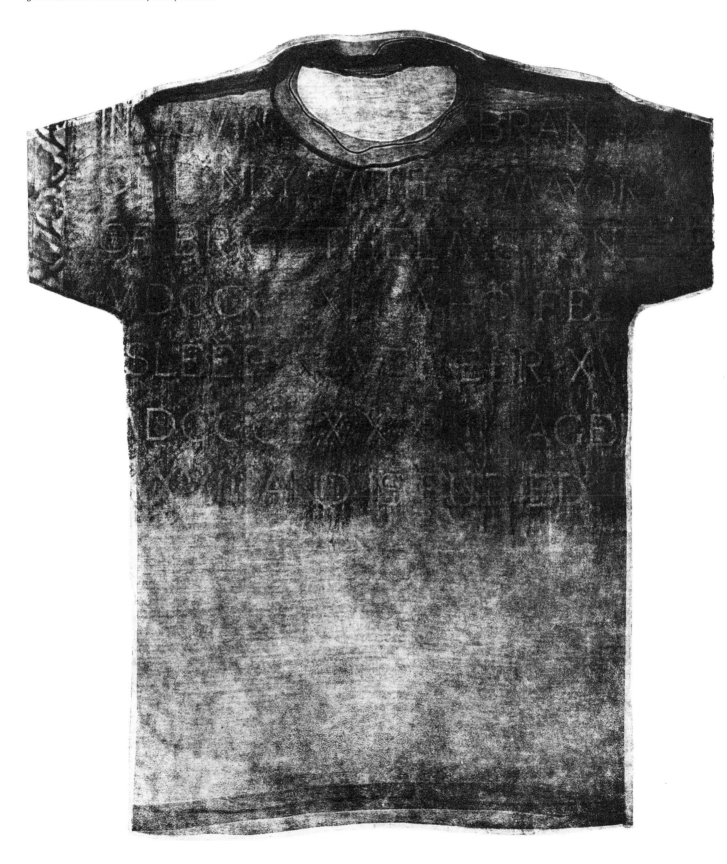

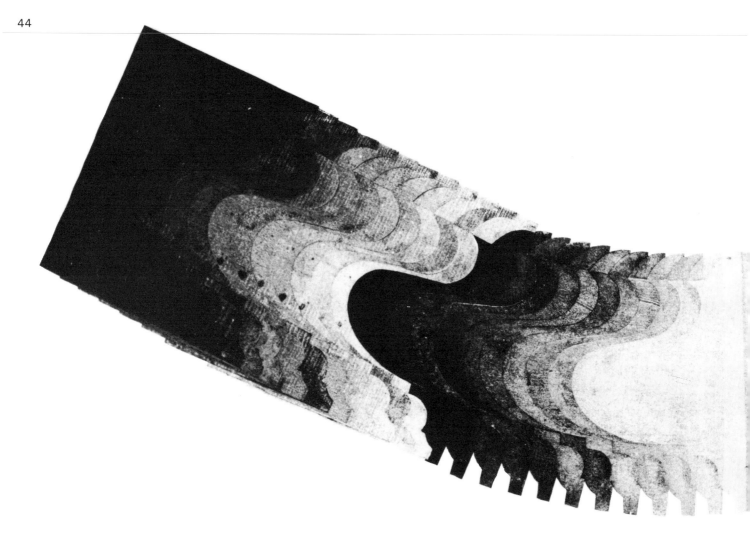

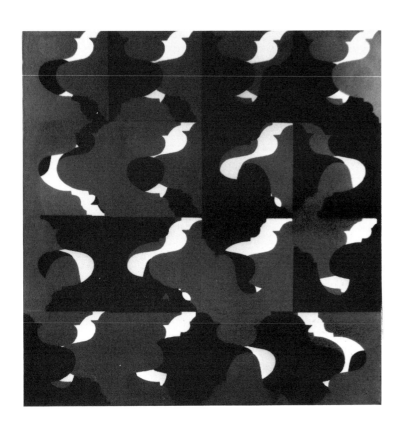

Scrambled design system, *relief and photo silkscreen printed in gray and black, by second year student, Falmouth School of Art. (Photo by John Wilkinson.)*

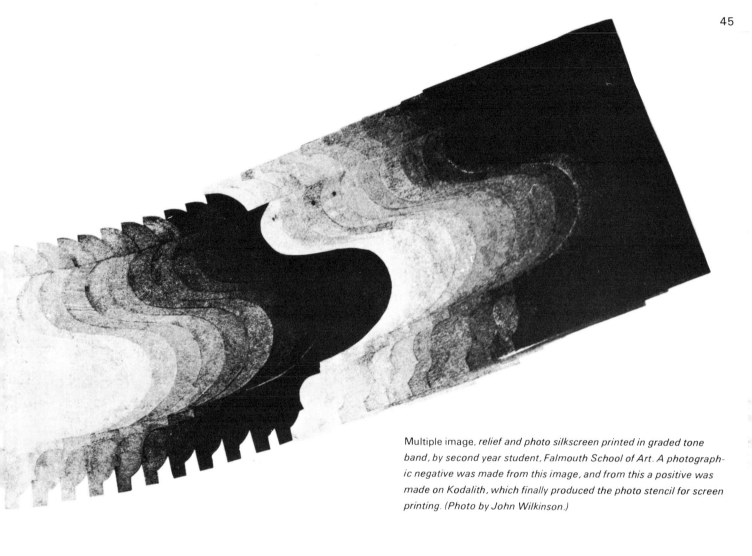

Multiple image, *relief and photo silkscreen printed in graded tone band, by second year student, Falmouth School of Art. A photographic negative was made from this image, and from this a positive was made on Kodalith, which finally produced the photo stencil for screen printing. (Photo by John Wilkinson.)*

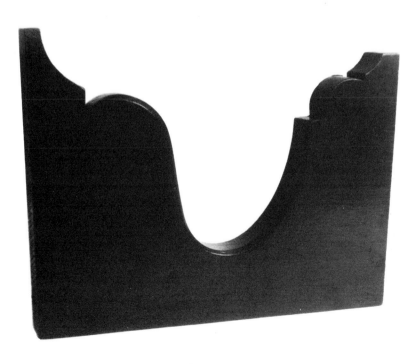

Shelf bracket *from which both images were taken. (Photo by John Wilkinson.)*

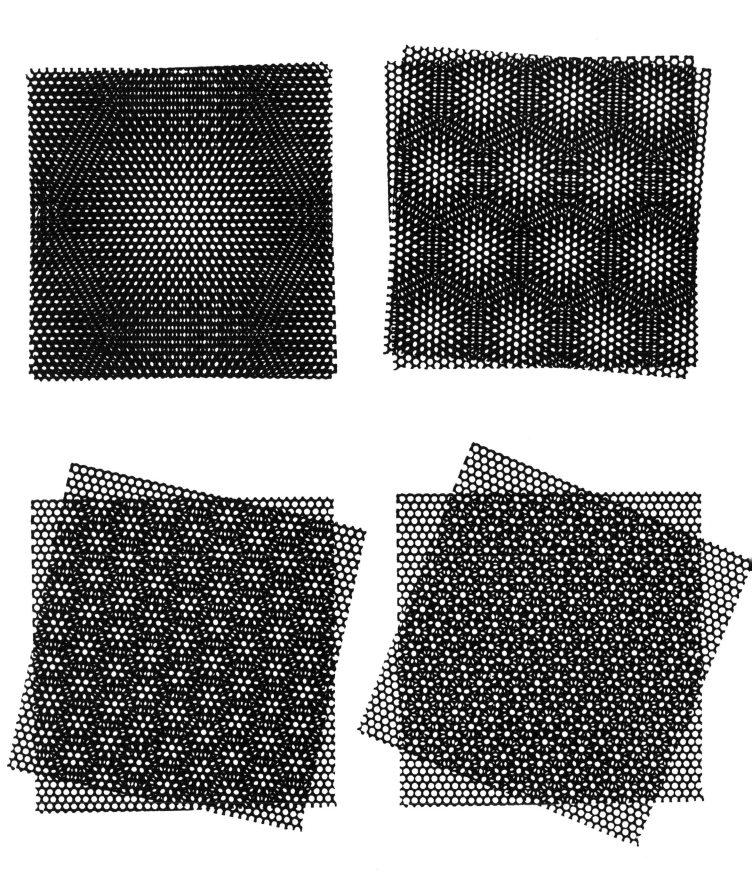

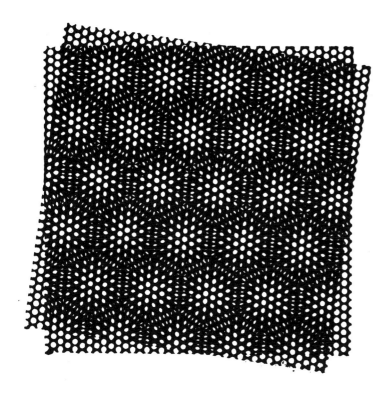

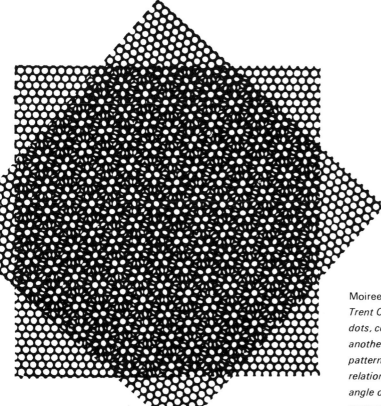

Moiree patterns *produced from a square of perforated metal, Stoke on Trent College of Art. By superimposing regular geometric systems — dots, concentric circles, parallel, wavy, or radiating lines — one upon another, moiree patterns are automatically created. Interference patterns in infinite variety can be produced by merely varying the relation of the two superimposed systems — by merely rotating the angle of the upper upon the lower one, for example. The smallest movement up, down, or across, will produce effects of whirling, rippling, or "blush" systems which may appear to expand and contract as the upper system is moved.*

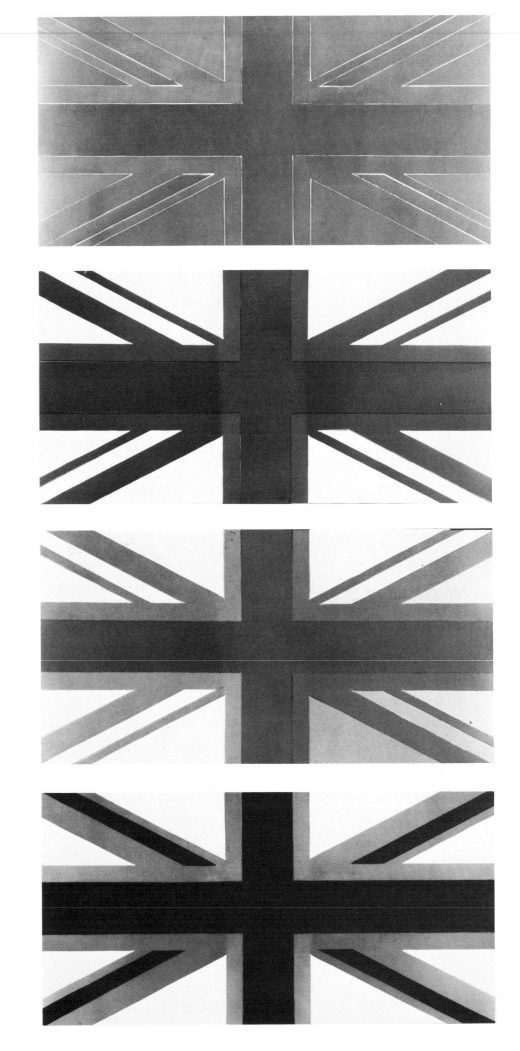

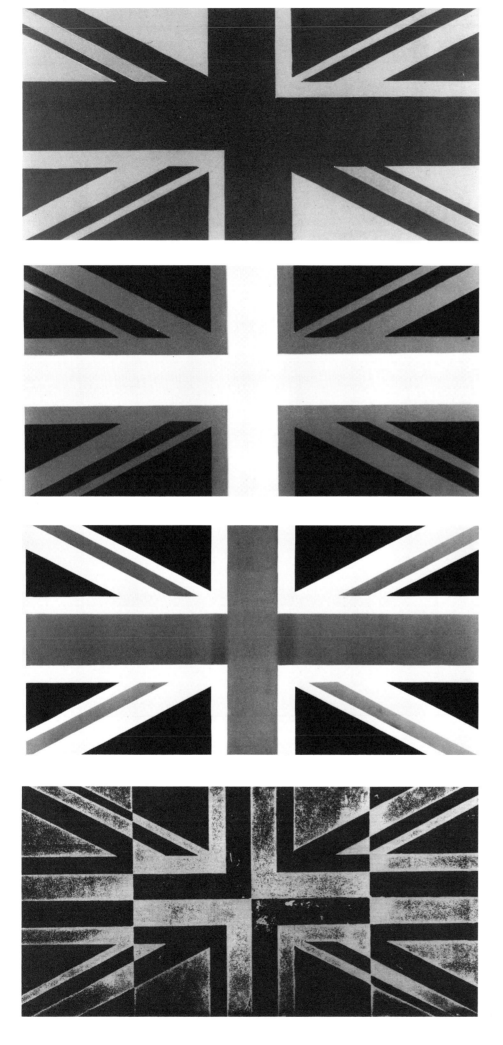

Flag *by Linda Lowe, Brighton College of Art. The block (top left) consisted of acrylic sheet, cut into sections, allowing the various sections to be inked separately and reassembled for printing. This intelligent use of the jigsaw form of block, in the course of basic study, enabled this student either to explore different combinations of color without recourse to cutting fresh sets of blocks, or to delete any element from the series to gain further experience of the different combinations possible.*

Illusion and Reality *(left)* by *Dunata Foks, Teeside College of Art. Each student was asked to construct an illusionary figure based upon a photograph of himself. The photographs were enlarged to full figure height, mounted on board, and displayed in a "real" environment. The students taking part in this project were likely to ask how far the photograph became the "equal" of reality once it had been rephotographed in a "real" setting. From there, they went on to inquire which is more "real" (in terms of their own experience): a photograph of such a figure, a drawing, an etching, a woodcut, or whatever? All these questions were very closely related to the uses and abuses of photographic imagery in printmaking.*

Arrowhead *(opposite page, upper) photo screen print from hand rubbed image of pierced architectural frieze (24" x 18') by Tonie Renwick, Bournemouth and Poole College of Art. This student made a series of hand rubbed images from the architectural frieze for this 18' long print. The individual rubbings were cut out, laid out on the floor, and collaged together to form the maquette for the print. The arrowhead format of the image arose from a close study of the original object. This is also an impressive instance of how one technique — surface printing — can be transformed into another — screen printing — through the medium of photography.*

Diagonals in Red and Black, *(opposite page, lower) large scale print collaged together from separate pieces, by second year student, Bournemouth and Poole College of Art. The diagonals are printed in black and red on a white ground. This print, some 8' high, was made by a student accustomed to working on a large scale. It makes the point that this form of study — the experience of color and movement on canvases of masterful scale — need not be interrupted by the insistence on small format print study.*

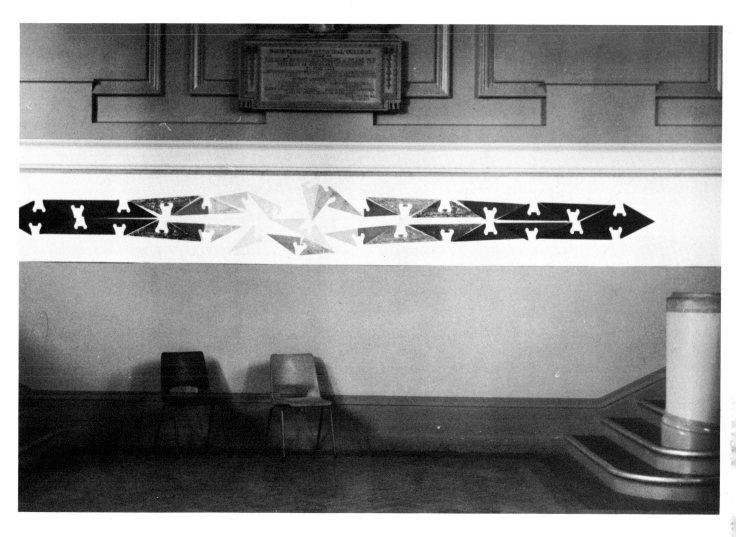

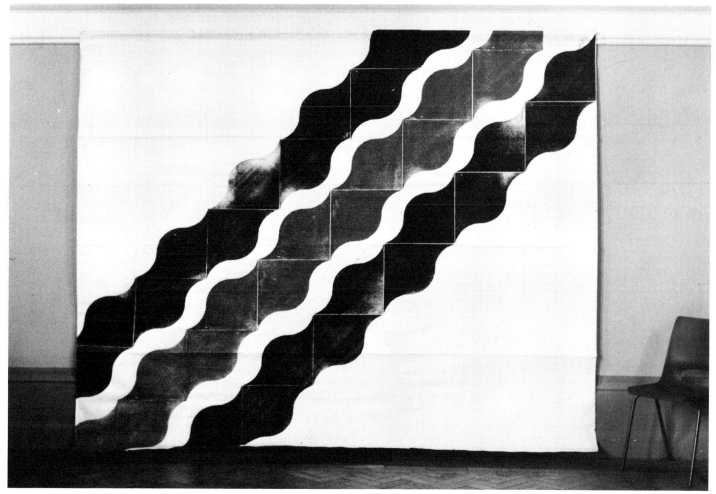

Electronic circuit, *Teeside College of Art*, was inked and printed to produce a ''found'' design. The multiple image was based on a single found form.

Photo screen print, *Middlesborough College of Art. Detail of halftone plate used as repeat unit.*

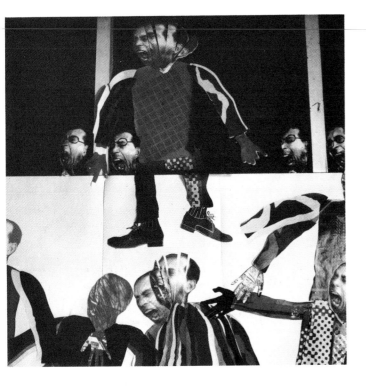

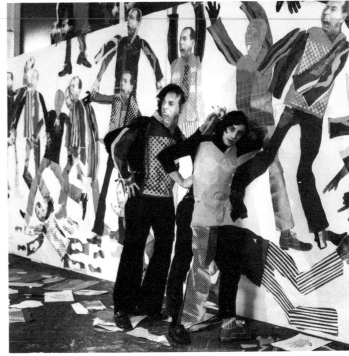

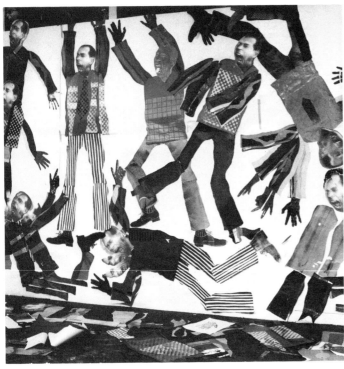

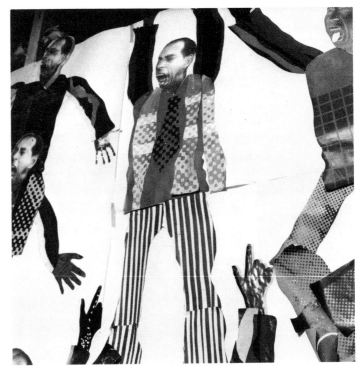

The Project of a Hundred Figures *by student group, Goldsmiths College, School of Art. The proportions and contour of a standard figure for this project were provided by tracing the outline of one of the students onto a large sheet of paper. On this "standard," all further work was based. The "figure components" were screen printed separately in fluorescent color using basic screens for head, body, legs, etc., providing an extensive file of figure "kits". Any available material was used for patterning, striping, and texturing the figures; this included mechanical tints, enlarged dot screens, photos of skyscrapers, and much else. The figures were freely articulated when the work was finally put up, using the dozens of kits provided, the facial expressions of pain, brutality, or sneering laughter appearing to alter with the arrangement of the different poses. In the final results, the printed figures swarmed everywhere in the classrooms: clinging, climbing, or falling from the walls; sitting on the sills; or peering aggressively into the rooms from the corridor outside. All this made a scene of wild animation; it had a vitality of color and movement that quite overwhelmed the presence of actual people in the room. Finally, the students themselves began gesturing and posing in impromptu attempts to emulate the crazy attitudinizing of the printed figures, and thus to become totally involved in the print environment they had themselves created. (Project set by Bernard Cheese and Roger Lunn.)*

Three dimensional photo screen print *(8' x 4') from hand rubbed*
*bricks by Jeffery Soan, Goldsmiths College, School of Art. Many*
*students are rightly refusing to acknowledge traditional limitations on*
*the format of prints. This "print" — in the form of a large rectangular*
*box — is intended to produce experience of a quite different kind from*
*the print trapped behind glass in the traditional way.*

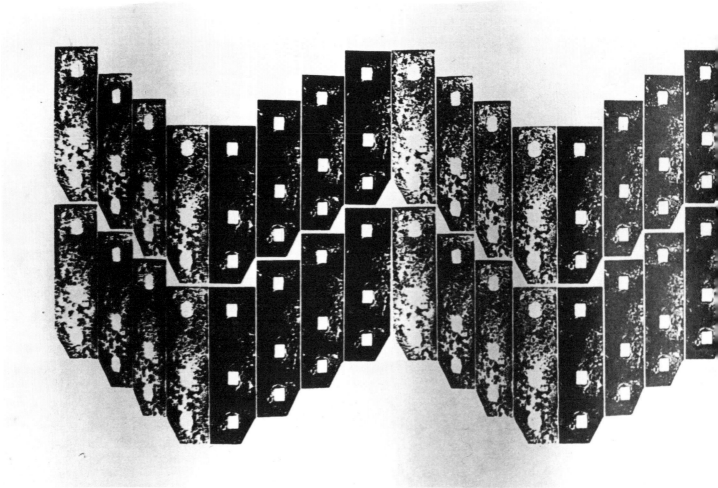

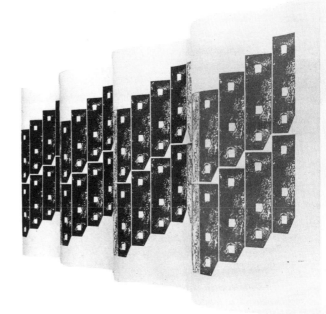

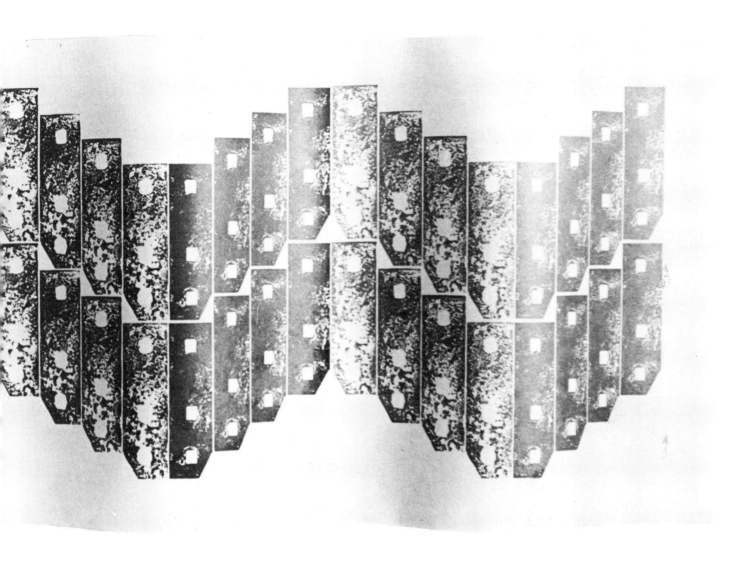

Relief and photo silk screen *(2' x 8'')* printed in graded tone band by *Richard Dack, Camberwell School of Art.* This print has been mounted on a sheet of plywood, supported on a wooden frame so that the plywood sheet could be curved in and out, forming a series of waves. Like some other examples reproduced, the image has taken shape through the intelligent appraisal of the form of the basic unit — an iron plate picked up on a construction site. Hence the image was developed, stage by stage, through the progressive intensification of this appraisal, no paper or pencil being used in designing the image.

Knight, *linocut by fifteen year old student, courtesy London Borough of Education Office.*

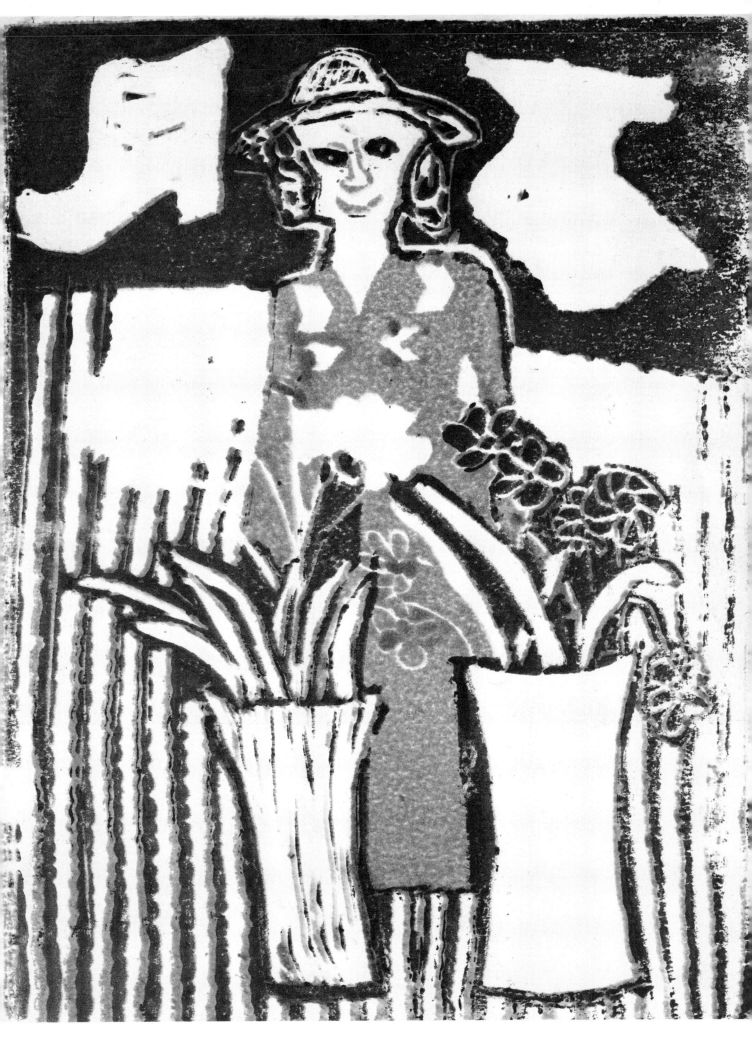

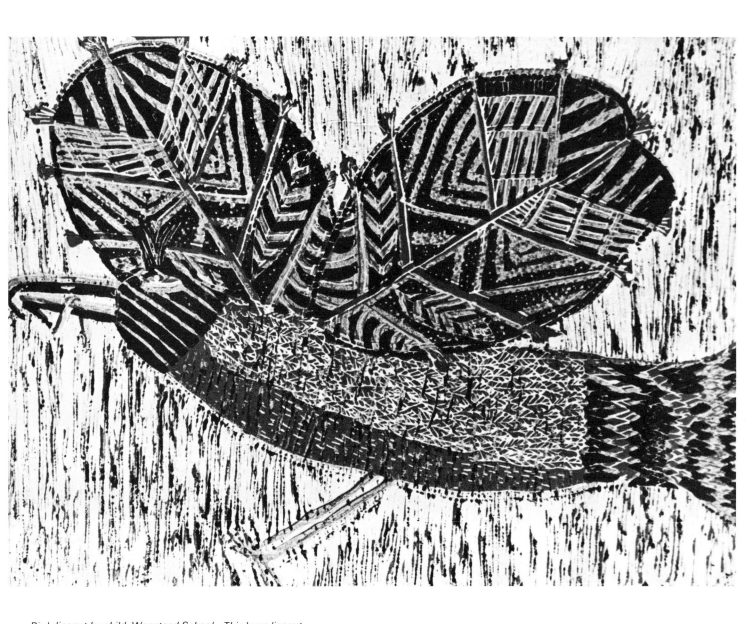

Bird, *linocut by child, Wanstead School.  This large linocut*
*of a fantastic bird, printed in shades of scarlet and ultramarine, was*
*made by a nine year old child in a school for deprived boys.*

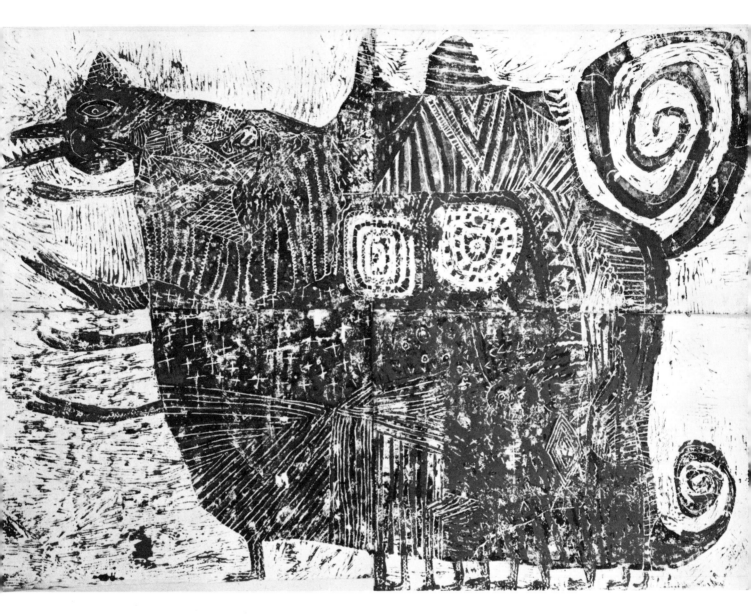

Monster, *linocut by child, age eight, Wanstead School, courtesy*
Sunday Mirror *National Exhibition of Children's Art.*

Multi-view relief print, *Stoke on Trent School of Art. Images were*
*printed from relief blocks on vertically folded sheets that leave a series*
*of V-shaped folds projecting forward when the print is displayed. The*
*print shows three separate images: one as you view it from the left,*
*another from the right, and a third as you stand in front. The system*
*was based on research carried out at the Bauhaus.*

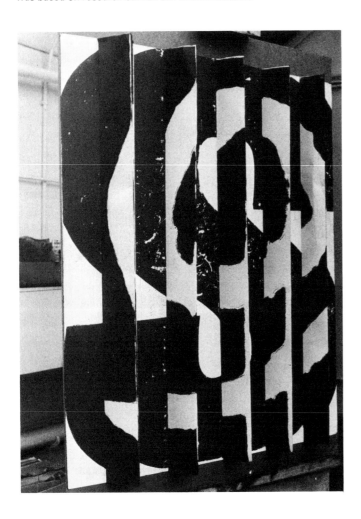

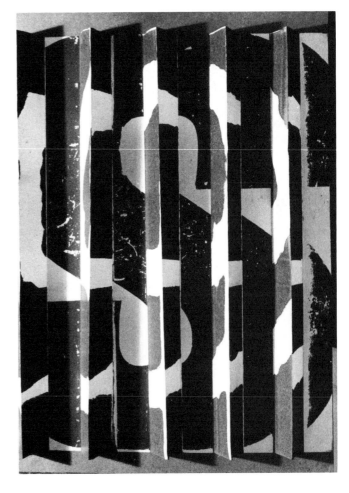

# 3
# WORKSHOP

As he went about the country lecturing and teaching, Lionel Feininger took his woodblocks with him, carving away with his pocket knife as he sat in the train; his work-kit was as easy to carry as a roll of knitting. This story makes its own point. The grass roots character of this technique — that can be carried on with so little specialized equipment — makes it of the utmost use to the student, the amateur, and for work in the primary and secondary schools. Used by the professional artist for more ambitious aims, relief printing will clearly need specialized equipment and more sophisticated work patterns.

Fine work, however, can be done with simple methods and simple tools: a sharp pen-knife to cut the block, an ink roller, a tube of printing ink, a wooden spoon for hand burnishing, and for materials, a piece of linoleum, plywood, or a pine board. You will also need an ink slab, but almost any piece of smooth, hard, nonabsorbent material will do — a piece of plate glass or plastic is excellent. Work can be done at any table with sturdy legs, standing in a good, clear light.

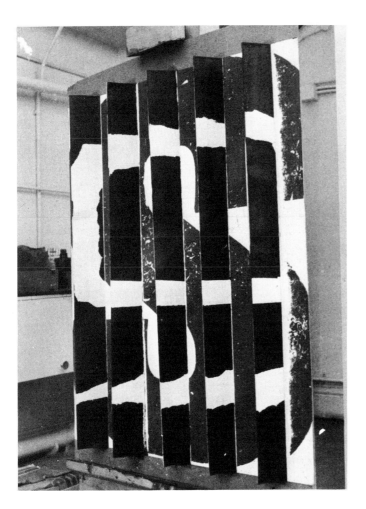

These again are the essentials for work done in the studio; but as the scope of printmaking widens, it is clearly necessary to widen the scope of your facilities. For carving large blocks, you need a heavy table, strongly made, with overhanging edges for use with clamps. Some woodcutting gouges should be added to your kit. A second table may well be needed for inking the block and for printing; this should have a large ink slab, for work in color, fixed to the top. Tubes or tins of ink and well made hand rollers are also necessary. These few straightforward arrangements are quite sufficient for effective block cutting and for hand printing proofs to start with. Lacking a press, however, it is hardly practical to print editions in color. Though a hand burnished run of prints is sometimes done, the process, on the whole, is found insupportably slow.

In the primary or secondary school art room it may be difficult to provide many facilities. Many schools undervalue the work of the art class and funds for equipment may be severely limited. Unluckily, de-

partments must often make do, in the face of opposition, with the barest, leanest essentials: small hand rollers; poor quality color; construction paper — known in England as sugar paper — and newsprint. In this case, it may be difficult to do much more than arrange the tables in a good, left hand falling light; to keep stores and equipment in order; and to insure some sort of storage for students' work in hand. But even here, worthwhile — even remarkable — results may come.

In the art college or university art department, where the necessary facilities exist, work begun with the knife and gouge on a piece of linoleum or a plank of wood can extend into areas with a high content of more sophisticated technology, where photoengravers' plates or photo screen stencils can be included in the build-up of the image — a subject we shall presently discuss.

## Planning the Graphic Studio

With a fixed, long-term commitment to printmaking, working facilities tend to become sectionalized around separate work functions. This is common ground, shared by both the college art room and the private studio. In school or college, however, these functions are normally clearly demarked, while in the artist's studio the separation is less clear. Alone in his workshop, the artist is free to improvise.

The basic conditions of a good workroom are plenty of space and light, a supply of running water, and good ventilation. Arrangement of equipment and storage depends on experience and good sense. Each press or piece of equipment needs space to be used effectively. It is better to have one press, properly positioned, than two or three leaving the surrounding spaces cramped and cluttered.

Each activity needs servicing with appropriate tools, materials, and equipment: inks and rollers near the presses; art materials and working tools within easy reach of tables. Arrangement of storage, which should include the storage of students' work-in-hand, is no less important than the positioning of heavy equipment.

Blueprint cabinets or plan chests, cupboards, shelves,

racks for drawing boards and folios — all the facilities for rationalizing the flow of work deserve consideration.

## Art School Print Departments

Ideally, the print department should share a building with the studios of painting and sculpture. This is because printmaking tends to become a hermetic study, sometimes overengrossed in its own technical problems. This may lead to a narrow viewpoint. Specialization can be dangerous: it needs checking by constant exposure to the rigors of the open mainstream thinking more likely to flourish in the fine art studios where the lower technical content of the job leaves the student freer to center his energies around bolder ideas with more far reaching consequences.

I have worked in some art schools where the whole printmaking operation — etching, lithography, silkscreen, as well as relief — was mounted in a single workshop. In this case, the presses should always be placed as far as possible from the creative area. The job of cutting and engraving blocks, or setting out ideas for printed images, can be done at shared benches or tables. On the other hand, work on the press always needs a more formal pattern of discipline.

The logic of planning, here, calls for the reduction of steps taken between inking table and press, between press and drying rack. Inking tables are placed as near the presses as a free flow of movement allows, while drying racks, which may be positioned between presses and wall, should again be reached with the fewest possible steps. The drying rack can be hung on pulleys, well above floor level, where it may be raised or lowered as the needs of work arise. When a run of prints is taken, any two or three steps saved, multiplied by the sum of the edition, will save the printer a great deal of effort.

## Separation of Functions

The printing operation and the creative one form, in a sense, two separate systems gearing at one point only — when blocks are moved from worktable to inking table in readiness for proofing. These systems, to summarize, need four basic facilities or groups of facilities: (1) tables

for designing and preparation of blocks; (2) adjacent benches where power tools are used and where jobs with a specialized technical content can be carried out; (3) sinks, inspection tables, surfaces for paper cutting and press packing; (4) the press area itself, with its presses, inking tables, drying racks, etc.

These four basic needs will always eat up space, normally much more space than is allowed for. Only a few schools have allotted the printmaking room the space it needs. No easy answers exist, since the space resources of any given school are limited by existing buildings, limits that no amount of goodwill can stretch. But where departments are run on a rationalized pattern, with a clear recognition of the different and interlocking functions of the printmaking rooms, space restrictions can to some extent be alleviated. At present, students like doing big prints, and this again puts pressure on available working space.

In the private studio, these functions will obviously merge; but if space is effectively arranged, they are likely to find a recognizable pattern. Where resources are restricted, one should be wary of suggesting possible arrangements. Planning, in a small space, will always serve the quirks of personal convenience. Outside advice may have the ring of an intrusion, unwanted in a private world.

**Facilities and Equipment**

No student ever has enough table space for work. Large color prints, in particular, need a large amount of work surface. In some cases, tables can be fitted with a "double" top; a second top fitted on supports some 4" above the existing one. Where this is done, a great deal of working space is saved.

Ideally, between the design tables and the presses, room should be found for inspection tables, and for places where paper can be trimmed and prepared for printing, though few printmaking rooms have space available for this necessary operation.

Along the wall, midway between the creative and press area, the sinks needed for cleaning and washing should be fixed. A large sink, with hot and cold water, and a shelf for abrasives and soap, are constantly

necessary. A big shallow industrial or farm house type sink is probably best.

If the plumbing is of steel or brass, the danger of corrosion through the use of acids is lessened. After employing acid, fresh water should be run down the sink.

After work, cleaning rags should be hung up. Rags saturated with turpentine, kerosene, white spirit, or other cleaning fluids emit heavy fumes; they should never be stored in closed containers. In my own studio, an iron rail has been fixed some 3' above the ink table. Rags are hung on this; hand rollers, fitted with small hooks on the handle end, are also hung up. In this way, space is gained and the ink table kept clear.

For badly lit rooms, good artificial light is always a necessity. In any case, it will be needed for evening work in the art school. Large fluorescent tubes should be installed, fitted with egg crate diffusers or filters to prevent glare.

Some of the main developments in printmaking depend on photographic aids. These facilities, wherever possible, should be close to the printmaking department. The darkroom, light box, and process camera become increasingly necessary to any sophisticated print study.

In a large print department, the question of storage is of considerable importance since large quantities of ink and paper pass through the students' hands. Always vulnerable to inexpert or careless handling, presses and other equipment need regular servicing.

A central area, shared by all the printmaking rooms, might well prove a useful solution, since inks, paper, rollers, screens, etc., could (to a great extent) share common facilities, thus saving space in each of the different workshops. If the storekeeper or technical assistant had some engineering experience, enabling him to do routine maintenance on the presses, this could well be of enormous benefit to each of the workshops concerned.

Finally, in planning the workshop, space should be allowed for pinning up students' work. Good work displayed on the wall is a permanent challenge to further good work being done. Panels of cork, Celotex, Homasote, or any material that takes staples or thumbtacks — set along the wall — are always of special use in the event of group criticism.

# 4

# TOOLS AND EQUIPMENT

Looking back, we see that gouges and knives were almost the only tools the relief printmaker once employed. These he used with a fairly set gestural pattern — but often with immense practical skill — on a limited range of materials, mostly certain types of wood and later linoleum. Today, both materials and tool kit have undergone transformation. Power tools have been added to manual ones. The set gestural repertory is replaced by a freer, more inventive movement range, and this in turn may be directed at a photographically aided result in the final image. We now accept that anything capable of marking the block can be legitimately used; we also realize that the accepted boundaries of gestural expression may well mark the edge of a new frontier where photo techniques are likely to take over increasingly from the human hand.

## Tools for Wood and Linoleum

On wood, linoleum, and hardboard, gouges and knives are still the basic tools for working the relief block, though any tool or instrument capable of inflicting a mark on the block's surface can be legitimately used when it furthers the artist's purpose. Later, some of these secondary instruments will be discussed; the section opens, however, with a description of the primary ones — the gouges and knives.

The incisive stroke of the knife, having virtually no width, may be looked on as the purest expression of linear direction. Its stroke can be compared to the thin decisive track left by the pen, while the broad, chunky mark of the gouge, having width as well as direction, may be compared to the stroke of a brush. Unlike pens or brushes, which are normally held lightly in the hand, gouges and knives are firmly grasped, and also have certain firm limitations on *direction*. The gouge is pushed from behind; it moves away from your body. The arm unbends as the stroke proceeds. The knife, on the other hand, is pulled towards your body; the elbow and arm bend more acutely as the stroke proceeds. Once the angle of the stroke, relative to your body, moves too far to one side, the block itself must be turned to increase the possible angle of the stroke.

Writing gestures, like the gestures used in drawing and

Cutting with a mat knife. *One always hesitates to lay down rules, particularly for the use of any hand held tool. These are shots of the way I hold a mat knife. Normally, I stand to work, and hold the knife with an overhand grip, using the left hand to give added strength and control in cutting the line. The block is locked in position with clamps.*

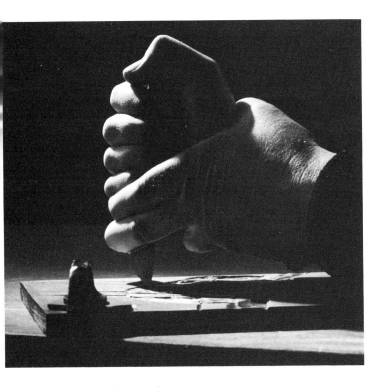

Japanese style dagger grip.

painting, are all closely related. We can consider these the range of gestures most "natural" to the human hand, since the movements employed in forming letters, practiced from childhood, are used throughout our lives, while carving and cutting gestures, using a specialized hand grip and arm movement, are more closely related to the manual range used in certain forms of sculpture. At first unfamiliar, they form a specialized gestural repertoire; but with active practice, the basic procedures should be easily mastered.

## Knives

First statements made on the block, cut or scored with a knife, are likely to be those of linear direction. The types of knives most useful to the printmaker are the Japanese knife, the English knife, and the Stanley or mat knife. Probably the Japanese and mat knives are those most often used.

Sold in America and England, the Japanese knife is a tool with a small handle and small blade. A large hand may indeed find it too small, though string is sometimes bound round the handle to give firmer grip. Some good printmakers, however, favor this tool above the others, especially for a close or precise system of marks.

The mat knife, in contrast, has a strong handle with a textured surface, giving it extra presence in the hand. It should be used with "heavy duty" blades that are stouter than the usual ones. The blades are quickly and easily changed, a point much in their favor, since, in the heat of creative effort, the slow process of resharpening may sometimes lead to a buildup of nervous tension. The English knife may be considered the least satisfactory; it appears, indeed, to be passing out of use. An ordinary pen-knife, with a bound up handle, may occasionally prove quite a serviceable instrument. Whichever knife you choose should feel firm and comfortable in the grip of your hand.

The Japanese hold the knife as a dagger is held to strike a downward blow, the thumb gripped firmly on top of the handle. But one or more fingers of the left hand are hooked round the blade. A two handed grip exerts greater force than a single handed one; for wood, in particular, the two handed grip will be found to give the necessary power.

Japanese woodcutting knife.

Round gouge.

Extra flat gouge.

V-tool or veiner.

Outside Japan, the knife is commonly held with an overhand grip, as you would hold a stick to deliver a blow; but this position, too, should either be used with the left hand fingers hooked round the edge of the blade, or curled round the fingers of the right hand.

The V tool, presently described, cuts a channel at a single stroke. The knife cuts one side only. The incision is made at an angle, hence a second cut, made at an opposite angle, removes a sliver of wood along the length of the stroke. If the angle of the knife is low, the channel cut will be wide; if the knife is nearly upright, the cut will be narrow. Normally, however, in following the contour of a form, the knife will be held nearly upright when the first cut is made. This position gives a strong, exact "feel" of linear direction. For widening the cut, the opposite stroke is made at the lower angle needed for its expression of width.

## Gouges and V Tools

Gouges are made in considerable variety. For convenience, we can put them in two separate groups: round gouges, and V tools or veiners.

The blade of the round gouge is semicircular in section; but one of the most useful kinds is only slightly curved, the "extra flat" or shallow gouge. The small size, round gouge, is for clearing narrow spaces or cutting broad lines — broader than the knife usually cuts. The larger round gouges are used for clearing away large spaces of wood or linoleum, thus lowering the surface to a point where no ink is taken from the roller. However, the "extra flat," held at the correct angle, is probably the most useful instrument for this: it will peel away a broad strip of material at a single cut.

The V tool is for cutting narrower channels than the small round gouge. It is a faster tool than the knife, since it will cut lines at a single stroke. It offers more freedom than the knife, but may give a sense of direction less intense.

Gouges are often supplied with absurdly old fashioned mushroom-type handles. But most printmakers prefer the cut down chisel handle that gives greater strength for the broad cutting which a large image may need. Tools should normally be ordered from the dealer with ordinary chisel handles, cut down to measure 2" long from the ferrule. The end of the handle should be rounded. If tools come loose in the handle, they should be held with the handle end towards the body and the handle-top struck sharply several times with a hammer. This should drive the blade securely back again.

Tools with small blades (supplied separately) fitting into a standard handle are normally used in schools where children do linoleum cutting. Unfortunately, this is often necessary owing to their low cost compared to the type used by the professional. In any case, the latter may well prove dangerous in the hands of children. This fitted blade type, however, is quite inferior; the tin-like blade often works loose in the handle, killing the feel of the cut. Whenver circumstances allow, the proper type of gouge should be supplied.

Even when not in use, the tool edge becomes blunt with any repeated contact with a material as hard as, or harder than itself. Any commonsense measure of protection will help to maintain the sharpness. A piece of felt, baize, or foam rubber laid on the shelf, table space, or tray where tools are kept is always a sensible precaution.

## Multiple Tool

For cutting a close system of lines, the multiple tool is sometimes employed. According to its size, it will cut six, eight, or more channels at one operation. This tool has a square shaped section, sharply beveled down at the end. Its underside has a ribbed formation meeting at the bevel in a series of teeth. On linoleum, this tool generally cuts well; but it should be firmly grasped, used with considerable pressure and a sharp, decided stroke.

## Sharpening the Gouge

Gouges and knives are sharpened on ordinary artificial stones, such as axolite, carborundum, or India. They are finished with Arkansas or Washita, both natural stones, when great keenness is needed.

For woodcutting, the tool should be very sharp; in addition to honing on the stone, it may be stropped on leather to razor sharpness. Any piece of soft leather will make a strop, the leather is rubbed over, on the rough or undressed side, with the razor strop paste obtainable at

tool or cutlery stores. In my own studio, carborundum stones are used for quick sharpening and axolite for sharpening at normal speed; for working on wood, the edge is finished with a strop. The tool may need frequent honing during work. It is tried for sharpness either by feeling the edge carefully with fingertip or thumb, or by holding the tool blade pointing at the window or some other source of light; if a glint along the edge is reflected, the tool is blunt.

With a medium oilstone, the knife is easy to sharpen. If a mat knife is used, the blade is cheap to replace. But the gouge and V tool need both care and practice to maintain. This care, however, should *always* be given. Time spent honing the tool is no more wasted than time spent pointing a pencil; the printmaker no more dreams of working with a blunt tool than the draughtsman with a blunt pencil.

Sharpening hollow tools needs some experience. A main difficulty lies in keeping the tool at a constant angle as it is passed over the stone. If you make a habit of putting the stone in the same place relative to your body, this problem is partly overcome, for arm and wrist then tend to take up the same position relative to the stone.

To sharpen the outside curve of the round gouge evenly, the method is either to roll the tool between the fingers, or to rotate the wrist and hand as the edge passes over the stone. To sharpen the inside of the hollow gouge, a slipstone is employed. This is pressed level against the inside of the blade; its function is to cut away the slight burr raised by honing the outside of the curve. The stone is held flat against the hollow and moved evenly up and down, or along the edge, by rocking it from side to side.

The slipstone, generally made of axolite, has a wedge shaped section, sharp on one side for the V tool, rounded on the other for the gouge. The V tool must be sharpened on both outside angles, keeping the bevel flat against the stone. The meeting point of the two sides, making a small rounded angle, is ground in the same way as the hollow gouge. This small rounded angle decides both the accuracy and energy of the stroke; it is the critical point and should be sharpened with close attention. Failure will result in the cut either tearing the wood fiber or slipping and jumping when used on linoleum.

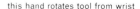

this hand rotates tool from wrist

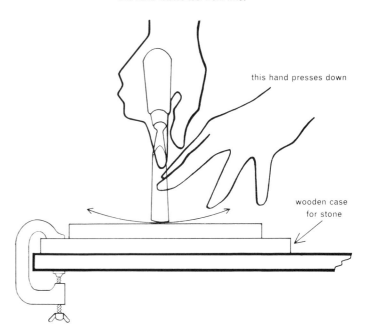

this hand presses down

wooden case for stone

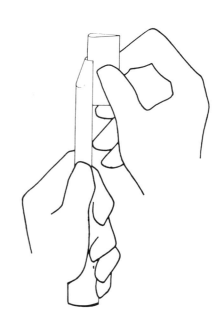

*The stone can be moved up and down or pushed along the inside edge, following the curve.*

72

Snips.

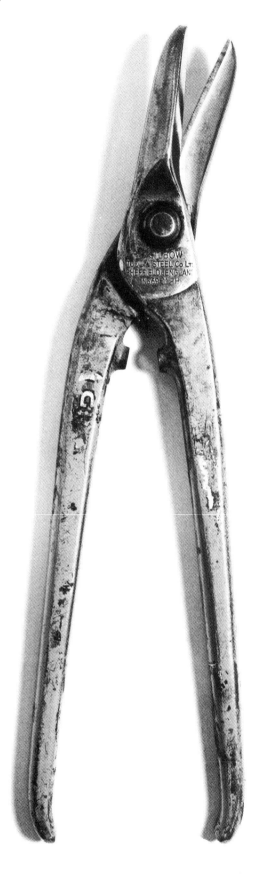

For large gouges and woodcarving tools, the basic method may be reversed and the stone rubbed against the tool. The stone is grasped and rubbed over the bevel of the blade, a procedure sometimes adopted by woodcarvers and carpenters.

Plenty of oil is put on the stone. The particles of steel that come adrift (during the process of sharpening) float in the oil and can afterwards be wiped away. With too little oil, the steel fragments stick to the stone, glazing its surface.

The gouge must be reground when the edge becomes irregular through repeated sharpening. A small geared grindstone is used for this, one that can be screwed to the table top. To straighten the edge, the tool is first held on the tool rest at a right angle to the surface of the grindstone. This position is maintained until the metal is ground level with the lowest point of any irregularity. The tool is next held at an angle, until the existing bevel is ground back to meet the newly ground edge. The tool is then sharpened in the ordinary way upon the oilstone. However, if the edge of the gouge has become only slightly irregular, it can be corrected on a fast cutting carborundum stone by merely holding the tool upright and rotating it firmly, until the wandering edge is ground straight.

## Mallet

In working a tough surface, such as elm, or for cutting through knots in pinewood, a carpenter's wooden mallet is used; this drives the gouge effectively through the timber, saving any unnecessary effort. A medium weight, flat faced mallet is probably best. To receive the blow of the mallet effectively, the gouge should be fitted with a strong handle, such as a cut down chisel handle.

## Snips

This instrument, normally employed for cutting sheet metal, is a valuable tool in the graphic workshop. The type used should be for cutting either straight or curved lines. This tool will snip through linoleum and veneer as well as sheet metal, and enables you to contour free form blocks in any desired shape. The track cut by the snips, however, is hardly expressive of exact linear direction. It

is better to employ a knife to contour the block; the snips can then be used to trim the material away outside the knife cut, saving labor in clearing unwanted areas of the block. In the "open block" system, where free form blocks can be independently positioned on the register (later described), this procedure is of particular value.

## Tools for Cutting Sheet Metal

The Monodex is a specialized tool for cutting metal. Like the snips, it has a scissors action. It cuts a track through the sheet with a small but powerful jaw. Hence it will make an interior cut, but the sheet must be drilled with a 1/4" bit to insert the jaw through the metal in starting the cut. (Similar products are made by Wiss and Compton.)

Although its action is extremely slow, a hand held fret saw, fitted with a metal-cutting blade, can be used for cutting small zinc and copper plates, when a divided block is wanted. The cut is narrow, however, and in skillful hands it may well be accurate. For straight lines and slow curves, an ordinary hacksaw will be found a faster tool. Several types of powered jigsaw are capable of cutting sheet metal and thin metal plate. The Lesto jig, for example, can be fitted with many types of coarse and fine toothed metal cutting blades. Fitted with the correct blade, this instrument can be used for trimming and dividing photoengravers' line and halftone plates.

## Punches and Carpenters' Tools

Any instrument capable of marking a surface may sooner or later find a place in the printmakers' equipment: spikes, nails, knives, blunt etching needles, and so on. These can all be used to scratch, score, scrape, or incise lines or marks on wood, linoleum, and even sheets of the softer metals. Any number of hard objects — metal rods, doorhandle shanks, nailheads, washers, etc. — can be punched with a hammer blow into a material such as wood, just as more conventional types of punches can be knocked into a surface with a blow from a mallet or hammer. For many industrial and craft purposes, scores of different types of punches are produced for metal-workers, woodworkers, jewellers, bookbinders, etc.

Wood will need sawing to size with the handsaw.

Bought directly from the lumber yard or woodyard, timber needs to be planed smooth. Planes are also needed for smoothing the edges of plankwood, when two or more pieces are butted together to form a single block. The small, bull-nosed plane is specially well adapted to this. The carpenter's chisel, with its flat and powerful cut, is another useful tool. Vises are necessary for gripping timber, and clamps and heavy weights for locking wood in position after it is freshly glued.

## Clamps

Clamps are basic equipment in the print studio. In cutting tough materials, the whole attention should be centered on the stroke, on the exact feel of the material under the cutting edge; should the block slip or move during this operation, the attention is suddenly dispersed, with a consequent buildup of negative tension. Hence, the block should be locked to the bench or table top with the G clamp at two points: locked at one point only, the wood will pivot, swinging away from the tool.

Several sizes of clamp are needed. Small ones with a 3" or 4" "throat" are suitable for linoleum, hardboard, or plywood; larger sizes are for thicker material, such as plankwood. The "deep throat" clamp may also be found useful; it will grip the block several inches back from the table edge: A piece of felt can be glued below the clamp's upper grip; this prevents the wood getting bruised when the screw is tightened. Alternatively, scraps of hardboard or linoleum can be used beneath the grip, where it meets the block.

## Bench Stop

In the printmaking group for young children, the bench stop, or bench hook, is used in place of clamps. This is merely a small board with one stout piece of wood screwed securely under the bottom edge, and another along the top, above the board. The bottom strip grips the edge of the table; the top one acts as a stop, preventing the block slipping forward under pressure from the gouge.

An L-shaped piece of wood, however, makes a better arrangement to secure the block, since it acts as a stop

Block held in position *with an L stop*.

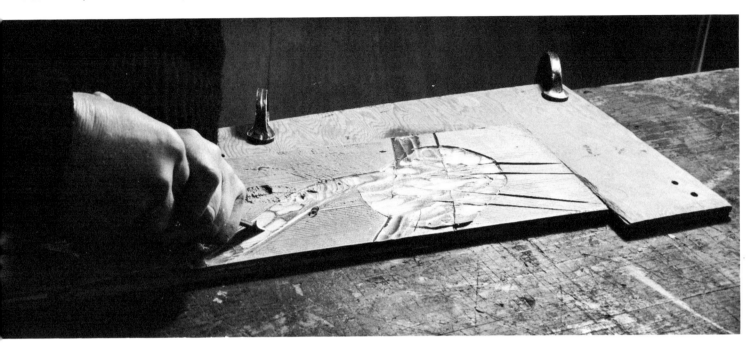

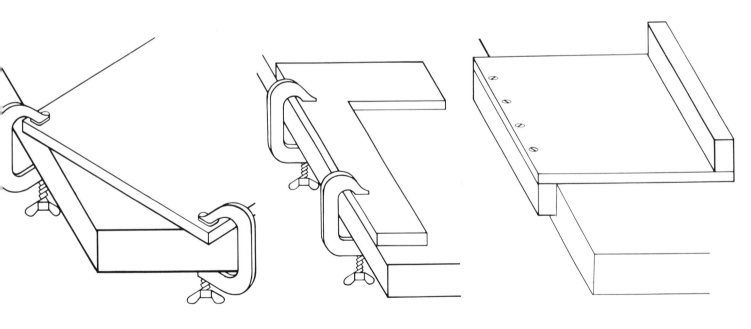

The table corner *is the best position for
cutting or carving a wood or linoleum block*.

L stop.

Bench hook.

along *two* edges of the block, both top and side. The L-shape is cut from a piece of thick plywood or block-board. Two clamps should be used to secure it along the table edge. In a class for young children, bench hooks or stops cannot always be supplied. In this case, the child is shown how the left hand (in a right handed child) presses down, holding the block, while the right hand controls the cut. The left hand should always be kept *behind* the cutting edge, clear of the direction in which the stroke is running. This relation between the two hands — the block-holding one and the tool-holding one — should be explained with the firmest emphasis.

## Electric Power Tools

Chisels, gouges, knives, hammers, held in the hand, become a specialized extension of our arm, wrist, and finger movements, enabling us to perform a range of functions, delicate or forceful, that would otherwise be impossible. The electric tool, however, interposing a powered motor *between* our hand grip and the tool itself, is an extension of altogether another kind. The power tool alienates the hand from the action of the cutting edge. We *guide* the tool, using the jigsaw, or sweep it from side to side in using the sanding disc; but in either case, the sense of direct and active touch is lost. At the level of sensation our involvement is therefore less complete. Once in contact with the metal casing of the power tool, the sensitive resiliency of skin and flesh, with their spreading tree of embedded nerves, is almost entirely nullified.

Within these understood limits, however, the power tool is of the utmost value. It places within our grasp the accomplishment of many jobs that would otherwise be difficult or impossible. It yields a store of unlimited energy, often saving hundreds of hours of hard and thankless labor, and freeing us in the meantime to attend to more important creative opportunities.

The basic requirement is a hand held power tool of the standard type with a 1/4″ or 5/16″ chuck that will take a variety of attachments. This tool is attached to a power line, long enough for work at all required positions around the workshop, or a shorter line that can be used with conveniently placed plugs. If separate power tools are used for different jobs, an adaptor is fitted to the line,

so that sander and jig, for example, are quickly interchangeable. As a safety precaution, art schools may well insist that all such equipment be used only with a transformer. (In case of shock, the fingers may contract, gripping the casing of the tool; should this happen, the tool should be immediately jerked free of the adaptor or plug.)

Coarse sanding discs can be used to cut away uneven areas of wood that may be found impractical to plane by reason of their knots or exceptionally fibrous grain. Fine discs are used for slightly hollowing the block's surface where a lighter patch of tone is intended in the print. Tough, open grit discs, employed with a heavy duty power tool, have great cutting power and will rapidly clean down dirty timber, clearing away old paint, plaster, cement, etc. They raise a storm of dust, however; ideally, they should be used over a grid, with a dust extractor fixed beneath, or under an ordinary hood with a fan extractor placed above.

The power jig saw is another tool of great value; it may be either an attachment to the standard power tool, or a separate unit with its own motor. A separate unit is recommended; it will have a smoother action and a more powerful motor. It is an altogether more attractive tool to use. The Lesto jig is a well designed piece of equipment; it is made in Switzerland, however, and may be found difficult to ·service and maintain. (For the art school, the maintenance of tools is a first consideration. Wherever group work is in progress, all types of tools are bound to get rough wear.)

Attached to the power tool at one end only, the jig has a thicker blade than the fret saw, in which the blade is supported at either end in the frame. The jig, in consequence, has the disadvantage of cutting a wider track. For normal work on the divided block, however, its function is well adapted. For multicolor printing, the jig will cut a complex system of interlocking shapes from a single woodblock, shapes that can be readily fitted back together for printing on the press bed. The electric jig is capable of cutting free form shapes in almost any type of wood or plywood of practical thickness for printing. If the type of jig employed is adapted for use with inter-changeable blades, it will cut plastic, sheet metal, hardboard, and linoleum as well.

## Woodworking Power Router

I had the opportunity of trying this instrument at the University of Wisconsin art department. Although my own experience is too limited to predict the scope of its potential, it appears to have some very striking possibilities for working either plywood or hardboard. This can be done, moreover, from either the back or the front of the material.

Worked from the front, the tool gives a channel of absolute mechanical precision, and of even depth and width as the tool is maneuvered over the face of the block; but as the router can be fitted with heads of different sizes, the width and depth of the channel can be varied. If the block is worked from the back or the reverse side, the cutting head can be set to cut a channel which leaves only a thin crust of material above the cut, a crust thin enough to become deformed under pressure from the press, producing a corresponding change of tone when the block is inked and printed in the normal way. Thus hard, mechanically perfect lines can be contrasted with smoky, shadowy ones.

## Wire Brushes

The wire brush attachment for the power tool is another useful instrument. In block printing, it is used chiefly to abrade different types of wood and plywood. Its action tears the softer fibers from the harder ones, leaving these tougher elements standing slightly forward on the block, giving a low relief "landscape" on the face of the block. The tool may be found most effective when employed in combination with a hand held wire brush. No machine tool can match the sensitive control offered by the human hand; but for clearing a quantity of material from the block, the powered wire brush will be found to function far more rapidly than the hand held tool.

The hand held wire brush takes many forms, from the scouring brush, made for kitchen use, to the brass wire suede cleaner, to the brush with hard steel wires used for cleaning down dirty, rusted, or corroded metal. Sooner or later, any of these may well find a use in the print studio.

Power tool brushes, too, are obtainable in great variety. The wire wheel brush has wire set round the edge of a disc; in the cup shaped brush, they project forward from the base; in others, the wires are packed in a conical, cylindrical, or splayed out shape. The wire wheel brush, however, that can be run with the direction of timber grain, has a fast cutting action and is generally the most useful attachment. But some of the cylindrical or splayed out shapes will be found to have further value. A brush with a small head of high quality tempered steel, skipped or played over linoleum, will cut systems of whirling lines. On an otherwise impassive surface, these tracks are able to create a field of speeding directional marks.

## Hand Burnishers

Hand pressure printing, or burnishing, is the simplest, most direct way of getting a printed image. It must also be among the oldest. This technique is of the utmost value. It can be used anywhere, without cost or equipment, for the summer school in the remotest country, or for the grade school in the poorest district. The triumphant images of Gauguin, Nolde, and Munch, were mostly hand printed in this way. Countless thousands of hand printed linocuts pour from school art rooms; chunky and awkward many of these may be, but how many other radiate a jubilant charm!

In burnishing, the paper is placed face downwards on the inked block, and the back of the sheet is rubbed over with a hard instrument, such as a wooden spoon. While press printing removes ink from the entire face of the block through the action of the platen, which presses evenly over the entire surface, the hand held burnisher covers only a small area with each stroke, and must be passed again and again over the back of the sheet, until the crossed and recrossed mesh of its tracks covers the entire area and takes a solid film of ink from the block beneath.

For burnishing, a hard, rounded object is used, one that is easily grasped and held in the hand, and that will slip quickly and smoothly over the surface of the paper. The Japanese baren, a metal or wooden spoon, or the metal, ivory, and bone instruments found in the art supply store are all effective instruments for burnishing.

You are able to burnish with an ordinary, metal kitchen spoon, using either the round undersurface of the spoon itself, or the flat part of the handle if your work is on a

small scale. A large hardwood salad spoon, however, is the instrument in general use. With wear, its underside should become polished and smooth; but if it fails to slide easily over the printing paper, some beeswax may be rubbed onto the wood. In use, the handle is held firmly in the right hand, while the left hand fingers are pressed downwards into the bowl of the spoon.

## Japanese Baren

The Japanese baren consists of three parts: bamboo husk fibers tightly bound into a coil; a shallow disc of paper laminated with rice paste; and the sheath, forming a combined printing surface and grip, made from a single bamboo husk. The laminated disc, both flexible and durable, protects the back of the fiber coil. The ends of the bamboo sheath are twisted together and tied across the back of the disc, forming a handle. To prevent the sheath becoming dry and brittle, it is lightly coated with camelia oil, both before and after each printing session. From time to time, the baren will need to be recovered; the Japanese printmaker keeps a supply of husks for this purpose. Barens are sometimes improvised by using circular pieces of veneer, or by winding heavy twine round a block of wood which is then coated with glue. Inexpensive barens are made in Japan from twisted paper or paper cord.

The underside of the baren is slightly rounded, presenting a much broader surface to the printing paper than the spoon or burnisher; the baren's action, in consequence, removes ink much more quickly from the block. The spoon, smaller and harder than the baren, removes a narrow strip of ink with defined edges to the mark; but the resulting tone or color left on the paper is likely to be more intense. Functioning so differently, both baren and spoon should be tried by the printmaker and each can be used in combination with the printing press as the needs of work arise.

Hence, the process of burnishing has two different functions: it is used either for printing entirely by hand, or in combination with press printing, when added control is needed over certain areas of the image. If a woodblock is warped, or an area of its surface is slightly hollowed, the burnisher can be used to print those parts of the block which the press platen has failed to reach. The burnisher,

Japanese baren, *back view, showing hand grip*.

Japanese baren, *front view, showing printing surface*.

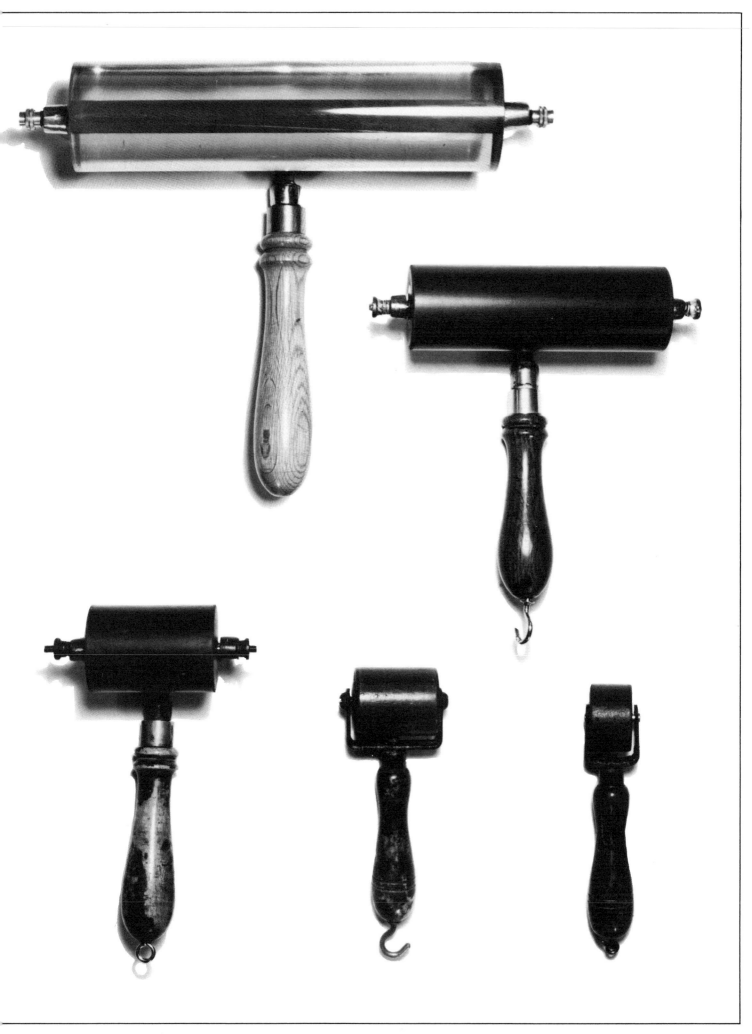

moreover, can force the paper more closely into the "sculpture" of the block, taking more ink from its carved modulations than the flat press platen is able to pick up. In certain cases, direct manual control may add to the range of expression possible in the print.

## Ink Rollers

The ink roller or brayer (as it is still sometimes called) is the standard instrument for inking the relief block. Its function is to apply an even film of ink to the printing surface.

In use, the roller is moved backwards and forwards over the face of the block with smooth, even strokes. But to understand the way the ink is discharged, the printmaker should try running an ink loaded roller over a large sheet of paper. Starting at one edge, the roller is rotated across the surface. As the ink is "unpeeled," the density of tone is reduced in a series of clearly defined "steps," each "step" corresponding to one full revolution of the ink coated cylinder. This will demonstrate why the roller should be passed *many* times over the printing block to give an even film of ink, lifting the roller clear of the surface, between one movement and the next, to distribute the ink more quickly. With any failure to do this, the "steps" of the roller will show on the print.

The stroke of the roller is three times its diameter. In "unpeeling" the first layer of ink, with one complete rotation, a 2" roller will lay a strip of ink 6" in length.

The roller should have a strong, firm handle; a frame which allows the cylinder extra play as it turns, to prevent a build up of ink between roller and frame; and an axle that fits snugly into the stock, to ensure a smooth and level action when the roller is in use.

The material of different rollers varies from a hard consistency to a resilient, rubbery softness. In ordering a roller from the maker, the hardness or softness is indicated by the term *shore*; the higher the shore number, the harder the roller. A hard roller stays on the surface of the block, while a soft one presses into its relief. In using "wild" materials or a warped plank, a soft roller will give a fuller image than a hard one, which tends to run over only the highest points. But for inking a fine system of marks on a level surface — or for the halftone letterpress plates or blocks presently discussed

— a hard or medium roller will be the most effective. In general, however, rollers of medium hardness are found the most useful, and those bought from an experienced dealer are likely to be of medium shore. But if you order from a manufacturer's catalog, the shore number should be quoted; this will run from thirty to forty for medium rollers.

Three types of rollers are in common use; gelatine, rubber, and polyurethane. However, through the use of rollers in the immense industry of commercial printing, the manufacturer of rollers now possesses a sophisticated technology, and many variants of these basic types are now produced. For the amateur or student printmaker, the simplest course is to trust the advice of an experienced dealer in getting the kind of roller needed for your particular work.

The gelatine roller is easily subject to accident; it has the disadvantage of becoming soft, and melting, at fairly high temperatures. Left near a radiator, or on a window ledge in the sun, it will sag like a sack of flour and lose its shape.

Polyurethane and rubber rollers are harder wearing. The polyurethane roller has a polished surface, well adapted to printing a close, finely cut system of marks. For general purposes, however, in the private studio as well as the art school, the rubber roller has the advantages of keeping a true surface under sustained wear and cleaning more quickly and easily than the other types discussed. The rubber roller should be of the highest quality and made by a manufacturer of repute.

Rollers are obtained from the dealer in a variety of sizes; special rollers of almost any required length or thickness will be made to order by the manufacturer. For multicolor printing from a single block, small rollers are needed; while for printing large surfaces of low and open relief, such as an etched metal relief plate, a large roller is called for. For effective inking, it may well have to be very large since it should span the entire width of the plate.

The small rubber rollers used by school children can be used with success for small blocks, and are equally useful for printing. This is done by using an uninked roller to rub over the back of the paper, placed face down on the inked block.

Woodblocks were originally inked with an inking ball:

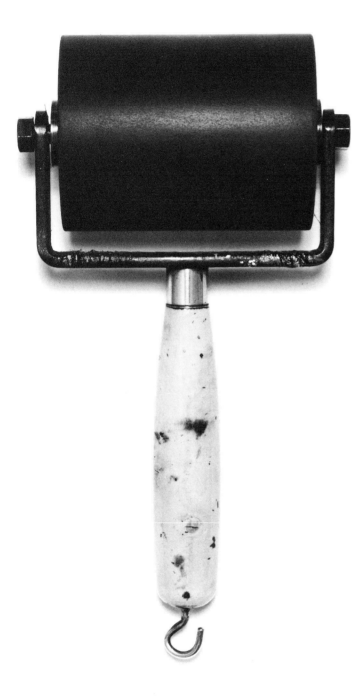

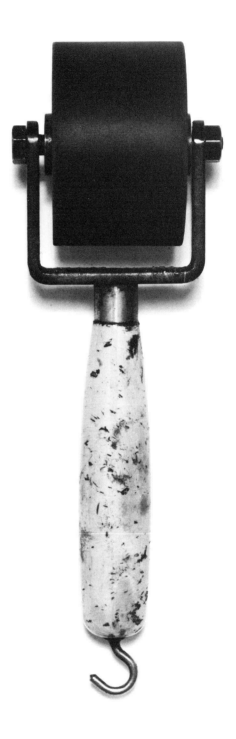

4″ synthetic rubber hand roller (30 shore).
*This type of roller is both hard wearing and easy to clean. It is the recommended type for general use in both the private studio and the college art department.*

2″ synthetic rubber hand roller (30 shore).

a pad of some resilient substance wrapped in a tough, flexible covering, attached to a wooden disc which carried a handle. By rocking and beating on the ink slab, this ball was charged with ink; the pigment was then discharged on the block by similar rolling and beating. During the early nineteenth century, rollers superseded this system and the ink ball became a forgotten relic of the printing trade. As printing grew into large scale industry, roller manufacture also grew. But a printing manual published as late as 1890 still gave recipes for "homemade" roller making. At that time, the small printer might well have made his own rollers by boiling together a mixture of treacle, glycerine, sugar, and glue. This was boiled for an hour and poured into a lightly oiled tube — oiled to deliver the roller more easily from the mold. Larger rollers were cast from a two piece hinged mold. It was closed, to form a tube for casting, and opened to release the cast.

At the present time, gelatine rollers are made from a mixture of gelatine, glycerine, and water. The same basic process of casting under pressure in "guns" has been used for many years. While the traditional type becomes soft when heated, modern technology has altered the formulation of the raw materials used and unmeltable gelatine rollers can now be supplied. All rollers are normally made 1/8" larger than the finished size; only in the final stage of manufacture is the surface precision ground to the exact dimensions required. This is done on an emery wheel that passes from end to end, up and down the roller.

New gelatine rollers may be found soft and tacky, but after some weeks the material becomes "cured" and hardens to some extent. The makers recommend that kerosene (called paraffin in Britain) should be used for cleaning, and that the rollers should be lightly oiled if they are to be stored for a considerable time.

Polyurethane rollers are a fairly modern invention. They are made from polyester resin and isocyanate; the hardness of the finished roller depends on the quantity of isocyanate used in the mixture. The rollers are cast in steel tubes polished to a mirror-like surface; the mixture is pumped into the mold under pressure and heated for vulcanization. It is then left to cool, when the rollers are extracted and trimmed to length.

Rubber rollers were originally made from the natural product, but today their formulation is more complex. In manufacture, they are made from rubber sheet, wound round the stock, until its bulk reaches the required dimension. The wound rubber sheet is then vulcanized, at high temperature under steam pressure, to form a mass.

Hand roller frames are made in some variety. One type can be turned over and laid on the back of the frame when not in use. Others are made with projecting legs to keep the roller clear of the ink slab when put in a reversed position. My own preference is for one with a straight frame; a small hook may be screwed into the end of the handle to hang the roller on a bar above the ink table. Ideally, rollers should be placed or hung in a cupboard when not in use, or hung on hooks beneath a shelf, to keep their surface free of dust.

After use, rollers must always be carefully cleaned. Quick drying inks, used in hot weather or in heated rooms, dry rapidly and crust on the roller's surface. In routine cleaning, the roller is passed up and down over the ink slab until the ink is loose enough to be cleaned away with a rag. A few drops of kerosene (paraffin) should be used on the ink slab for the gelatine roller; mineral spirit (white spirit) is a solvent for other kinds.

In the private studio, gasoline or petrol can be used for cleaning. When color has to be changed, this solvent has the advantage of drying the roller's surface for immediate reuse.

A half used tin of crusted ink will cause a good deal of trouble when more ink is spread on the slab. Before rolling out the ink, the large fragments of dried skin mixed with the color can be removed with a palette knife, but the smaller fragments remain and finally stick to the roller, often sticking so closely they are very hard to remove. Left to dry, they do permanent damage. Sometimes you can rub them away with the fingertip, or scrape them off with a fingernail or the edge of a palette knife. In some cases, only fine sandpaper or glasspaper will rub them down; but only the super fine grades of paper obtainable at specialized tool stores should be used. Fine sandpaper or glasspaper is also employed to rub down old rollers, roughened by wear; even and repeated rubbing is necessary, but only the gentlest pressure should be used.

## Japanese Inking Brushes

In Japan, the water soluble printing inks commonly used are applied to the blocks with brushes of various kinds. In some cases, the pigment used may be watercolor, tempera, or gouache; but inks and dyes are also used. Brush inking offers a good deal of freedom, since different shapes on a single block may be colored separately.

Different forms of brushes are used to suit the work in hand; some have an angled handle, others a straight handle and broad spread of hair, like a housepainter's brush. For a small detail of separate color, a pointed writing brush, or an ordinary ox bristle oil painting brush, is used.

One in general use is a long handled, square cut brush with short bristles, something like an ordinary house decorator's brush; another is a big flat horsehair brush, without a handle, rather like a shoebrush. It is used for covering broad areas of the block, and for moistening the wood before color is put on. A different brush is used for each color. Thin pigment is applied with a stiff brush, a fat or heavy pigment with a soft haired one.

## Weights

Weights of various sizes are in constant use in the print studio. Heavy weights are needed to lock the paper to the block in burnishing, to inspect the print while still in position on the block, and for many purposes for which tacks (drawing pins) are also used. Weights can be quickly moved and leave no marks on the sheet. A varied collection are kept in my own studio: a sixty pound weight found on a building site; the heavy counter-weights once used for a sash window; a tin biscuit box full of iron chains; and metal scraps of different sizes from the engineer's workshop.

## Inking Table

The inking table is always an important feature of the print studio. Its size will depend on the type of work done, and on studio space available. In most cases, the larger the table the better, since it should allow for three different functions: the storage of inks and cleaning fluids; the rolling out of ink; and the inking of blocks.

The height of the table will depend on the printer's height; a 6' man, for example, needs a working surface 3' from the floor. A table width of 3' 6'' allows space for the inking of a large block, while keeping the farther side still within the printer's reach. A right handed printer needs the storage area on the right of the table; the ink slab should be centrally positioned, the inking up section to his left. If large color prints are undertaken, the ink slab should run the full width of the table. This allows two printers to work at either side in inking up blocks. The reverse, or rough side of hardboard is recommended surfacing for this area; the tooth of its pitted texture helps to prevent blocks slipping under pressure from the rollers while inking up.

Where practical, a metal bar is fixed some 2' 6'' above the table along its whole length. It is attached at either end to suspension brackets fixed to the workshop ceiling. This arrangement saves valuable space. Both cleaning rags and rollers can be hung upon it, leaving the working surface clear. The rollers, however, will need hooks screwed into the tops of their handles. Hung this way, the rollers are within sight and reach of the printer, but clear of the working surface.

These general working arrangements should meet the needs of the art school and college printmaking room, as well as the private studio. The amateur or student, often working in cramped conditions, can still follow the main features of these commonsense arrangements in a simplified form.

Space, in the productive studio, is always in short supply. Proofs, editioned prints, and press packing quickly absorb all available surfaces, however large and numerous the worktables. Hence, the double deck table is something of an asset. This is merely a table with a second top fitted above the first by using a sheet of thick plywood or blockboard supported on two-by-fours or battens to lift it 4'' above the existing surface. This leaves ample room for paper, tracing materials, and press packing that are not immediately wanted. Alternatively, a wide shelf can be fitted between the four supporting legs, below the table top. Either way, the available surface is doubled.

Inking table. *The blocks are inked on the left hand side of the table; a plastic inking slab runs the full width of the table at center. Rags and rollers are hung on a metal bar hung from the ceiling.*

Ball clip drying rack *is made in 6' lengths, each length holding twenty-five clips. If the sheets are hung singly, one to each clip, the rack holds fifty sheets; but if the sheets are paired and hung back to back, the rack holds 100. Large sheets of soft paper, however, may need hanging lengthwise, across the rack, supported by clips at either end.*

Carved linoleum block *(32" x 23")*
*showing shallow open areas cut out with snips,*
*by Michael Rothenstein, (Photo by the artist.)*

## Drying Racks

A drying rack is needed when more than a few proofs are pulled. Even a small edition of, say, twenty sheets can hardly be spread out to dry without a great deal of inconvenience to further work. In the art school, where scores of sheets may need stacking on any working day, racks are clearly a necessity, and may be considered a basic feature of studio equipment.

The simplest form is quite a homemade affair, consisting of a run of ordinary "bulldog" clips or clothespins (clothes pegs) attached to a wire. Prints are easily hung on this, secured to the pins, pegs, or clips, and allowed to dry. However, a ball clip drying rack is a much more convenient arrangement; it is also quicker and more efficient in use. This ingenious device consists of a strip of wood in which small glass balls are anchored within a series of wedge shaped openings. As the sheet is inserted, the ball is first pushed up, but then falls down again by its own weight, gripping the slanted sides of the wedge and the paper with it. An electric heater, or mobile radiator, can then be placed on the floor below the vertically hung sheets. This will set them moving in a rising current of warm air, greatly accelerating the drying of the ink.

Another method of drying freshly printed sheets is to stack them on trays. A simple type of tray can be made of hardboard, with a wooden strip or batten fixed along two sides. The sheets are placed singly in the trays as they come off the press, and the trays are stacked vertically as they are filled. This arrangement is easily made, though not entirely satisfactory, as air cannot circulate freely over the sheets. The commercially made tray has deeper sides — giving more space between the prints — and a bottom formed of open wooden slats, allowing the air to pass from beneath. A wooden nest of trays, however, is a rather heavy and bulky arrangement for its modest function, sometimes taking up space that might well be better used.

A piece of much more advanced equipment is made for the rapidly expanding silkscreen trade. This consists of fifty hinged trays mounted in a metal frame that runs on castors. The steel trays are covered with a wire mesh to support the prints, and hinged on toggle action springs, so that the trays are quickly raised or lowered. In use, however, the tilt up tray has this disadvantage: the print may slip out and fall at the back of the rack. Though this is fairly costly equipment, it is a recommended investment for the productive print department.

## What Tools and Equipment Are Needed?

Lists are bound to be invidious. Making them is an unattractive task. Art colleges and professional artists, however, in setting up a workshop or extending facilities, may find items of interest below. Every artist and student likes some tools more than others; fine work, in any case, can be done with the simplest tools.

The list is divided into three columns for convenience: one column for primary and secondary school, one for the art school, and one for artists. Younger children need simpler equipment than older ones; in the first list, I have italicized those items likely to be most useful to the youngest groups. The amateur is a separate case. He is free to give full reign to the quirks of personal choice. Those parts of the list he may like to consider are marked with an asterisk in the professional artist's column.

## Basic Needs for Elementary and Secondary Schools

*Italics indicate items useful for youngest groups.*

*Small gouges*

*Linocutting tools fitting standard handles*

*Small rubber or composition rollers*

*Palette knives*

Hardwood salad spoons

Plate glass ink slabs

Bench hooks

## Items That Can Be Added

Mat (Stanley) knife

G clamps

Fine grain oilstone

Slipstone

Medium size red rubber rollers

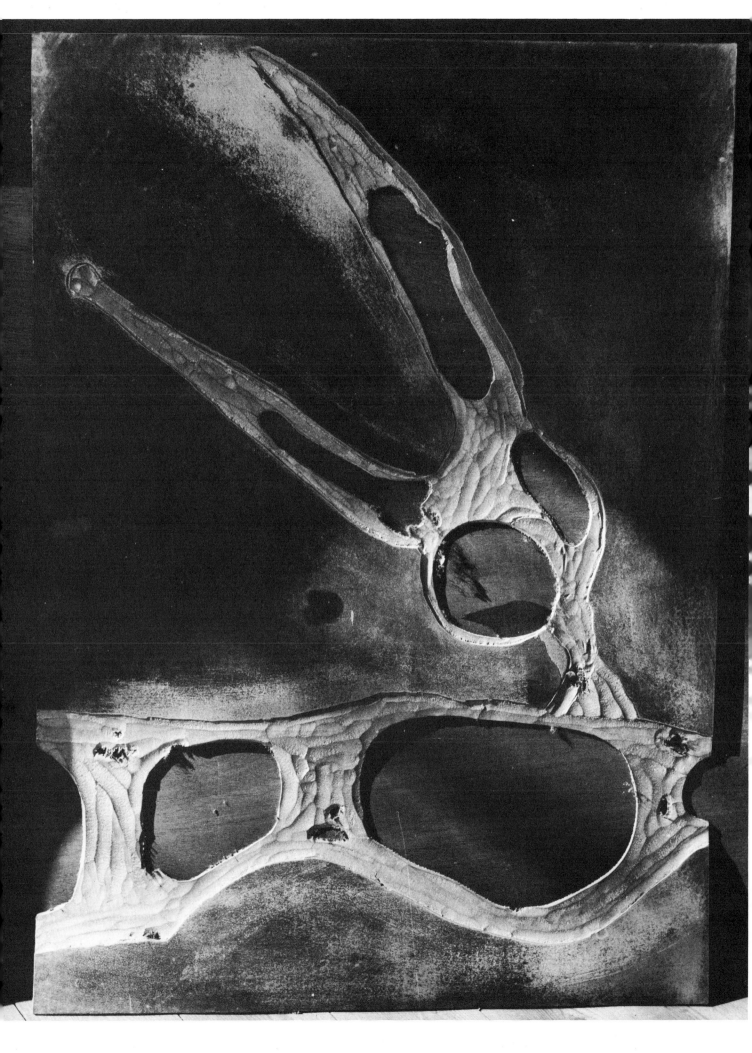

## Basic Needs for Art Schools, Colleges, and Universities

Round gouges (1/8" and 1/4" width)

Shallow gouges (1/2" and 3/4" width)

V tools

Mat (Stanley) knives

Red rubber or polyurethane rollers (4" and 6" length, 2" and 3" diameter)

Palette knives

Hardwood salad spoons

Fine and medium grade oilstones

Slipstone

Small geared grindstone

Wire brush

Weights: various sizes

G clamps

Plate glass or plastic ink slabs

Blueprint cabinet or plan chest

## Items That Can Be Added

X-acto handle with set of blades

Soft synthetic rubber roller, 4" x 22" or 6" x 24"

Hard synthetic rubber roller 4" x 22" or 6" x 24"

Tin snips

Mallet

Handsaw

Carpenter's chisel

Smoothing plane

36" steel square

Steel straight edge

Ball clip drying rack

Hinged metal drying racks

Electric power tool (1/4" or 5/16" chuck)

Sanding discs

Wire wheel brush attachment

Jig attachment

Lesto jig

Renda, Rockwell, Stanley power router

Monodex metal cutter

Portable shear metal cutting jig for metal plate

Powered band saw

## Basic Needs for Professional Artists

* Round gouges (1/8" and 1/4" width)
* Shallow gouges (1/2" and 3/4" width)
* V tools
* Mat (Stanley) knives
* Japanese woodcutting knife
* Red rubber or polyurethane rollers (4" and 6" length, 2" and 3" diameter)
  Small rubber rollers
* Palette knives
* Hardwood salad spoon
* Fine and medium grade oilstone
* Slipstone
  Wire brush
* Weights: various sizes
* Large plate glass or plastic ink slab

## Items That Can Be Added

X-acto handle with set of blades
* Multiple tool
* Washita stone
* Arkansas stone
* Leather strop
* Japanese baren, metal or bone burnisher
* Tin snips
* Mallet
* Handsaw
* Carpenter's chisel
* Smoothing plane
36" steel square
Steel straight edge
Tray or ball clip drying rack
Electric power tool (1/4" or 5/16" chuck)
Sanding discs
Wire wheel brush attachment
Jig attachment
Lesto jig
Monodex metal cutter
Blueprint cabinet or plan chest

* Items most useful to the amateur marked with an asterisk

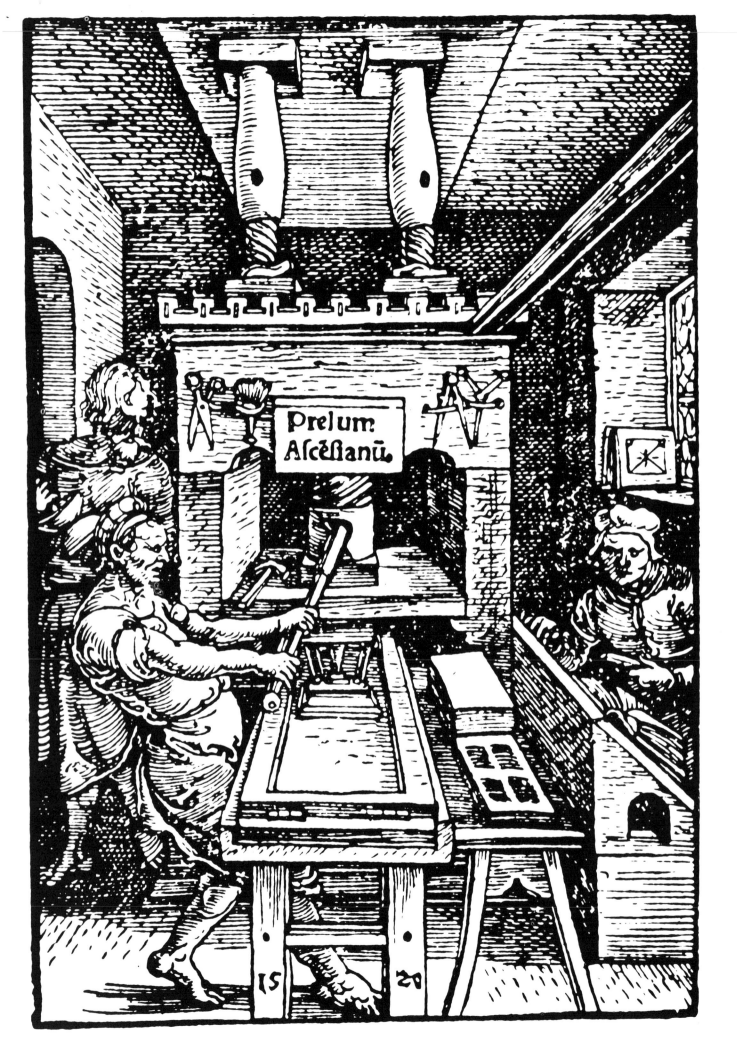

Prelum Ascensianū.

# 5
# PRESS

Apart from manual procedures, press printing is the most practical way of getting an image from a relief block, and several kinds of presses will do the work. The press, after all — as its name suggests — is merely an instrument for producing pressure, for pressing the sheet down on the block to pick up the image. Platen presses, such as the Washington and Albion, have generally been considered standard equipment for relief blocks; but as these presses become harder to get, other types, the proofing press in particular, are progressively more often used. There are also combination presses, such as the Dickerson, which can be quickly adapted to the work in hand, whether relief printing, etching, or lithography. I have also seen lithographic presses, with the bed stripped down or lowered, used for shallow relief blocks. The etching press, too, can be adapted to this form of printing.

Before getting a press, you should clearly state your needs. Ask yourself what functions the press would be called on to perform. What space is available for its use? Should it be adaptable to the full spread of your work or do only one job supremely well? How much of your energy — and endurance — would it take to print, say, thirty sheets in three colors? Will it increase the reach and range of your printmaking, bringing with it exposure to new experience?

The young artist, the ex-student, might ask: Is the press one I can afford? Within one year, if I can sell three editions to a dealer, will it pay its way?

The teacher, for his part, will want to know if a press will help his students to do better work on a more ambitious scale; if it will bring needed prestige to his department; if its operation will be a source of pride to the craft-orientated student, and so on.

## Which Type of Press?

Old hand presses are now hard to get. In old fashioned printing works in England, they are still sometimes found, since they were used for poster printing earlier in the century. As more modern machinery moves in, the old presses are either broken up for scrap or sold at auction. But they can still sometimes be traced through trade

The Printer, *woodcut attributed to Albrecht Dürer, 1520. The carriage has been run under the platen. The printer is pulling the bar handle which operates the screw, driving the platen downwards onto the block or onto the type to be printed. This type of press was derived from the wine press, dating from hundreds of years earlier. The columns joining the frame and ceiling are a feature of interest, clearly designed to give the top of the press stability by preventing it from being forced upwards when the screw is turned on the block below.*

advertisements or printers, engineering works. However, the long wait necessary before a chance of getting one comes along may be very frustrating — and here the advantage lies with the more modern press. A reconditioned proofing press is much more easily obtained, and may not be expensive. The modern, all-purpose press is ordered, like any other equipment, as the need arises.

If a chance of getting a large hand press is offered, it should be taken. An Albion, Columbian, or Washington press, well balanced and in good condition, is specialized and dependable equipment, though the larger types take up a good deal of space. For a student of small stature and limited reach (a girl student in particular), they may be found difficult and heavy to handle. A large press, however, will print a small block effectively, while a small one is useless for ambitious needs. All in all, the large platen press is by far the best equipment for this type of block.

Though a good deal less adaptable than the platen press, the proofing press will print editions from color blocks rapidly and effectively, and once the job is properly set up, it can be used without much physical effort. For any alert student of fifteen or over, its use should give little trouble. Moreover, the proofing press is compact in design. Placed against a wall, it takes up little space.

My own experience with the Dickerson Combination Press is limited; on the strength of this, however, I have found it much inferior to the platen press. For the etching plate, its action appears better adapted. It is difficult to assess modern combination presses; they have been in regular use only a few years. The Dickerson Combination Press, and also the Meeker McFee Press should prove their value, however, in the summer school or small art department where adaptability may be an advantage, offering varied experience with different media. But conversion in the classroom, from one process to another, remains an obvious drawback.

The custom built, geared etching presses made by Charles Brand of New York are fitted with a roller that can be raised high enough to print from woodblocks. We took some trial pulls of relief blocks on these presses at the Cleveland Institute of Art; they appear to function well for this type of work. For aligning and checking the roller height, the micro-dial indicator is clearly a device of great usefulness. I hear good reports, too, of the presses made by the Graphic Chemical and Ink Company, and certain Craftool presses, designed primarily for intaglio, which can also be used for relief printing.

The ordinary etching press, too, can be adjusted for relief printing by using "runners"; these are strips of wood, attached to a backing on the bed of the press, positioned at each side of the block. However, this remains a compromise, limiting and even cumbersome in use. Unless perfect adjustment is made, a linoleum block, for example, will stretch and distort under the roller's pressure; hence, if more than one block is used, the resulting image may well be out of register in the case of color printing.

## Albion, Columbian, and Washington Presses

To produce pressure on the block, the earliest press employed the downward pressure of a single massive vertical wooden screw; the same action is produced by the old fashioned linen and bookbinders' presses still seen sometimes today. This follows still older patterns, used centuries ago, for pressing grapes in the process of wine making. The early hand printing presses were made mainly of wood. The first all iron presses — the Stanhope press, devised by the Earl of Stanhope in 1800 — still employed screw-produced pressure, but its movement was associated with an ingenious lever system to speed its action.

The Albion and Columbian presses are next in line of descent. The Columbian press is probably the older and has the greater strength. It was introduced into England by Clymer of Philadelphia in 1820. The power is produced by a system of weights and counterweights, a main feature being a crossbeam of enormous weight. A large Columbian attests the robust sculptural sense of the nineteenth century engineer: the topmost counter-lever is crowned with a cast iron eagle — a last flash of feudal splendor — which rises and falls with the movement of the handle. In use, I find the Columbian bar handle less easy to swing than the Albion, on account of its positioning, but the actual muscular effort needed is reduced by the system of counterweights in a well balanced press.

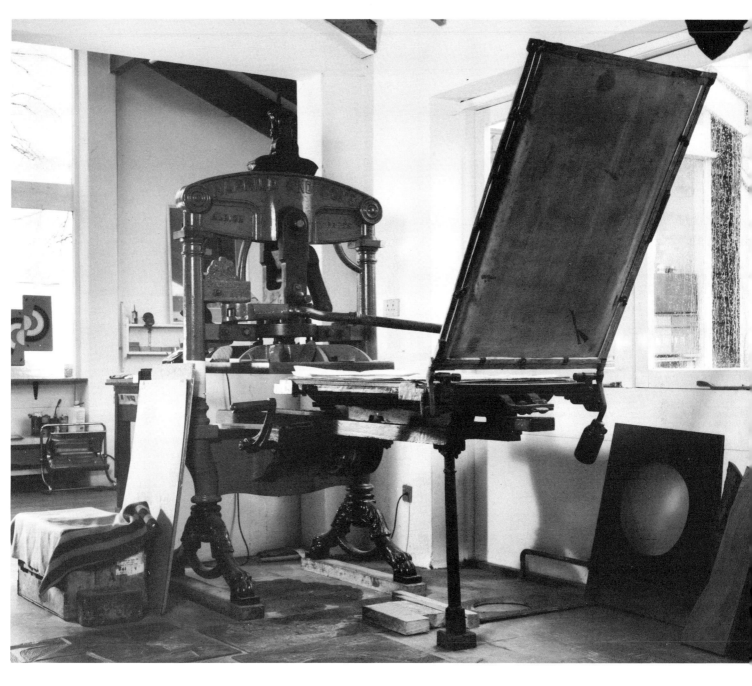

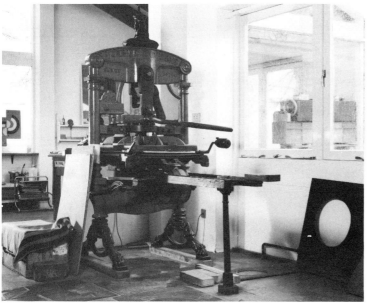

Albion press, *open*. The tympan, a linen covered metal frame hinged to the press carriage, is shown in the open position to the right of the image. Its main function is to keep the press packing securely in position when the press is closed. The press carriage moves along the rails when the operating handle, at the side of the press, is turned. The platen is the heavy metal plate which descends vertically on the block when the bar handle is pulled.

Albion press, *closed*. To operate the press, the tympan is closed, the carriage is run under the platen, and the bar handle is pulled towards the printer. This lowers the platen to produce the printed impression.

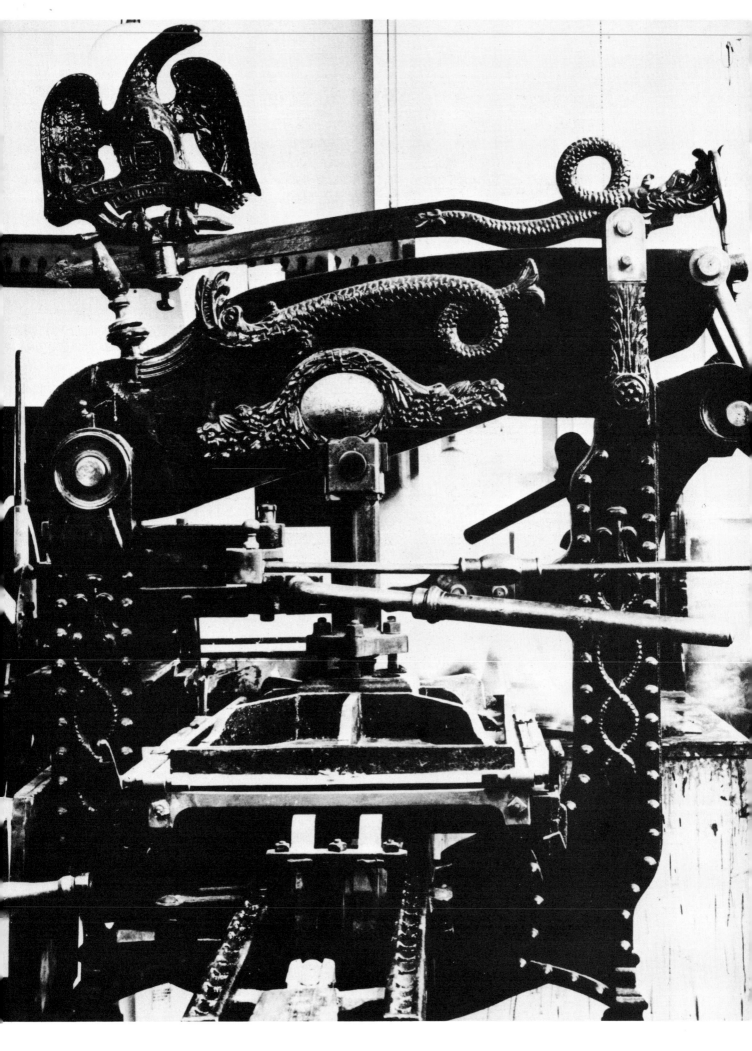

Columbian press, *open, back view.*

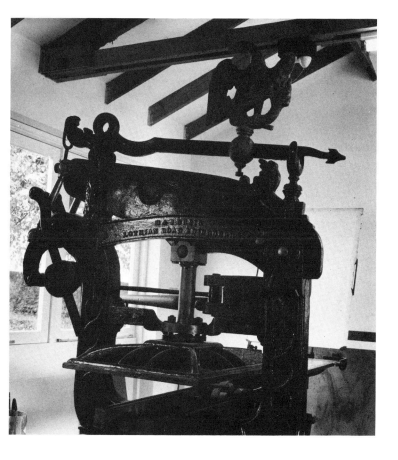

The Albion press, first manufactured in 1823, has a toggle jointed lever system for producing pressure. The toggle is an elbow or knee shaped joint, set at an angle. Once the press handle is pulled, the knee joint of the toggle straightens, bringing it to an upright position, producing enormous pressure on the face of the block. Once released, the handle returns to its original position, the toggle assumes its knee joint angle, and the platen is raised from the block by the recoil of a spring contained inside the box at the head of the press. By turning the handle at the side, the press bed or carriage is brought directly under the platen, or run out to inspect the print and recharge the block with ink. The carriage is operated by belts of heavy webbing attached to either end and wound round the wooden drum attached to the handle. It runs on a pair of heavy rails, or "ribs," supported by a single column at the far end. The tympan — more strictly tympans, since there are two — are metal frames with fine-textured linen stretched over them. Vellum was once considered the proper covering, but it is now difficult to obtain and appears to have gone out of use. I do not recall a single vellum covered tympan in any workshop I have visited.

## Setting Up the Hand Press

The various sizes of hand presses were made to fit the different paper sizes. The amateur, for his part, may well find that a small press will suit his needs, but for the professional studio or art school, the press should be capable of printing a sheet size of 29'' by 21''. But clearly an even larger size would be a great advantage: students may need to work on bigger sheets or the artist may need to print a larger image. The following are the three largest sizes of hand presses made:

| Double Crown | 34'' x 22-1/2'' |
| Double Demy | 36'' x 23'' |
| Double Royal | 40'' x 25'' |

An effective platen press for printing large blocks is a heavy piece of equipment, the largest sizes weighing anything up to two tons. The frame of the Albion, known as the staple, is cast in one piece; it is heavy to lift and difficult to handle. In acquiring a press, you may well need professional help for transport and for setting up.

Columbian press, *closed, front view. The eagle can be moved either way to balance the action of the press. When the bar handle is pulled, it takes up the same position as the handle shown in Dürer's* The Printer. *(Photo by Ken Randle.)*

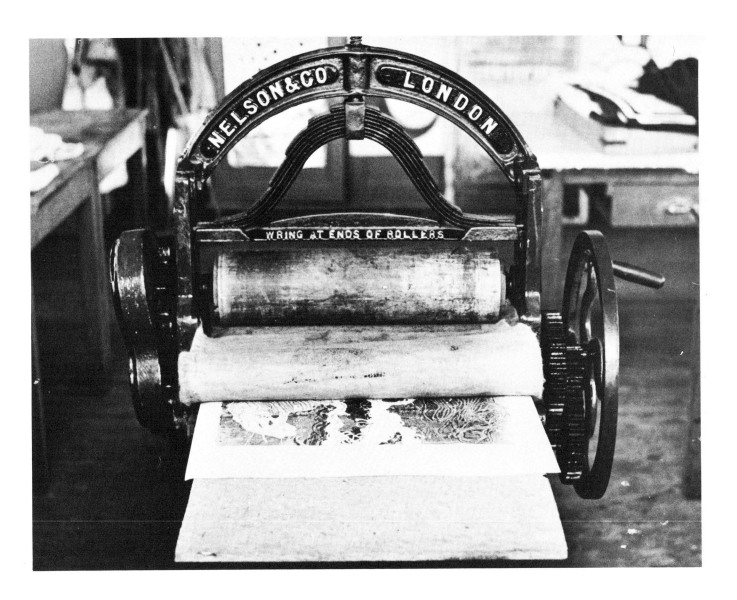

Clothes wringer, *made in 1913, now used at Redbridge Teachers Art Centre, London, to print relief blocks and monotype plates. Maurice Barrett, who made the conversion, believes that the pressure of its rollers is considerably greater than that exerted by the Albion or Columbian press platen. It remains to be seen whether or not a new and more modern type of platen press will be built in the future, following the example of the recently built etching presses produced in the United States, England, and Italy. Certainly, this ingenious adaptation indicates one solution to the problem of finding a suitable press. It also indicates how far the scarcity of adequate presses is forcing the printmaker to go in this search.*

Two men can manage to install a press of medium size, but the largest sizes will need at least four men to lift and put in position without tackle. The main feature of this operation consists in raising the main frame by tipping it upright, having first fitted it to the supporting legs. If the large press is to stand on any but a ground or basement floor, it will need placing on "spreaders," pieces of timber 2" x 4" that will spread the weight of the press across the floor joists. The spreaders must therefore run at right angles to the direction of the joists. With the heavily constructed floors of most university art departments or art schools, however, there need be no problem here.

A wooden block, acting as a stop, is screwed to the floor below the rails. However, if the press stands on a tile or concrete surface, the block is placed against a heavy board with its far end set firm against the adjacent wall. In using the press, the right foot is placed against the block, giving the body much greater power as the handle is pulled. This essential feature is one which no printmaker should overlook. Printing is heavy work. The floor stop helps materially to conserve your energy.

## Maintaining the Hand Press

The large hand press is a heavy machine, strongly made; its action is slow moving and hence gets little wear. Kept reasonably clean and properly oiled, it should not be difficult to maintain.

Occasionally, the webbing belt, driving the carriage, slips sideways off the drum, but this is easily secured again.

From time to time, the tympan needs recovering, particularly in the art school where it sometimes gets rough wear. However, this is not difficult to do. The tympan is unscrewed, the old linen removed, the frames separated and thoroughly cleaned. Any rust should be rubbed off with emery cloth or coarse steel wool. The smoothest available white linen is obtained; the frames, in turn, are laid on this and the linen trimmed large enough to turn around the metal. Sections are cut out to avoid the hooks. A white glue (called P. V. A. adhesive in Britain) is painted on the frame. Starting along one edge, the linen is then pressed and stretched down. Some printmakers recommend moistening the linen before use, but I have not found this much help, myself.

The press carriage should have a smooth, easy movement. If it feels heavy or sticky, the rails need cleaning out, a messy, dirty job, since the old oil must be soaked up and any stiff sediment scraped away. The rails are then partly filled with a high viscosity motor oil.

From time to time, the platen goes out of alignment with the carriage, or bed, and as a result your block will print darker on one side than the other. When this happens, you will probably find that one or more of the controlling nuts on the platen top have worked loose. To correct this, you need four wooden or metal type-high blocks, approximately 9/10". The press carriage is now stripped down by removing the base packing and the four blocks are placed to coincide with the four corners of the platen. The tympan is lowered in the usual way and the carriage run under the platen. The bar handle is then pulled across, lowering the platen down hard, having first loosened the four controlling nuts. One person must now hold the handle back, while another tightens down the nuts to fix the platen in the new position.

## What Types of Presses Are Available?

For all types of relief printing, some form of pressure is needed. From hand pressing with a wooden spoon to the large proofing press or precision etching press, we have a related sequence of ways of getting more control over this pressure; of getting it faster, with more power; and of bringing it increasingly under more sophisticated forms of control. Platen presses, like the Albion or Washington — with a steel plate or platen — produce pressure over the whole of the block. In most other types of press, this pressure is produced in a narrow band as the roller or scraper moves forward over the face of the block. In still another type, the cylinder proofing press, the paper is clipped round a cylinder, which is then rolled over the block to pick up the image.

Relief printing can be done in different ways with different tools for producing pressure. Some are so simple that, on the basis of equipment alone, few schools or art colleges need neglect the remarkable

potential of this type of printing. Indeed, many will already have presses that may be easily adapted to this purpose.(If any of these are power driven, the teacher should guard against the obvious dangers of breakdowns where such equipment is used in secondary schools, or within easy reach of inexperienced operations.)

*Albion, Columbian, Washington Presses:* Still the most effective types for relief printing. The larger sizes, much the most useful to the school or artist's studio, are now difficult to get, but still occasionally available through printers' suppliers and printing works auctions. They are becoming expensive to buy and may also be expensive to transport and set up. A medium size press, 21" x 16", will be found valuable at elementary and secondary school levels.

*Proofing press:* Many types and sizes available. Easy to operate and effective for the single color block or the divided block. Can be obtained without much difficulty either reconditioned or new. Clearly of particular use where images are to be printed together with type.

*Dickerson Combination Press.* May be adjusted for lithography, etching, or block printing. Of particular value in the small art department or summer school where diversification may be needed.

*Brand's custom built etching press, Meeker McFee press:* Both are effective for woodblocks as well as etching plates, though less adaptable than the platen press. Precision setting of the upper roller is a great advantage.

*Graphic Chemical and Ink Company press, Craftool press:* These are considered sound presses, designed primarily for intaglio, but can also be used for relief printing.

*Etching press:* Etching presses can be adapted for block printing with the use of "runners." The upper roller must be carefully set to avoid bruising or crushing the block. The runners must be beveled off at either end, allowing the roller to mount smoothly to the level of the block. Paper or cardboard packing can be used, as well as blankets.

*Lithographic press:* To a limited extent, the lithographic press can be adjusted for relief printing. It is chiefly used for color printing from free form blocks of thin material such as cardboard, thin metal sheet, or the thinnest types of plywood. The work should be carefully set up, using cardboard or other packing to protect the tympan. Thicker materials should be used with discretion; in such cases, the tympan may need to be raised.

Meeker McFee press *(two views). This modern, motor driven press was designed by the artist, Dean Meeker, working with a highly skilled engineer. It is used for both intaglio and relief printing. The upper roller, which is fitted with micrometers for accurate height adjustment, can be raised 1 1/2" above the printing bed to take relief blocks. (Photos courtesy Dean Meeker.)*

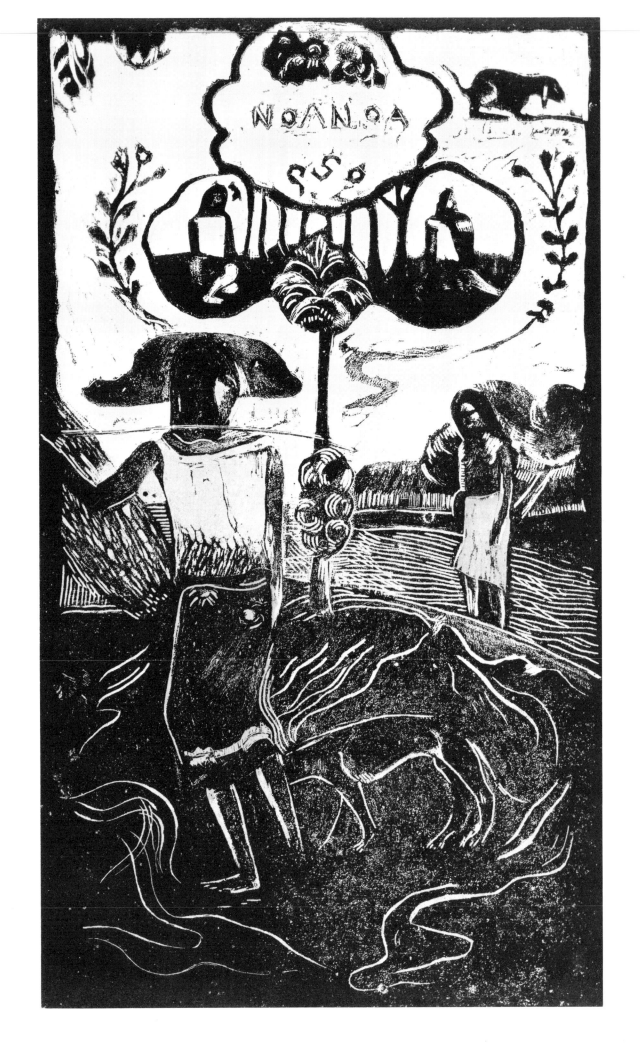

# 6

# MATERIALS

In the relief method, scores of different materials become "grist to the artist's mill": materials old and new, smooth and rough, costly and common. We have made blocks from sheets of driftwood found on the coast; from old, rotten boards taken from derelict farms and city building sites; from battered sheets of iron; from the "tea chest" plywood used in packing. Equally, we have used others special to the job, sought out often with difficulty: certain types of wood, plastic, or rolls of exceptionally thick linoleum.

The relief printer has the chance of using materials taken from the world of organic life and can work with a host of others drawn from the world of industrial technology. Every environment can provide something for his use and inspection: the city dump as well as the woodyard; the car wreckers, the junk store, as well as more expected sources, such as the art supply shop and printmakers' supplier. Materials of wide diversity are there, serving the needs of both amateur and university art department.

### Plankwood

To walk round a woodyard to see great planks cut through the heart of a tree, weathering in the open, is to realize something of the extraordinary character of this material. The inner structure of wood is like an arrested or frozen river of sap accreting in silence and secret the movement of its amber stream, hidden by the dark, unsmiling bark. Thus, of all the materials open to the printmaker, plankwood — wood cut in the direction of the grain — has the strongest character. It is the classic medium for prints taken from a carved block. When the character of this material is fully developed in the print, the artist may be said to have conspired with something already there, existing outside himself, within the wood: a dense, mysterious presence torn from its context in the world of organic life. And here the artist is placed in a position known to earliest man, since the original race of artists always *added* marks, hand marks or drawn or incised marks, to an existing backdrop of rock.

In using colored pigment to mark the tracks of his hand, primitive man joined direct gestural invention to something ready-made by nature; thus by carving lines

Fragrance (Noa-Noa)
*woodcut (7 1/2" x 4 3/4"), 1894-1896,*
*by Paul Gauguin,*
*courtesy Museum of Modern Art, New York.*

Knelende Pike,
*woodcut (20 1/2" x 16 1/2"), 1899,*
*by Edvard Munch.*

Girls on Fehmarn,
*woodcut (16  5/8 x 14''), 1913, by Ernst Ludwig Kirchner.*

into the face of a structured material — such as wood — modern man is merely reenacting the most ancient of work patterns. Artists of a more immediate past, however — working in the gap between antiquity and the present time — have favored the cool, impersonal surface of planed and sanded wood; they have denied the structural nature of timber, since they did not want the character of the block to intrude in any way on the network of graven line. Their situation might well be compared to the draughtsman of the present day, whose pencil executes its gestural dance against the empty white "sky" of a sheet of paper.

At the close of the nineteenth century, however, Munch, working in Europe, and Gauguin in Polynesia, both started carving blocks, using the wood itself to confer an added organic dimension to the lines and masses of their image.

Timber exists in immense variety; of hardwoods alone, over 2000 kinds have been listed. No material has a wider range of expression. You may think of it first as coming from the woodyard freshly sawn, a cheerful yellow, smelling of sawdust. Yet a piece of timber may last for centuries, carrying on its face the wrinkled map of its history, its color changing slowly from warm, light tones to darker ones, and finally to somber gray, bronze, or ashen-silver, in its last tottering decay. In contrast to plankwood — planks cut along the length of the trunk — the plywoods and blockboards offer an entirely different spectrum of expression; indeed they appear to us, normally, as almost entirely withdrawn from the old cycle of growth and decay, since they are constructed by man — plywood from layers of wood and blockboard from strips bonded securely together.

## Hardwood and Softwood

For practical purposes of definition, wood is divided into two groups: hardwood and softwood. The hardwoods come from trees with broad, flat leaves that shed their foliage in the fall: oak, chestnut, sycamore, birch, maple, elm, and many others. Softwoods come from trees with pointed, narrow, resinous leaves: the conebearing trees, such as larch, pine, redwood, and douglas fir. Softwoods have a simpler cell structure than the hardwoods and

date their origins from more remote periods in the history of the planet. The terms hardwood and softwood are to some extent misleading, since the hardest softwood is harder than the softest hardwood.

The word *grain* will normally apply to the markings on the end of the wood, cross-sawn. *Figure* is used for the length marking — so-called long grain or side grain — and is largely influenced by the method of cutting from the log, since different systems of sawing and cutting are used for different purposes. The systems used may vary in different woodyards and joinery works.

## End Grain Wood

While side grain or long grain timber is the usual material for woodcutting, end grain wood has occasionally been used in recent years. A circular drum of wood sawn through the trunk of a tree has a character quite different from plankwood. The outer shape will have indentations and curves, an untamed contour, emphasizing the tensions at work inside the tree's slowly swelling girth. If cracks develop through shrinkage, they will print as radial marks, pointing outwards from the core of the log, an exploded, centrifugal image unlike the up-and-down system of marks in a cracked plank. In the terminology of the woodyard, cross-section cracks are known as *shakes*.

## Side Grain or Long Grain Wood

Among softwoods, white and yellow pine, and parana pine, are all good material for carved blocks; they are also easily obtained and inexpensive. Some of the cheapest are among the best. Packing case pine, taken from disused crates, may be an excellent material; its loosely packed texture is entirely suitable for certain kinds of broad, open cutting, such as the gouge cut images of Shiko Munakata, who often favors this form of timber. It possesses, too, a variety of surface that makes it of the utmost value in color printing. Blocks for consistent, detailed cutting should obviously be free of knots and splits, and should have a firm, even grain. Wood where the spring and autumn rings vary in density make cutting difficult and uneven unless the tools are extremely sharp. The harder the wood the more finely worked the network of line may be. Pear, cherry, and

From the Kegon Sutra Suite, *woodcut, 1937, by Shiko Munakata.*

Fisherman, *woodcut, by Lionel Feininger*.

other fruitwoods — much harder than pine, denser, more crisp in cutting — have always found favor in the past, since these qualities enabled the woodcutter to give his block a high degree of finish.

Among fruitwoods, pear, cherry, lime, and apple have been widely used; of other hardwoods, sycamore and maple have been used in Europe, while Japanese linden, Siebalds beech, katsura, lauan, silver magnolia, and basswood are among those chosen by the Japanese. Cedar and mahogany are also useful woods that are easily obtained. Both have a surface specially amenable to abrasion with wire brushes, and body crisp enough to cut effectively with edge tools.

In general, plankwood boards have a severe limitation on width. The planks the printmaker needs are normally obtainable in the woodyard in 6", 9", and more occasionally 12" widths.

Boards wider than 12" are quite often found in junk shops and old furniture stores. Thin, wide pinewood boards were used, in the past, for picture frame backs, mirror backs, and the bottoms of furniture drawers, sometimes in one piece, sometimes skillfully glued together. Since the wood is dry and perfectly seasoned, it is nearly always good material for making relief blocks.

If you discover a junk shop, the kind that buys the entire contents of old houses, you should search its back rooms and outbuildings; such boards may have stayed stacked away, unnoticed in out of the way corners.

Elm boards, however, still used for cladding farm buildings and garden sheds, may be obtained in large free form sheets — free form because, in this case, the tree trunk is sawn through its entire bulk and the edges of the board follow the often wild contours of its natural growth. If the board is cut from the center of a big tree, it may well be 4', 5', or 6' wide. Such pieces are stored in a barn near my own studio; sawn along the grain the boards have a distorted figure, whose swooping curves and eddies have the look of whirlpools, and the great looping currents of a sea receding along a wide flat coast.

## Straightening Warped Boards

Elm boards tend to be warped and curled. Like any other wood, they can be soaked in water and held down flat under pressure with clamps or heavy weights in the case of small boards, but big planks are always difficult to straighten and need enormous pressure. If time is then allowed for the timber to dry out under sustained tension, the board should remain flat, or flatter, at least, than it was before. But the wood must be thoroughly submerged at the start.

Elm is not altogether easy to work, but the size of plank available, the "landscape" of its figure, and the wildness of its contours make it an attractive and exciting material. Measuring freshly cut boards for either width or thickness in the woodyard may be deceptive: timber, 1" thick or more, shrinks as it dries out. The thicker the wood, the more noticeable the shrinkage.

## Joining Plankwood

To produce a large surface, wood planks need not always be glued or joined together. If two boards are butted up and clamped tightly in position across the corner of the work table, it is quite possible to carve directly *across* the join. When the table is narrow, it should be equally practical to clamp the boards together from edge to edge. If the boards must be turned round to suit the angle of the tool cut, it is easy enough to re-position them at the new angle and clamp them down again.

When the boards are to be printed, they are again laid side by side, and registered, on the bed of the press. Since the press platen descends vertically on the blocks, they will remain in place. When they are printed by hand, however, heavy weights are put on the back of the printing paper, to keep the boards in register.

When two planks are to be joined permanently, each piece of wood is placed edge upwards in the table vise and the surfaces to be glued are planed level. Water soluble resin glue is applied to both edges with a palette knife, and the wood clamped to the work table, with edges butted firmly together until the glue has dried. The tongue-and-groove pinewood boards always obtainable from the woodyard are specially made for ease of joining. It is easy enough, in this case, to draw some glue along the edges to be joined. Finally, for those with specialized skills in woodwork, grooves can be channeled out of both edges to be joined and tongues or slips of wood, ready glued, can be inserted as the joining agent.

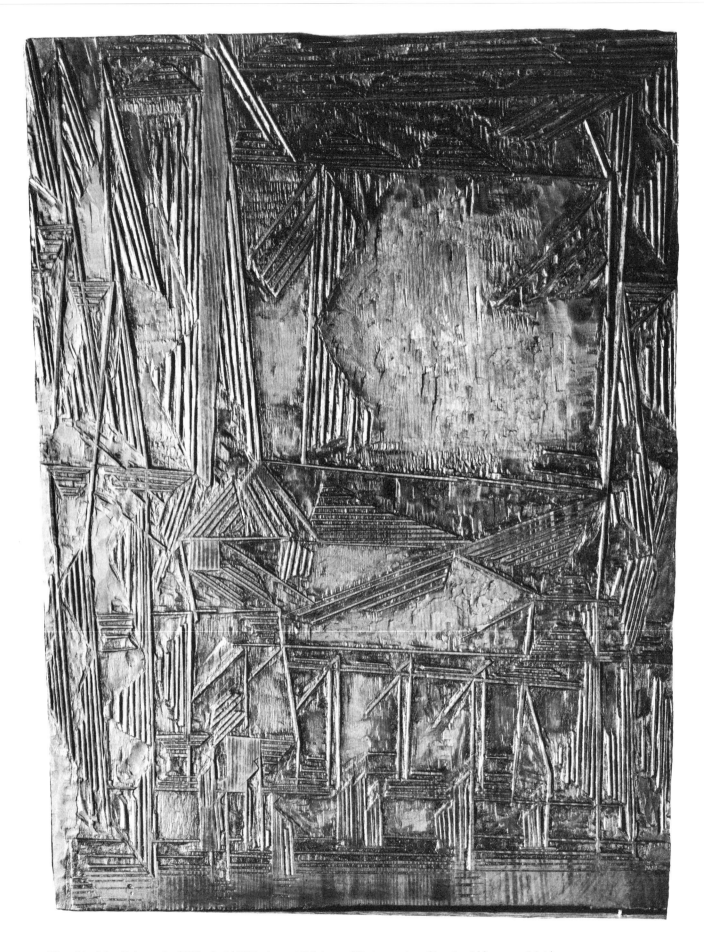

Woodblock for Gelmoroda, *(13" x 9 5/8") by Lyonel Feininger. (Photo courtesy Cleveland Museum of Art.)*

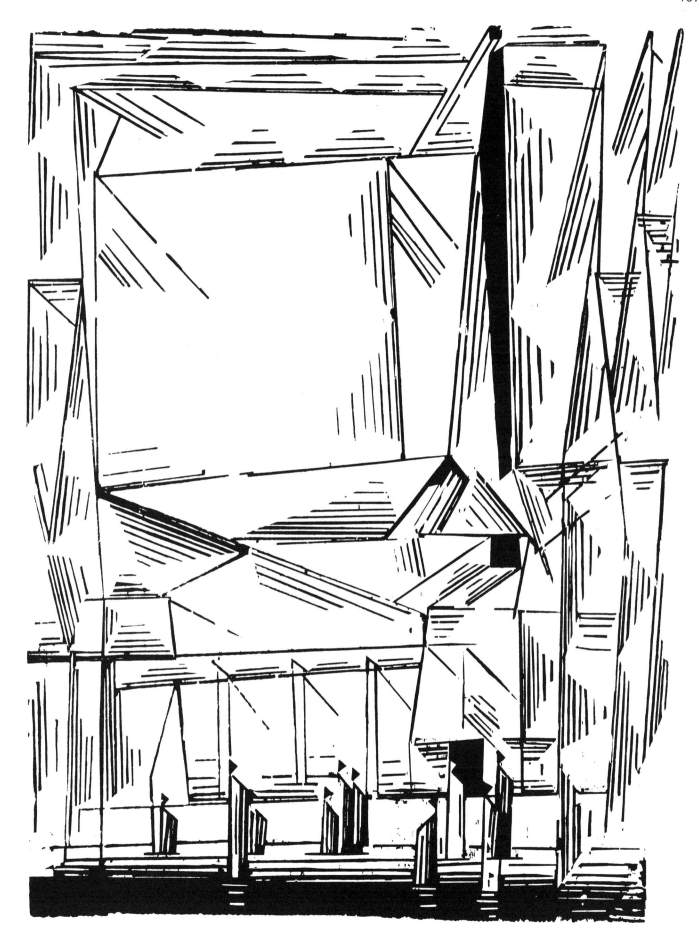

Gelmoroda, *woodcut, (13" x 9 5/8") by Lyonel Feininger. (Photo courtesy Cleveland Museum of Art.)*

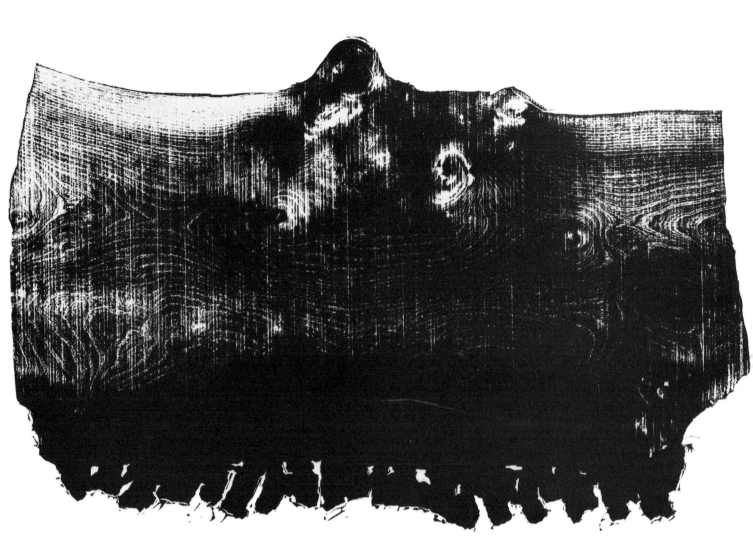

Black, *woodcut (28" x 38"), 1962, by Michael Rothenstein.*

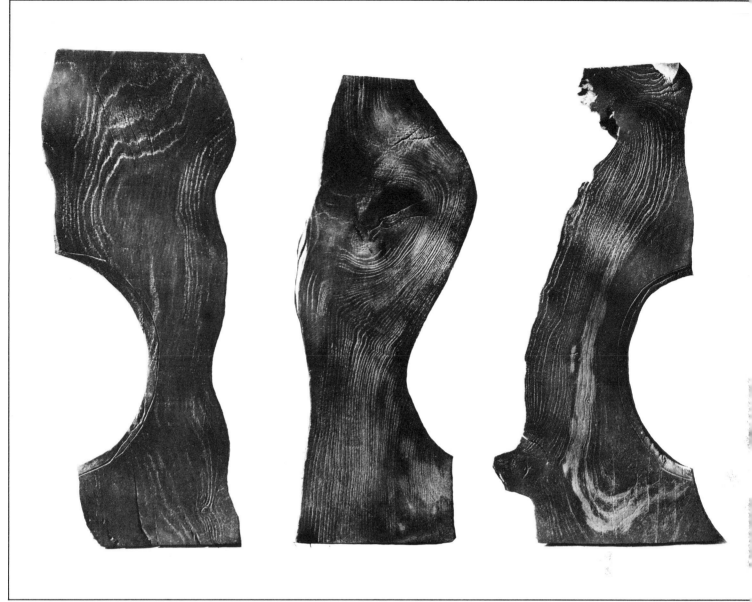

Blocks cut from elm boards *(above)* by Michael Rothenstein. Although the different woods, considered as a group, have much the same basic structure — large numbers of tubular cells, consisting of about 60% cellulose, fitting closely together — the form of their growth has marked variation. Elm wood has a notably "wild" figure, its grain forming eddying and swirling lines that resemble the looping currents of a tide running inshore over a shallow coast.

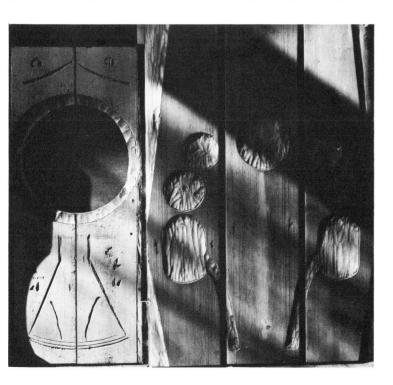

Blocks cut from pinewood *(left) by Michael Rothenstein. (Photo by the artist.)*

Fritillary,
*woodcut*
by Tadek Beutlich.

## Plywood

Unlike plankwood, plywood has practically no limitation on size: a standard sheet may well be 8' x 4', or even 12' x 8', giving an area large enough for the largest print. Plywood is manufactured by "unwrapping" in a continuous sheet from a treetrunk held in a powerful mechanism which rotates it against the edge of a knife. As the sheet is peeled away, the blade is fed forward automatically until the entire trunk is unwound in a continuous sheet. Cut into sections, each layer of wood is glued to the adjacent layer at right angles under enormous pressure; hence the grain formation is crossed and recrossed within the sheet, giving great tensile strength.

A great many plywoods are obtainable from the dealer, lumber yard, building supply house (called builders' merchant or woodyard in Britain). Specialized industrial needs produce more and more varieties year by year. The cheapest, sometimes known as tea-chest plywood, chiefly used in packing, is hardly more costly than ordinary cardboard. While it is too thin for carving, it may yet have a surface of great interest. This may have a peculiar vitality owing to its openness of grain and irregularity of surface, qualities that make it of special use in certain kinds of color printing.

Plywoods with a thick center layer are called "Stout-heart" in Britain; the thicker grades are known as multiply. In Europe and the United States, those in general use by the printmaker vary from 1/4" to 5/8". The Japanese, however, using the techniques of abrasion, may work on sheets as thin as an 1/8".

Plywoods may sometimes be bought in damaged sheets from the discount house or wrecker at low cost. The graphic studio, summer school, or art department can always store such materials with advantage. They may be used with a freedom, an unselfconscious boldness that more expensive materials inhibit, a restriction that may remain unacknowledged even by the artist himself. The printmaker should be ready, at all times, to destroy any block that frustrates the true reach of his intentions, just as he is prepared to throw away a useless drawing or unwanted sheet of sketches. In this event, it may well be realized that damaged plywoods, obtained so cheaply, may have a certain "moral" advantage over more expensive materials. They tempt us to express our ideas with unwonted directness; they endow us, while we use them, with something of the extravagant freedom of the millionaire!

Some of the plywoods, such as Columbia pine and gaboon, have an open surface, the fibers running in ridges with small interstices between. The printed impression they produce has a silky look, linear and directional. If two similar blocks are used in a single image, one printed with the fibers running up and down, one with the fibers running across, a net of fine lines is produced.

Different types of glue are used in the manufacture of plywood; in marine plywood, the glue is specially hard. The Japanese avoid this type as tough adhesion prevents one layer being peeled away from another. The printmakers, Hagiwara and Yoshida, for example, cut down through the top layer with a knife, splitting the wood away from the layer beneath with a carpenters' chisel, thus saving any unnecessary labor of carving away the open, unwanted, areas on the surface of the block. These artists like plywood weakly glued, faced with a soft veneer such as Japanese linden or shina — known in the west as basswood. These are both light and easily worked. Another type of weakly glued plywood, used normally for ping-pong racquets, is highly valued for its property of easy stripping. In Japan, rawan and lauan are also much in favor; both are medium weight hardwoods that are easily carved.

## Weathered Plywood

Like other woods, the structure of plywood changes with exposure, and these changes are capable of producing effects of great interest in the hands of the printmaker. Left out of doors, in a wet climate, the surface layers of plywood take up moisture and swell, while clinging in wave-like ridges to the layer beneath. Plywood driftwood found on the seacoast may have become eroded by the action of salt water, shingle, and sand until the layered structure of the wood is exposed in depth. One of my own most striking discoveries was a sheet of thick plywood, 4' square, half buried in wet sand in Holcombe

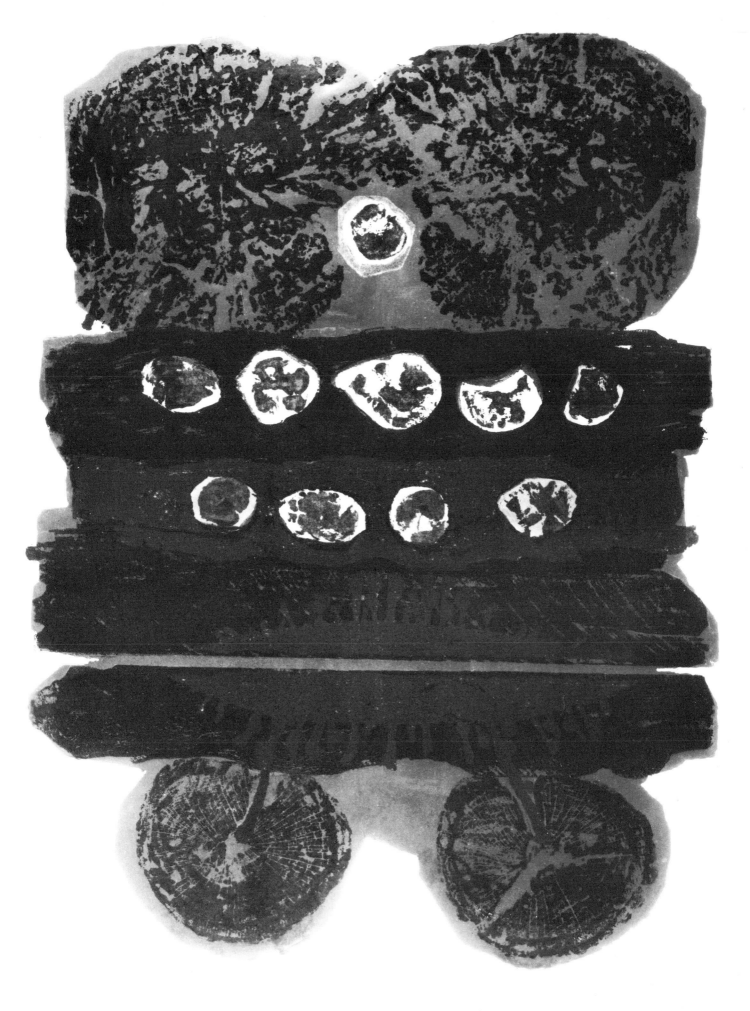

Woman with a Flowered Hat,
*linoleum engraving in two colors,*
*(13 3/4" x 10 3/4"), 1962,*
*by Pablo Picasso.*

Braintree Station, *linoleum engraving, (22" x 42"), 1960, by Edward Bawden.*

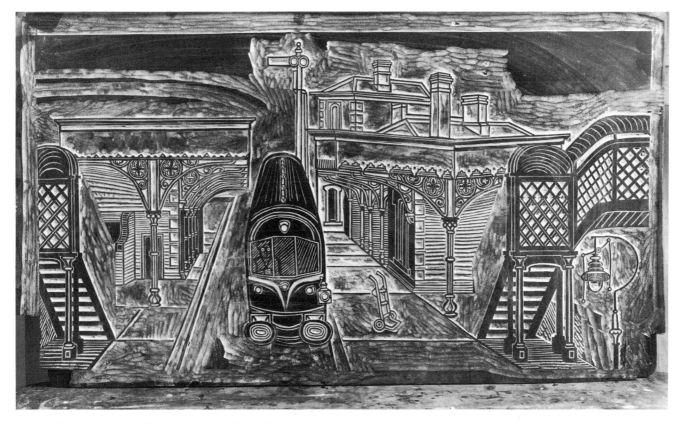

Braintree Station, *engraved linoleum block by Edward Bawden.*

Bay, off the Norfolk coast. Alternately soaked with salt water and bleached by the sun, it had been tossed by the waves until its surface was ground into a landscape of torture. Layer by layer, the body of the sheet had been torn away, leaving a system of splinters, tier on tier, showing on its face. Sand was driven deep between the interstices of the wood; which weighed heavy as a sheet of iron, soaked with salt water as it was. My wife and I just managed to drag it across the sand, about two miles, to where the car was parked, away across the bay. We brought it back to the studio, where it stood drying for some six months before the wood could be used.

## Using Defaced and Damaged Boards

All timber contains moisture, normally from 10% to 25%, much more when the wood is damp. Damp wood can be stood edgeways to dry, near a stove or radiator. If you put it facing the source of heat, the warm side loses moisture quicker than the unheated side, so the wood will tend to curl. It should then be turned round, when normally the plank will straighten out again.

Wood which is partly rotten and defaced, full of wormholes and studded with nails, can still be treated and used. Though difficult to carve, such wood can contribute the imprint of a hundred accidental marks, a heritage of considerable interest to the printmaker. In the main, the artist's common sense will indicate how such timber is prepared for use. Coming from the building site, it may be wet and dirty, half covered with plaster, cement, or mud. It should be scrubbed and dried. A wire brush is used to clean away loose or rotten fibers. When the surface is ridged and rough, a smoothing plane is employed. Rusty nails driven below the surface can be knocked right through the board with hammer and punch. If thin pinewood boards are in danger of splitting apart, they can be backed with hardboard, using a cold water resin glue, so-called white glue, P.V.A. solution, or any other practical adhesive. If outside storage is lacking, worm eaten wood can be immersed in a solution of weak caustic soda to kill the worm. This is fully as effective as the more costly, commercial agents used for this purpose. A large plastic acid bath, the kind used in etching, is a convenient container for this immersion.

Such wood, rotten and defaced, is inked at first with difficulty. The surface will be found abnormally absorbent, the dry, open fibers soaking up the ink. It may well be an economy, at this stage, to use only the cheapest commercial inks until a dried ink crust has formed. Only old, worn rollers should be used, since loose fibers strip away from the wood, clinging to the roller and clogging the ink. With use, however, the uneven surface of wood becomes smooth, and once amenable to the roller's action, such blocks are a particular pleasure to use.

We can now make a photo silkscreen from *any* fragment of wood that can be inked, and from which a hand rubbed image can be taken — a fragment, that is, that would be impractical to print in the normal way. Nor need the wood be flat, since it is possible to make wrap-around images by bending paper or plastic film round a curved surface. The original image, taken by hand from a tree stump, floorboard, or door panel, can be faithfully transferred to a screen with the proper equipment, and subsequently printed, a method described in a later section. With this development, of the utmost consequence to the future of relief printing, the most ancient of print techniques joins hands with modern technology.

## Linoleum

Unlike wood, linoleum has little perceptible structure; only when etched with caustic, or some other agent, does it give much evidence of texture. It is a cool, impersonal medium. A color printed from smooth linoleum presents a flat and even surface to the eye; it may, indeed, be entirely featureless, like colored paper or plastic. Hence a piece of lino, with a few bold cuts on its surface, printed in a strong, bright color (red, blue, or orange), is stark and emphatic in effect. Shining up through the gouged or engraved marks, the white paper grins with a luminous hardness disturbing to the eye.

The feel of linoleum is inorganic. A block prepared for work appears to await, in passive acceptance, the surgical attack of the knife and gouge. In contrast to wood, it is easily cut and may be cut in any direction. Except when old and brittle, it offers little resistance to the cutting edge. Here, in this complete submission to your will, lies its special virtue. For of all the materials open to the relief method, linoleum remains the most

Perforated and counter sunk sheet metal, *a collage of samples taken from a sheet metal manufacturer's catalog. Perforated metal can be printed in either relief or intaglio (suitably backed), providing a remarkable vocabulary of repeat systems. Metal sheet can be printed from either side so that a system of slots set at an angle, for example, can be printed as either a left handed or a right handed system. A photo taken of a small sample from a metal manufacturer's catalog (such as those shown here) will provide a number of prints that can be collaged together to form a large area of any system wanted. This in turn will provide a black positive for making a photo screen or photo-lithographic plate that can be reproduced on any scale required.*

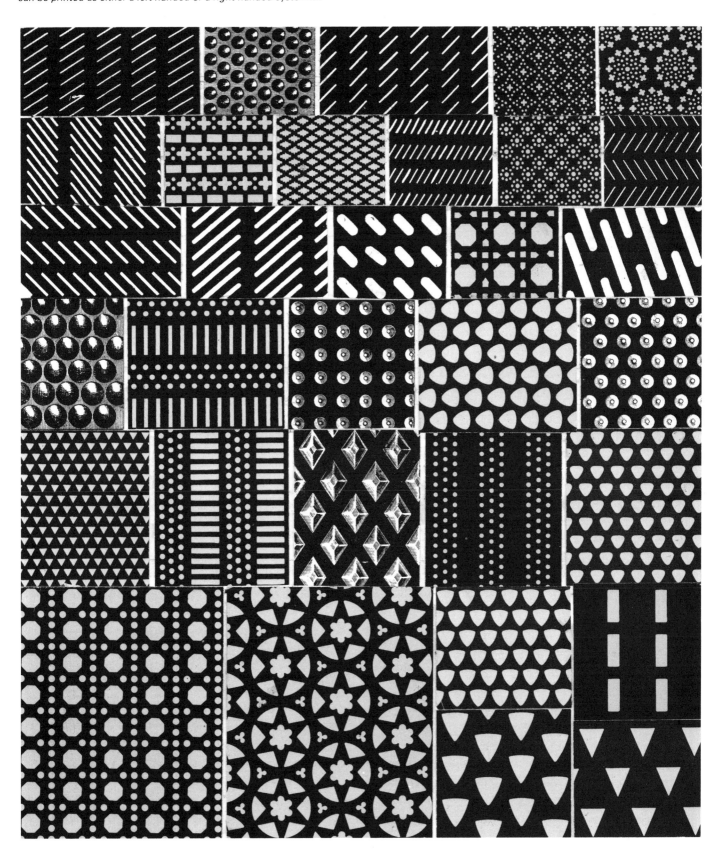

amenable, and this quality has given it the widest possible use, from the triumphant image of Picasso to the potato-face cut with an awkward infant fist. From the child's play school to the studio of the master, linoleum has served its plain and useful purpose.

## Nature of Linoleum

In the seventeenth and eighteenth centuries, it was not uncommon to waterproof carpets by painting them with linseed oil. But linoleum, as we know it today, dates from 1860, when Frederick Walton patented a process of oxidizing linseed oil. In true linoleum, ground cork and linseed oil are the main ingredients; the linseed may also be used with other resinous substances. In manufacture, these materials are laid in layers on a canvas foundation, with a calendar machine fitted with heavy, steam heated, iron rollers. Normally made in 6' or 9' widths, linoleum rolls may well be several hundred feet in length. It is the presence of oil, softening when heated, that makes linoleum plastic — and even flabby — at high temperatures, and that makes it stiff and hard when the temperature is low. Hence, in cold weather, linoleum can be warmed near a stove or radiator when it is found difficult to cut.

When first manufactured, linoleum is fairly soft, but as it "cures" it hardens, a process continuing with age; thus, when it has stood in a roll over a long period before purchase, it may be difficult to flatten. As soon as possible, it should be unrolled and laid out on the studio or workshop floor. The tiny marks and scratches it receives in wear are normally too fine to print, but if work is on a small scale, any light scratches can be removed by scraping the linoleum with a sharp razor blade. When fine line systems are to be cut on the block, however, it is clearly best to lay the linoleum on a table top or the floor of a little used room for protection.

The surface of linoleum can sometimes be very much improved for flat color printing by applying a thin coat of varnish; the varnish chosen should be impervious to the softening effects of the media contained in oil based ink, such as mineral spirit (white spirit).

The store that lays linoleum floors will sometimes sell off-cuts to students and artists; while the rolls of worn linoleum, found at auction sales, are bought at only a fraction of the original cost.

For block cutting, thick, medium-soft linoleum is best, since the tool should move through the material with a strong, decided stroke. The linoleum should be 1/4" thick; otherwise the burlap (hessian) back is too quickly reached, giving the system of cuts a thin and meagre look. For flat color printing, however, linoleum 1/8" thick is entirely practical; this material can also be cut directly with knife or snips when a free form shape is needed. Linoleum of more than 1/4" is exceptionally thick; for deep, open carving, however, it is the best. Sometimes known as "battleship," the heaviest grade of lino was indeed made originally for the floors of warships, as its name suggests. The medium heavy grade, brown in color, called in the trade "Plain Brown" or "Brown Office," is named in deference to its use on countless thousands of floors in banks, offices, and other commercial buildings.

A plain color is clearly best for the printmaker's purpose, though the discreet texture and marbling of many modern linoleums hardly interferes with the artist's use. But a contrasting design or inlaid color, where pattern is produced by different pigments in the body of the lino, may well make the material of little value.

## Joining Linoleum

For economy, or when material is short, a large block can be made up of separate pieces. The pieces to be joined should be slightly undercut — beveled inward from the top — using a steel straightedge. They are laid on a hardboard backing and secured, using any available form of plastic glue.

## Hardboard

Hardboard is used in the print studio for two purposes: either for making blocks, using tools like those used for linoleum cutting, or for backing lino blocks, fragile wood blocks, or sheets of thin pinewood that would otherwise split apart in use. For the latter purpose, being both stable and cheap, hardboard is a most useful material. It is also very generally obtainable. Linoleum or wood is

fastened to the hardboard back with any available plastic adhesive. Blocks should be stuck to the textured side.

Hardboard, sometimes called by the trade name Masonite, is normally sold in sheets that run in multiples of either 2' or 4', such as 2' x 4', 4' x 8', and so on. A usual thickness is 1/8", but both thicker and thinner grades are available.

It is a practical material for flat color printing; for free form blocks, it is quickly contoured with the powered jig.

Easier to store than either wood or linoleum, hardwood takes little space and can be stood in a rack or against the wall.

## Metal

Relief blocks can be made from metal plate and sheet in scores of different ways. Blocks can be made by etching in depth; by building up in layers from sheet; by using grids, wire mesh, old photographic plates, or stamped and pressed metal sheet for making constructional or collage blocks. In respect of these materials, modern industrial technology has an immense untried potential. To date, the printmaker has explored only the fringes of this new frontier. In a later section, making etched and constructional blocks is dealt with in more detail.

## Soft Materials Hardened

Advance in the manufacture of liquid hardeners, particularly the water soluble plastic adhesives, has put a new range of materials into the printmaker's hands. Almost any water absorbent substance — such as cloth, burlap (hessian), etc. — that can be spread out on some sort of backing, can be treated with these adhesives and hardened to the point where a whole series of exactly matched images can be taken from their surface.

Canvas, sacking, rags of every kind, nylon stockings, a glove, a piece of string or embroidery, once immersed in the proper solution, will become hard and stable. Other substances notably less absorbent, such as aluminum foil, thin metal sheet, paper, leather, wood veneer, leaves, straw or other vegetation, can also be treated and fixed to a backing with an overlapped, folded, pressed, crushed or crumpled system of shapes — if this is wanted. All these materials, too, will make a stable printing surface,

Fishing Net *by M. Humble, Teeside College of Art.*

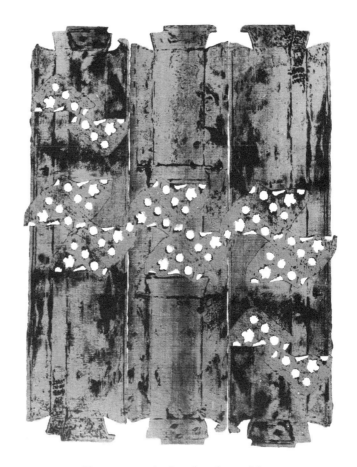

Photo screen print from found materials, *Bournemouth and Poole College of Art.*

strong enough to withstand the repeated pressure of the press platen. It is obvious enough that the relief of these blocks should not be too high, otherwise a printed image is no longer possible.

The technical procedure is extremely simple. A plastic glue (many kinds are on the market, sold under brand names like Elmer's glue, white glue, Cascobond, Uni-Bond, etc.) is mixed with an equal quantity of water to bring the bonding agent to the consistency of thin cream. It is then poured into a container — a large plastic etching tray is convenient for this — and the textile or other fragment is immersed. Materials of open weave absorb the solution quickly and easily; but a piece of rope, with its harder, less open texture, much less responsive to absorption, may need a stronger mix of the adhesive. A piece of hardboard or other backing is prepared with a coating of the same solution. The material to be hardened is then lifted from the tray and spread upon the backing. If the surface is to be crumpled, overlapped, or folded, it will need ordering and pressing with your hand. This should be done, however, while the substance is still pliable.

Since both material and hardboard base are coated with wet adhesive, the whole block will have a strong tendency to curl as it loses moisture and dries. This can be corrected, as drying takes place, by clamping down the edges of the board with strips of wood. This can also be done by covering the surface of the block with sheets of newspaper and covering this, in turn, with a heavily weighted board. (This method, however, has a disadvantage; once dry, the newspaper remains clinging to the surface and will need cleaning away with a damp pad or rag.) A highly absorbent material should be left to dry and harden overnight, but less absorbent ones will dry more quickly, often in a few hours. The diluted glue, milky white in appearance, will become transparent and glossy as it dries, a change so obvious that inspection of the drying process is made easy. Sheet material, aluminum foil, wood veneer, etc., do not need immersion. The bonding agent is used, full strength, to coat both surfaces to be joined, and the two materials are simply pressed together.

Blocks can also be made by the act of direct precipitation. A layer of liquid plastic adhesive (full strength) is spread on the backing and sand, gravel, metal filings, sawdust, cotton waste — any substance indeed sufficiently ground up, fragmented, or finely shredded — can then be shaken, crumbled, sprinkled, dropped, thrown, or spattered onto the wet surface. Once dry, the excess material is brushed away and a stable surface should be there for printing. If, however, any fragments tend to come loose after the first application has dried, a second coating of the adhesive can be given.

## Found Objects

While they are not materials in the narrow sense, found objects have certainly proved their worth in recent years, both in art school and private studio. It is, perhaps, impossible to assess the value of this source; such an enormous range of objects can yield a printed image. The main part of an earlier book was devoted to found object imagery drawn largely from student files. But it soon became clear that we have hardly begun to exploit the richness of this source; the incredible potential of found object study remains largely untried.

From the student's viewpoint, the use of found material carries a special advantage since it involves a search that engages him in a very direct dialogue with his own immediate environment. He discovers, to begin with, how many things can be printed, things he had never before thought of in this context. In getting a print from a wood fragment, a crushed metal can, a gear wheel, he is likely to find a quite unfamiliar image. In the printed version, the object has been transformed — transformed to the point where it carries the punch of almost total surprise, for even the most experienced printmaker hardly knows how a given object will look once it is printed.

The reach of all such study is unlimited — as unlimited as the reach of sketchbook drawing, where the act of gestural notation is intended to catch a reflection, a single gleam, from the enormous sea of outside reality.

Searching the environment for printable surfaces and objects is an activity particular to a particular place. A schoolboy in London's East End will find one set of things; a student at a summer school in Maine will find another. Wherever printmaking is done, in Los Angeles,

Photo screen print *from a hand rubbed image of a large metal found object, Bournemouth and Poole College of Art. The "leaves" of the print can be moved along the supporting frame, bringing them closer together, or taking them further apart.*

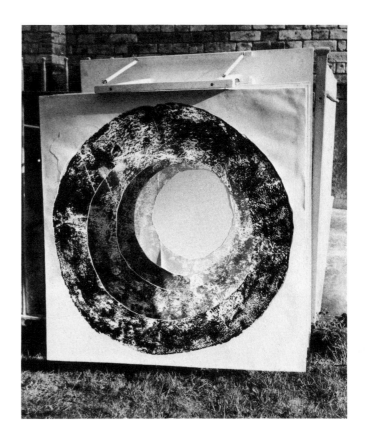

in South Africa, or in Mexico City, a unique and marvelous potential exists, unique to each locality, and those classic places of found object search — the ocean shore, the city dump, the car wrecker's yard — will each give up their different secrets. In this search, every school or college has an even chance and is equally poor or rich, even those in the poorest district. The yearly requisition schedules, that limit the use of conventional materials, have little meaning here; for the collection of found materials, filed away in crates and boxes, costs nothing — nothing beyond the imagination, energy, and initiative of the students and teachers engaged in its search and collection.

## Cleaning and Preparation

The cleaning and preparation of these materials needs a sink provided with hot water, and a workbench fitted with a vise to grip and secure the larger objects that need de-rusting with a wire brush. When wire brushing is done with a power tool, a surgical or industrial mask should be worn. The bench should also be provided with some carpenters' tools, the basic requirements being a hammer, hacksaw, pincers, and snips, for flattening, cutting or taking apart the various objects.

## Collecting and Organizing

Beyond their use for a particular project, a collection of the more arresting objects is also well worth keeping. They can easily be filed in boxes and kept in the workshop, available for future use. Their presence will often set a student working when ideas stagnate. There can be great advantage, too, in engaging an introspective student in active problems, needing straight forward practical solutions.

The flatness of the chosen object is an essential feature. If it is too irregular, with variously angled planes, or sharply indented or projecting forms, it will not be practical to print — even by the "soft pack" method described in section 10. If the image of a found object is to be repeated for an editioned print, it must always be taken from a flat — or flattish — surface. So much, perhaps, is obvious where professional work is concerned. But for study in art school or summer school, this

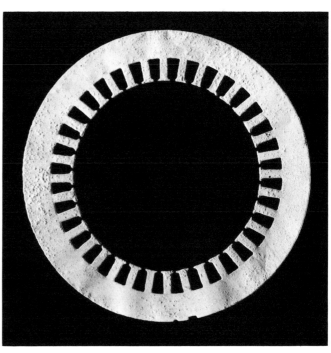

Found object used as stencil, *Camberwell School of Art and Crafts. The metal circle was placed, uninked, over an inked surface and printed under heavy pressure.*

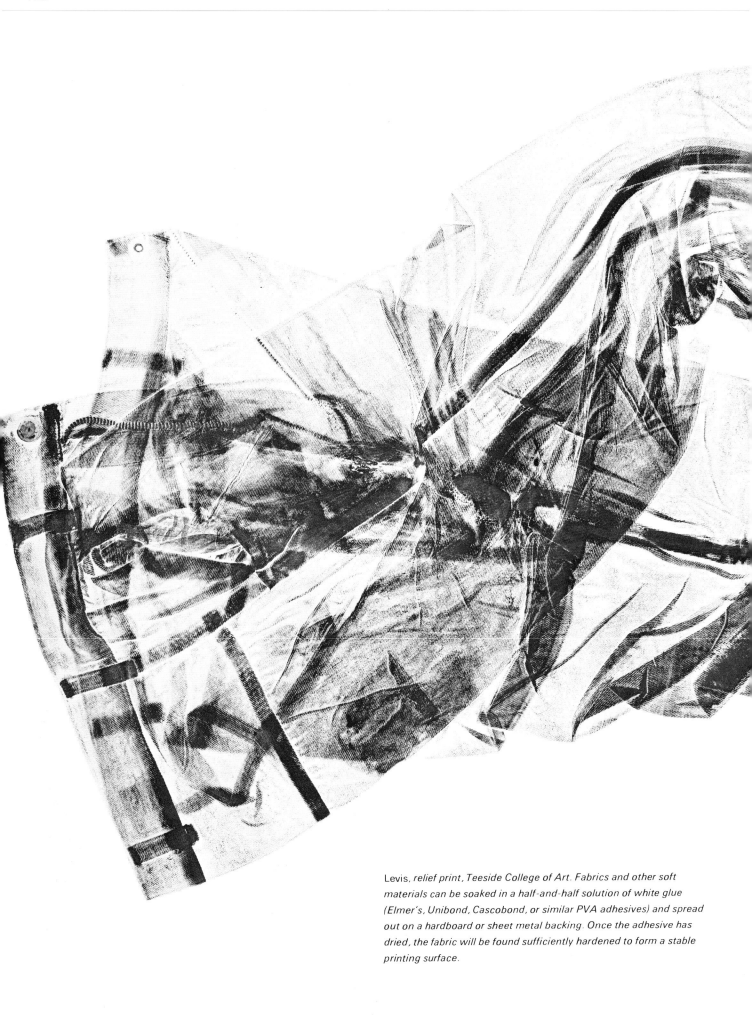

Levis, *relief print, Teeside College of Art. Fabrics and other soft materials can be soaked in a half-and-half solution of white glue (Elmer's, Unibond, Cascobond, or similar PVA adhesives) and spread out on a hardboard or sheet metal backing. Once the adhesive has dried, the fabric will be found sufficiently hardened to form a stable printing surface.*

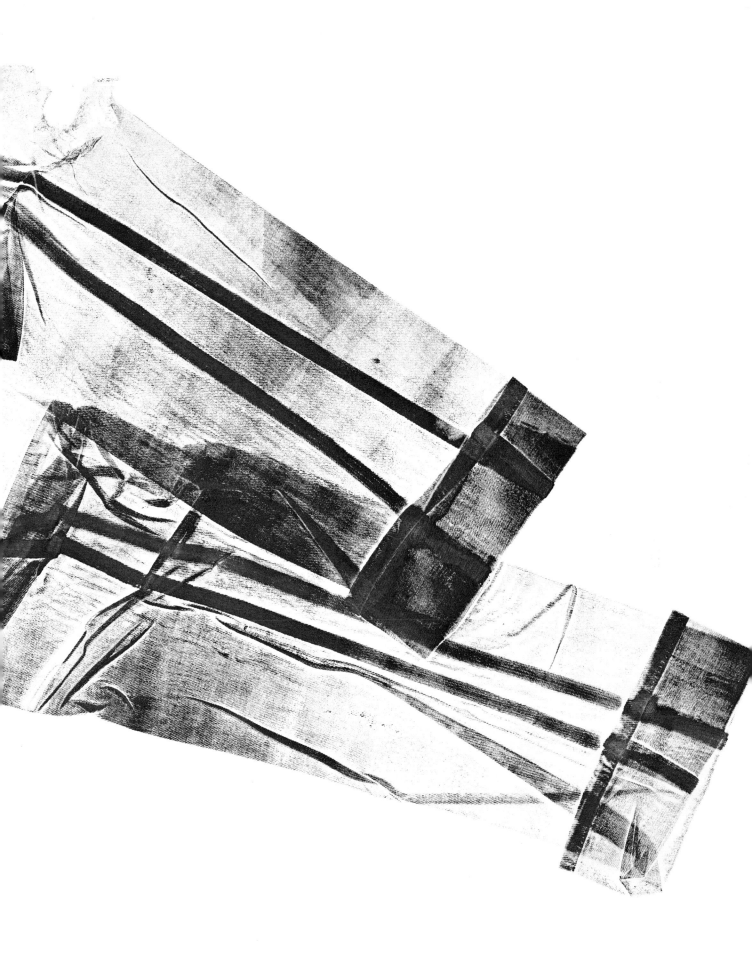

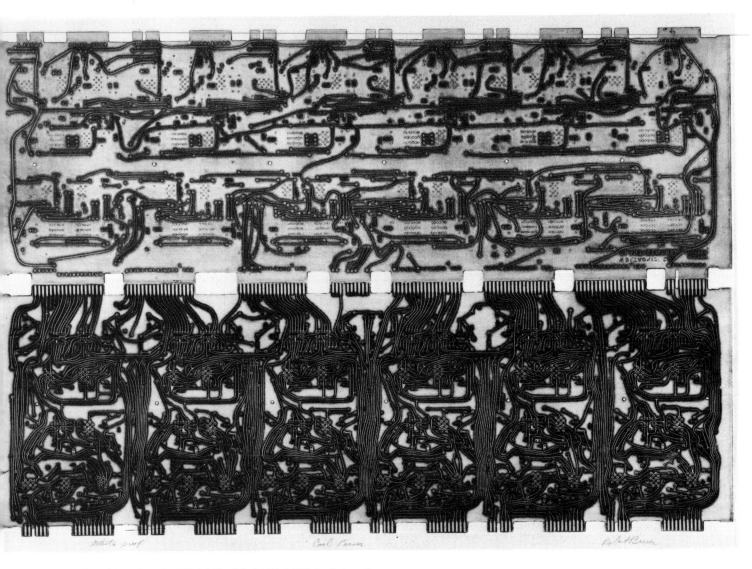

Cool Power, *found-form intaglio (19 3/4" x 29 3/4"), 1969, by Robert Broner.*

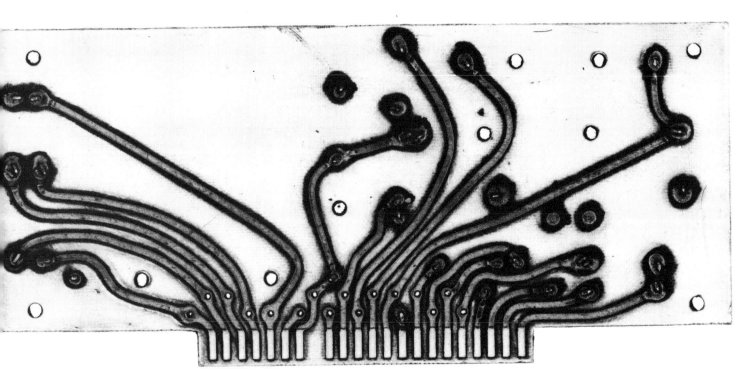

Mediacy, *intaglio print from printed electrical circuit board, 1967, by Robert Broner.*

general rule gives way to more open approaches. Here — away from the formal discipline of editioning — an immense variety of objects can be studied in many different ways: sometimes section by section, taking separate images from their different planes; sometimes taking them apart to gain a series of related images if boxes, clocks or pieces of broken furniture are used.

In art school projects involving found materials, the sensible course is to look for objects that are immediately available. The school dump or rubbish heap can often provide broken furniture, sculpture stands, discarded tools, pieces of wood and metal thrown out by the various departments. These should be sorted through, and the chosen objects thoroughly washed in warm water, and scrubbed down with soap, scouring powder, and disinfectant.

## Designing and Printing

Young groups are likely to choose small objects for their prints — buttons, coins, wrapping foil, fragments of cloth, feathers, the gears of a broken clock — and work done in this way is often engagingly inventive. This method, however, treats these materials piecemeal: by printing objects separately, they may remain separate and isolated in our own minds. Already, at an early age, more sequential methods should be demonstrated. A cigar box, for instance, could be taken to pieces, and the student asked to construct a design from printing the separate parts. This can indeed be an elegant exercise, since the set of images, taken from separate parts, will be found to fit together again in the printed version, since the design was taken originally from parts that fitted.

The simplest, most direct way of using found material is to print each element separately, cut out the separate prints, and collage them together. If this collage is then to become the "model" for a print, the positions of the various elements are marked on tracing paper or an acetate sheet in the normal way. The tracing is used to find the correct relationship of these elements — the found materials or other blocks — when they are set out on the backing for printing. (See the discussion of positional tracing in section 7.)

Let us say that you wanted to use a typical piece of found material, such as a metal gasket, as part of your image. You would clean the gasket, ink it with a roller, and print it, either in the press or by hand, in the ordinary way. You would then cut out the "print" of the gasket with scissors and collage it, in the required position, on the master proof. The overlay (or positional tracing) would then be placed over the master proof and the position of the gasket marked upon it with india ink. The overlay is then turned over and placed on the register backing and the gasket is placed in register with the markings shown. Next, you remove the overlay and mark the position of the gasket clearly on the backing. The gasket can now be printed in correct register with the other blocks you are using.

Any object chosen for printing in the press should be something less than 1" in thickness; anything thicker is impractical. In the case of combination presses, the limit is set by the height to which the upper roller can be raised. In exceptional cases, however, very thick objects — such as the cross cut of a tree trunk — can be editioned by hand burnishing, but will entail the method of vertical register if it is to be printed in combination with other blocks.

If a hand burnished image is taken on transparent plastic film, it can, of course, be transferred to a silkscreen with the aid of photo-sensitive film and the use of a light box (see section 11). Taken directly from the object a freshly inked impression can also be placed, face down, on a lithographic plate, run through the press, and processed for printing in the normal way. A further method is to photograph the object and to get a coarse screen halftone block, made by the commercial platemaker to the required proportion; it is quite practical to print this type of block, with the necessary adjustments, on the platen hand press, on the proofing press, or on the etching press.

To sum up, these are some of the ways in which found objects are used in printmaking:

(1) For direct printing in the platen or combination press.

(2) For direct printing by hand burnishing.

(3) For hand rubbing with a greasy chalk through the stretched fabric, to make a stencil for silkscreen.

(4) For hand burnishing an acetate film. This method

124

produces a positive for transfer to a photo sensitive film for silk screen.

(5) For hand burnishing or press printing for direct transfer to a lithographic plate.

(6) For casting, to make either a negative or positive printing surface, using a cold setting substance such as liquid rubber (latex).

Notes on most of these methods appear in sections 6, 10, and 11.

## What Materials Are Needed?

Particular conditions, particular jobs, particular school projects, all suggest different materials suited to the work in hand. All kinds of wood, for example, are used by printmakers and may be used for a particular school project, although they might form no part of regular school supply.

The recommended sheet sizes for hardboard and plywood in the following list are basic materials; wherever students work on an ambitious scale, a great deal of this material will be wanted. Hence, any sizes given are merely common sense suggestions for average practical needs. A more ambitious department, likely to encourage enterprising work, should order plywood and hardboard in full sheet sizes (such as 4' by 8'), provided only that adequate storage and cutting equipment are readily available in the school or college concerned.

In general, where funds are short, there is no substitute for a clever, knowledgeable, and active teacher, prepared to use his own initiative in getting materials from unconventional sources: auction rooms, junkyards, classified advertisements, etc. Again, with regard to found objects, while the use of such artifacts carries a general purpose in art school or college study, their use in the private studio is obviously dependent on the individual artist's ways of work. Few artists have used them effectively. No doubt, my purpose in including them in the professional's list voices a plea that the great potential offered by this source should be more fully exploited.

With regard to some materials, it is difficult to make any particular suggestions. The growth of a synthetics technology has brought rapid change. New rubberized materials are coming into the market, some specially made for blockcutting in schools and colleges; other types, made for the printing industry, are produced in sheet form for intricate outline cutting. These, however, are not only highly specialized products, but at present they are expensive and difficult to get.

The following list should be of some general use, although it is offered with reservations. As in earlier lists, I have divided the materials into separate sections. The needs of primary and secondary schools come under only one, and items likely to be of special use to the youngest or primary groups have been italicized. A second section is for art schools, colleges, and universities. Those items which the amateur may like to consider are marked with an asterisk in the last section — the professional artist's list.

## Basic Needs for Elementary and Secondary Schools

*Italics indicate items useful for youngest groups*

*Sheets or roll of medium-thick linoleum (sheet sizes 15" x 20", 12" x 16")*

Hardboard sheets (12" by 16")

1/4" plywood

Sheets of "Packing case" plywood

*Sheets of heavy cardboard (22" x 30", 27" x 40", 30" x 40", etc.)*

*Rags, canvas, metal foil, string, leaves, etc.*

## Items That Can Be Added

Any 1/2" plankwood boards available

Driftwood and other found materials

Found objects such as flat metal machine parts, gear wheels, gaskets, pierced furniture moldings, etc.

## Basic Needs For the Art Schools, Colleges, and Universities

Sheets or rolls of medium-thick linoleum (sheet size 20" x 30")

Hardboard sheets (16" x 24")

Sheets of 1/4" plywood

1/2" planed white or yellow pine (9" or 12" widths)

Driftwood, machine parts, and other found materials

### Items That Can Be Added

Sheets of 1/2" plywood

"Packing case" pine boards

Boards of parana pine (9" or 12" widths)

Pierced, stamped, perforated and metal sheets, etc.

Metal foil, wood veneer, thin plastic sheeting, etc.

## Basic Needs for Professional Artists

* Items most useful to the amateur

* Sheets, off-cuts, or a roll of medium-thick or thick linoleum

1/8" hardboard sheet

* Sheets of 1/4" and 1/2" plywood

* Boards of 1/2" planed white or yellow pine (9" or 12" widths)

### Items That Can Be Added

Boards of Planed parana pine (9" or 12)) widths)

"Packing case" pine boards

Fruitwood blocks

* Extra thick "battleship" linoleum

* Cedar and Mahogany boards

Sheets of gaboon and columbia pine plywood

* 3/4" elm boards; off-cuts from the lumber-yard

18 gauge zinc and copper sheet

Perforated metal sheet

* Found materials such as driftwood, weathered boards, corroded metal sheet, etc.

Found objects such as metal machine parts, gaskets, gear wheels, pierced moldings, etc.

* Items most useful to the amateur marked with an asterisk

# 7

# WORK METHOD

All experience of teaching points away from setting up rigid examples. Giving rules, even for technical procedures, is an unrewarding task, since work at every stage, and the tools and materials chosen to accomplish that work, must finally remain the prerogative of the individual personality. Hence, these first notes are for the guidance of the student or amateur only; professionals, accustomed to their own studio or workshop methods, will hardly need the commonsense directives given here.

The following stages are basic practice for the preparation and proofing of blocks: choice of material for the block; cutting the block to size; preparation of the surface, if necessary; transfer of the image from an original design, or setting out the image directly on the block. Cutting and carving is a step by step process. There are few general rules. In all cases, early proofing is recommended; the development from then on is normally dependent on an active "dialogue" between block and proof.

**Cutting Blocks to Size**

A large steel square is used for cutting linoleum blocks to size; otherwise a steel straight edge can be employed. The method is to true one edge of the block, cut the sides accurately at right angles, and make sure the remaining edge is trimmed parallel to the first. If your hands are strong, cut right through the material, pulling the knife directly towards your body. Otherwise, cut the linoleum partly through, fold it back double, and slit it from the back, just as you trim folded paper with a knife. When the block is to be used with a corner register, make sure the left hand corner and bottom edge are accurately cut. A mat knife, holding a heavy duty blade, is a convenient tool to use.

Wood is cut with either a hand saw or a powered jig saw, gripping the block in position with a G clamp. If a free form block is wanted, use a powered jig; the best of these will also cut metal plate up to approximately 18 gauge. Tin snips are employed for trimming thin metal sheet, veneer, plastic, and other thin materials: scissors or mat knife for cardboard or polyethylene (polythene) sheet.

*Liquitio,*
*etched and engraved linoleum*
*(36" x 25"), 1962,*
*by Michael Rothenstein.*

## Transferring Image to Block

An image is put on the block in different ways, according to the work in hand. For the direct, improvised attack used by children, and sometimes by professionals, little preparation is needed. India ink can be rubbed over the surface and the drawing made with a light colored chalk or paint. A dark surface has the advantage of showing up the tool cuts as you work, thus preserving the correct negative-positive relationship, always assuming that the block is to be printed on a white paper.

To make a pencil or ink line clearly visible, the wood or linoleum can be covered with white emulsion or poster paint; but if a detailed drawing is needed, it is better to use white ink to cover the block. This will whiten the surface without leaving the track of brushmarks.

To transfer an image to the block from an original design, any of the following methods can be used. For accurate transfer, place thin acetate film over the original drawing, frosted side upwards, and trace or redraw the forms in india ink on the acetate. Corrections are made with a drop of ammonia applied with a rag, a cleansing tissue, or a cotton swab. Both the face of the tracing and surface of the block are next coated with rubber cement (cow gum). The tracing is now turned over and pressed, face down, firmly on the block (the image will again be reversed in printing, bringing it the same way round as the original). The side of a pencil is generally used to burnish the acetate solidly to the block.

The cutting of the block is done with a knife through the back of the film, which is then stripped away, and the rubber cement (cow gum) is rubbed off with the fingers. This is a direct and accurate method of transfer, eliminating one phase of dull mechanical work — the job of going over the line with a stylo or ballpoint — which is certain to deaden the nerve of the original trace.

If ordinary tracing paper is used, the tracing is laid face down on the block, and black or yellow carbon paper put beneath. The surface of the block is brushed with white emulsion when a dark carbon is used, and swabbed over with india ink for use with a light carbon.

If you make your original drawing on thin paper, and put a sheet of carbon paper, *face up,* beneath the drawing as you work, you will get a reverse image of your drawing on the back of the sheet. This eliminates the necessity of tracing onto tracing paper. The drawing can then be placed, *face down,* on the block and directly traced from the back as in the normal method of tracing. For all these methods, weights are used to grip the sheet in position against the block, while work is in progress.

## Cutting the Block

Any material removed from the block leaves a white, unprinted line or shape upon the proof. This is the basic principle of the relief block; the inking roller, passing over the surface, cannot reach the lower level from which the material has been removed; the top surface alone receives ink.

In cutting the block, each printmaker evolves his own procedures. In the case of the gifted artist, the method is likely to remain his own. The basic procedures of tool holding and locking the block in position have already been described; all these will apply, to some extent, to professional, student, and amateur alike. At primary level, the youngest age group work directly and informally, and this jubilant openness of attack will be protected by a sensitive teacher until the child is of an age to take naturally to more rigid disciplines.

Whatever a given artist's abilities and background, it is certain that no preconceived ideas should intercede between instinct and action. An artist trained mainly as a painter, for example, may well have evolved approaches that are likely to be carried over in his approach to printmaking. He may want to score lines freely on the block before undertaking the tough, extended labor of cutting out the wood — much as he might indicate the leading contours of his painted scheme before committing himself to a heavy pigment.

In starting work, the forms are drawn on the block or transferred from an original in any of the ways described. The contours are cut with a knife, and the wood or linoleum is carved back from the line with a large gouge, holding the tool at a low angle. At first this process of clearing back need only be carried to a point that allows a proof to be taken by inking the various forms already cut, without also inking unwanted areas of the sur-

rounding surface. The cutting in depth is done by stages; to start with, only a channel is cleared around the line and proofs are pulled to check the progress made.

When a line is cut to print as a line (not as the contour of a solid shape), two separate incisions are needed. The first is made by holding the knife at an angle and pulling it towards you; the block is then turned around to make a second incision, which removes the sliver of wood along the line. However, in most cases, a series of lines are likely to be cut together; thus the repositioning of the block occurs only at intervals. The method of using a knife is more fully described in the section dealing with this tool.

In the "open block" method, later described, free shape blocks are widely used, and in this case all the material beyond the outline of these blocks is cut away with knife, tin snips or a power tool. This obviates the process of cutting back and restricts, to some extent, the traditional uses of the hand held tool.

The Japanese, in lowering unwanted areas of plywood, may cut parallel lines through the top layer of veneer, stripping away the wood between the incised lines. In this case, they favor the weakly glued material that makes this process practical, the main source here being the plywood made specially for the manufacture of table tennis raquets.

The Japanese are also adept at angling or rounding the edges of a cut for a soft effect in the printed image. If a rough or abraded edge is needed in the print, they may roughen the wood with a small, nail studded block. The printmaker, Sho Kidokoro, uses an electric drill to "draw" and scribe on the block — often letting the lightly held tool skip or skid over the material.

When working a block, it is *always* best to stand; no other posture gives the necessary power, control, or freedom. When possible, the block is clamped to the work table corner; in this position, it can be carved or cut from either angle of the table edge. If a studio is lit from one side only it is best to have a left hand light — assuming that you are right handed. Light in my own studio falls from three sides; except in bright sunlight, no shadow is thrown on the work.

Leaning over your work, while standing, is not only tiring, but puts the body off balance for full control of the tool. Normal table height is too low, unless you are short in stature; for a person of average height or above, the table level should be raised by bonding blocks of wood with resin glue to the tips of the legs. Only tables with square cut, sturdy legs, however, can be lengthened in this way.

### Counterproofing: Transferring the Image to a Second Block

A proof of any one block can always be transferred to another by counterproofing; a method of particular value when several blocks carrying different colors are used for the image. Counterproofing is done by placing a heavily inked impression of the first block face downwards, in register, on the second block — which is then pulled through the press. The resulting image can be fixed immediately with talcum powder or French chalk — any form of light dusting powder will do — and work on the new block can begin. The paper used for counterproofing should not be too absorbent, since, in the process of being transferred, the ink should be readily transmitted to the new surface.

### Proofing

Experience will always indicate the value of proofing at an early stage of work. This applies in particular to the use of color. Here each block is processed separately; it is thus impossible to judge the interrelation of the different blocks until proofs are made. To protect directness of approach and avoid wastage of valuable materials, a possible method is to indicate the image at first with finely cut lines alone. This has the advantage of allowing you to alter a given form, the direction of a curve, or the movement of a line before carving back the material in any depth. A proof is obtained either by inking these areas with bristle (hog hair) brushes, or with small rollers, wiping away the ink where it extends over the incised line.

Work can proceed by working either on the proof or on the block; effective development clearly depends upon an active interchange between proof and block, as I have already suggested. Hence, the tracing or overlay, original-

ly prepared for the transfer of the image, may again be brought into use, functioning this time as a "control" between printing surface and printed image.

Any of the methods described below may help to maintain the pace and dynamics of the work process:

(1) Use paper stencils for trial color areas. The stencil openings can be cut from proofs and printed by sight register. A roller is used to apply the color through the stencil directly onto the print.

(2) Trial proofs, taken in different color schemes, can be combined, collaging the pieces together in register to form a master proof.

(3) In working out color, or the interrelation of particular forms, the relevant sections of different blocks can be printed separately and collaged to the master proof.

(4) Blocks can be printed separately on acetate film and placed over the master proof.

(5) If line or halftone plates (blocks) or found objects are used, they can be printed on separate sheets, cut out with scissors, and collaged to the master proof.

(6) Sections can be cut from the proof, and colored paper put beneath; opaque or transparent paper or film can be collaged directly on top.

(7) To judge the effect of overprinting when proofs are on separate sheets, hold the relevant proofs against the window, or view them on a light box. In either case, the light, striking through the paper, will show both printings in relation to each other, one superimposed on the other.

(8) Carving is a reductive process; once removed, it may be impossible to put material back. When there is uncertainty, try brushing color directly on the block and proofing it, before cutting further material away. This method should give a clear indication of the "look" of the intended alteration — with minimum risk to the block.

## Lost Block Technique

In this method, all the colors are taken from a single block. Linoleum is the material commonly used. The image is developed by cutting the material back in successive steps, and overprinting, until the final stage is reached. Among professional artists, Picasso has made triumphant use of this technique. Normally, however, it finds its greatest use in primary and secondary schools, owing to its simplicity and directness.

The usual method is to begin by printing the uncut linoleum in a plain color on as many sheets as may be needed. Lines or shapes are then cut from the master block and printed, in register, over the first printing. At each stage, more of the material is carved back, and more of the original surface is consequently lost. Since prints are certain to be discarded along the way, in the process of developing the image, a whole series of proofs may provide no more than one or two completed prints.

But for children, when no commitment to a series of finished prints exists, the method is excellent: simple in procedure, and often giving unexpected rewards in the hazards of random overprinting.

## Registration

Registration is the method whereby the different blocks that make up the image are brought into correct relation; they are then said to be "in register." If one of the blocks is incorrectly positioned, it is "out of register." Where only one block is used for the image — as in the typical black and white print — registration may still be needed to align the print correctly to the white margin of surrounding paper. If the image is designed to fill the entire sheet, and when no margins are intended, the paper is then registered directly to the edges of the printing block.

For hand proofing or the roller printing commonly used in schools by young children, the paper can also be aligned to the block's edge or placed directly on the block, using either a corner register or marked backing. This simple procedure is quickly understood by children, and methods almost as simple can be used effectively by student or professional where hand burnished proofs are called for. Proofing and registration in the professional studio, in any case, must often be done without much preparation, since setting up any process that may be time consuming not only cools, but slows down, the active pressure of

ideas. **Under these conditions, the necessary image is taken from the block only to see what has been done — and with as little practical preparation as possible.**

## Methods of Registration

In the "four color" process and other forms of machine printed reproduction, registration has to be absolutely accurate. The smallest fraction of error leads to the blurred image that appears out of focus. Relative to the photomechanical techniques used in the printing technology, the registration used in printmaking is only approximate. Precise registration, for example, may hardly be needed for the large, broadly carved, hand printed woodcut, while a tightly drawn, hard edge or detailed design, will clearly need tighter registration.

In some forms of printing, the block is placed deliberately out of register. A light printing, placed over an identical dark one — out of register — can produce striking effects of optical relief. This is known as "off register" printing, and can occasionally produce consequences of the utmost interest.

A standard way of obtaining register is to use a backing: this is merely a sheet of stiff paper or cardboard onto which stubs are fixed. Both blocks and paper can be positioned against the stubs, and the different blocks printed in register. In color printing this "register backing," as it is called, should be made immediately after the first block is cut and proofed, allowing you to offset, or counterproof, the image onto any subsequent blocks by the method described earlier in this section, without the deadening labor of repeated tracing. Students, even at college level, are sometimes reluctant to make a register backing. Yet this sensible precaution is certain to save both time and a great deal of wasted effort.

For accurate register, the stubs should be trimmed with an exactly vertical cut, and positioned at right angles to each other at the left hand corner of the register backing and along the bottom edge. Stubs are made from cardboard, hardboard, linoleum, or any convenient material no thicker than the printing blocks; metal strip, cut into sections with snips, is an excellent material. Stubs are fixed to the backing with either glue or scotch tape. In the professional studio, a box of stubs

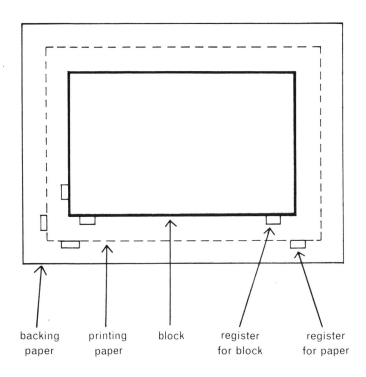

backing paper    printing paper    block    register for block    register for paper

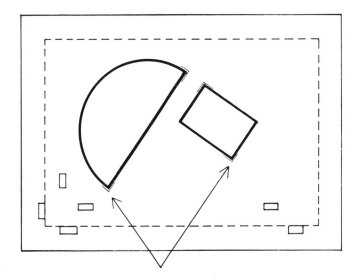

draw marks on backing outside edge
of free form blocks for register

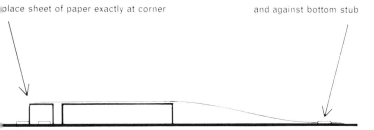

place sheet of paper exactly at corner · · · · · and against bottom stub

*If a thick block is used, put a piece of wood across one side of the register backing, fitting exactly into corner stubs. This gives you a vertical alignment of the register, acting as a guide in placing your sheet.*

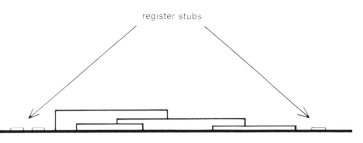

register stubs

*Blocks of various heights can be used for the same image in the open block system, but must be printed separately according to their height.*

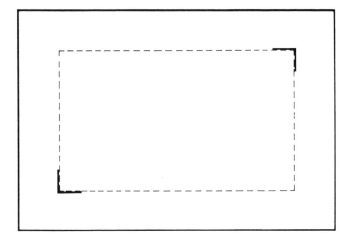

*Simple form of register, suitable for children, consists in marking the backing at opposite corners of the block. The paper is registered directly over the backing by aligning it to the left hand corner and bottom edge.*

is kept within easy reach; the top of the press platen is a convenient place.

For schoolchildren, the simplest form of register is also made with a backing sheet. The block is first positioned on the sheet and the corners are marked with pencil. When the printing paper is laid on the block, the corner and bottom are marked on the backing sheet, or the backing sheet itself can form a register by merely aligning the print to one corner and the bottom edge. In either case, the position of the block must be marked on the backing.

*Vertical register:* This consists in establishing the vertical alignment of the existing register by raising the left hand corner to the height of the block. The diagram shows how this is done.

*Sight register:* Normally in relief printing, the paper is placed on top of the inked block, and the pressure applied to the back of the sheet by hand burnishing, by the press platen, or by whatever form of pressure is used. Sometimes, however, this situation is reversed and the inked block is placed face downwards on the paper by using "sight register." The block, in this case, is merely aligned by sight relative to the surrounding margins of white paper. When more than one block is used, the subsequent blocks are sight registered at opposite corners of the first image. Sight register is of special use where children or students build up large images by repetition, printing and reprinting a single basic block, or more than one, as the case may be. When a complex format is employed, guidelines can be set out on the sheet in pencil. Printing is normally started along a central line and proceeds outwards toward the edges of the paper.

*Japanese method:* In this method, the block is made larger than the image, leaving a margin wide enough to take the Kento, as register marks are called in Japan. An L shaped depression is carved generally at either the left or right hand bottom corner — and a straight lateral cut is made at a point near the opposite side of the bottom edge. The register marks themselves are cut with a vertical stroke, and a flat chisel is used to carve a sloping depression towards the vertical cut. In registration, the paper is pressed against the upright sides of these marks.

*Fixed sheet method:* Two strips of wood, placed at right angles to form a corner, are fixed to a backing. The blocks are positioned by butting them against the strips. The paper is fixed, with pins or scotch tape, to the left hand strip. The paper, thus hinged to the left hand strip is turned down over each inked block for printing, and turned back, away from the block, at the end of the operation. The sheet remains fixed to the strip for any subsequent printings. When it is finally removed, the wide, unequal margin of paper used for pinning or taping is trimmed away.

With a power jigsaw, *it is quite practical to cut the block, leaving projections at one corner and one edge to form a register for printing. The level of these projections is then slightly lowered and cut at an angle with a chisel to avoid inking the projections when you ink the block.*

## Positional Tracing or Overlay

The proof or print is always a mirror image of the original. In the early stages of work in printmaking, the reversal factor is sure to be frustrating. The positional tracing — which is merely a transparent sheet for tracing, marking, or drawing — is the essential intermediary between work on the original design, and work on the blocks. One side of the tracing fits the original or the proofs; the other side fits the blocks. Provided that your own work methods can be adjusted to the use of the positional tracing, the difficulties arising from reversal will be largely overcome.

For traditional methods of color printing, where the image was taken from separate blocks of the same dimensions, the positional tracing was not so essential; but in using a mixed technique or the *open block* method presently described, the tracing can hardly be dispensed with. For here an image may be printed from various blocks of different shape and thickness, free form blocks, found objects, or halftone plates (blocks). The relative positions of each of these elements must be exactly established for proper registration in printing.

Young students can make a positional tracing from thick tracing paper; thin tracing paper is too flimsy for accurate registration. But in the art school, or for professional use, the positional tracing should be made of transparent acetate sheet. The transparent sheet is trimmed to the size of the printing paper, and may be used either to position the blocks, plates, or other elements when the acetate is viewed from one side, or to check the proof when the acetate is turned over and

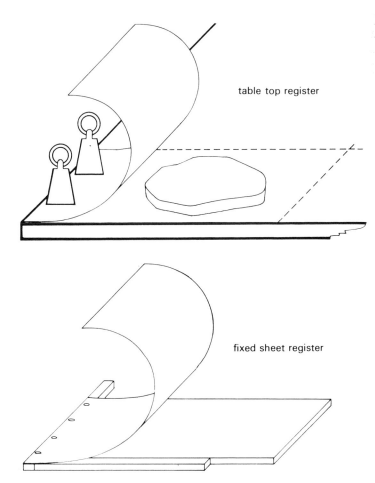

table top register

fixed sheet register

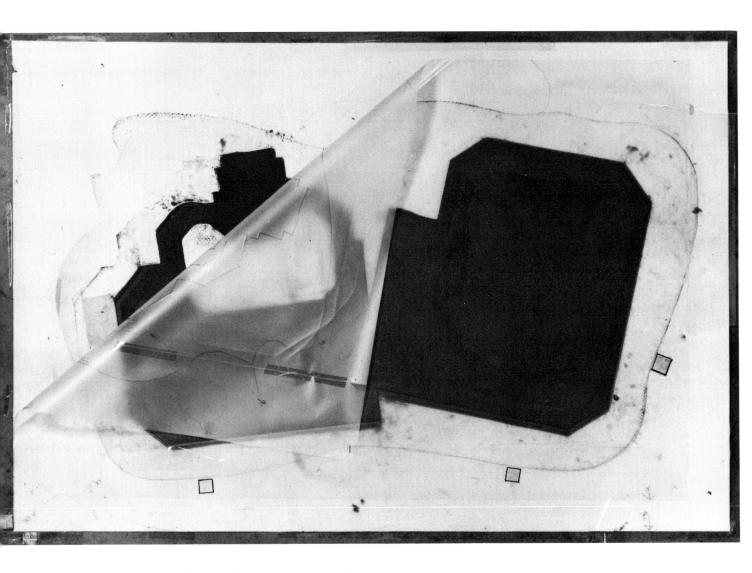

Marking on the positional tracing *(or overlay), controls the position of
the different blocks, in this case two halftone letterpress plates. The
tracing is trimmed to fit the stubs at the left hand corner, and along
the bottom of the register backing. The three extra stubs shown were
used to position a free form linoleum block.*

viewed from the other side. The marking is done on one side of the tracing placed against the proof, which is then turned face down and fitted into the register. The blocks can be maneuvered beneath the tracing until their position coincides with the traced marks. This placing is then recorded on the backing. The acetate should be dull (frosted) on one side, glossy on the other. The frosted side, giving a slight tooth, is used for marking or drawing with ink or pencil.

## Open Block Method

Open block printing has been developed over the last ten years, originally in my studio at Great Bardfield in Essex, and more recently in my larger graphic workshop at Stisted, built some miles distant. But judging by the documents provided by the international print biennials, artists in other countries, almost certainly in Japan, have been devising printmaking systems of roughly similar intent — the intent, in this case, being to import the open ended methods of collage, assemblage, and the combined image more directly into the artist's print.

In evolving the open block system, a good deal of the work has been carried out with the help of students, both in my own studios, and with the assistance of the printmaking group at Camberwell School of Arts and Crafts. From time to time, other schools and colleges have been involved, through both specialized courses and work done in summer schools, notably at Haystack Mountain School of Crafts in the United States and Voss Summer School in Norway.

The open block method has been devised not only to give greater working freedom in the use of hand worked blocks, but also to allow the artist to combine such blocks with other materials of quite different character: "wild" materials, halftone plates, found objects, and so on. The method is also suitable for mixed media prints, particularly those combining relief with photo silkscreen.

In using found or received material, the open block method allows the printmaker to start his design by setting out the needed components — planks, pieces of metal, and so on — directly on a sheet of paper. In many cases, this method should give an immediate indication of the "look" of the intended image. If these components are then separately proofed, and these proofs cut out with scissors and collaged together, a further step can be taken at once in reaching the particular image envisaged. This process of structuring the image by the free arrangement of separate components is, in some ways, analogous to the methods of Anthony Caro, where the sculptor is able to "think" directly in terms of the unedited materials used, and to keep the structure open — able to breath — until his ideas have reached their necessary conclusion. I recall a particular instance when a summer school student used this approach with impressive results. As work proceeded, he placed large sheets of paper on the workroom floor and printed various building boards, long strips of wood, and other elements, to produce an image of masterful size.

But when it comes to editioning, the use of blocks of different surface and different thickness is bound to make the printing itself more complex. The blocks may need setting out separately on the backing and, in the case of wild materials, special printing treatment may be needed. The open block method is shown to be practical enough for small editions, or for runs of limited size, say up to fifty printed sheets (though runs of 200 or more, in as many as eleven colors, have been carried out in my own studio). But on the whole, the care necessary, and the high content of manual processing, make it a comparatively slow printing method. Where open block is combined with other techniques, such as photo silkscreen or photo lithography, the work can, of course, be speeded up, while still allowing direct impressions to be taken from those parts of the image that are to be printed in relief.

Since the process may be a little difficult to understand, I will describe it in some detail. Let me suppose that you want to combine a photoengraver's plate, a piece of plywood, and a plankwood board in the same image. The following would be the steps you would take.

(1) Test the level of the press bed for the first block to be printed. If this is to be the 1/2″ plank, the number of boards on the press bed is adjusted to give the correct printing pressure; but for the plywood block and the photoengraver's plate, which must each be printed

136

Persian Girl,
*color woodcut in divided block technique*
*(18" x 18"), 1967, by Philip Sutton,*
*courtesy London Arts, Inc., Detroit.*

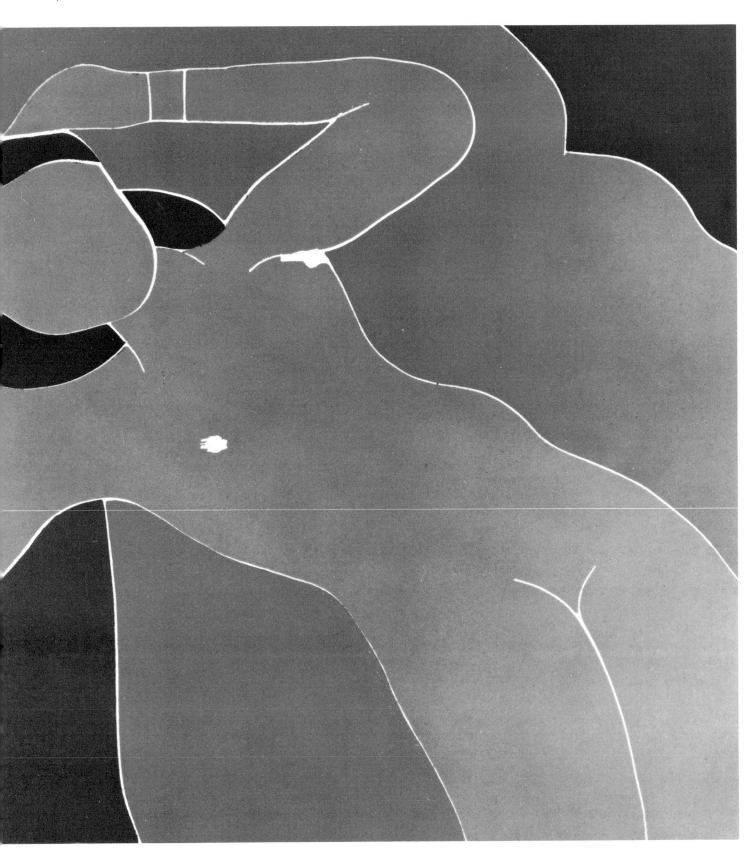

separately, two or three hardboard sheets should be added respectively to bring the bed to the needed height.

(2) Place the register backing on the press. This provides the key to the positioning of the different blocks. I am here assuming that the register has already been marked up by the method described earlier in this section.

(3) Check the thickness and the type of packing to be used. The piece of plywood and photoengraver's block, for example, should need normal packing of, say, four sheets of smooth paper or thin board; but the plankwood block may need a piece of etching blanket if its surface has a strong or irregular texture.

(4) In inking, for printing the blocks, the plywood is likely to need a medium inking with a roller of medium softness — or medium "shore" to use the technical term. The photoengraver's plate will need a stiffer ink, thinly spread with a harder roller; the plankwood block will need a medium inking with a fairly soft roller. With care, it is still possible to ink all three blocks with a medium roller; but here, for the sake of correctness, I am setting up the sort of high-standard technical situation found in the well equipped art department where a number of different rollers and inks are held in stock.

Blocks of different heights, or blocks that call for different types of packing, will always need to be printed separately; but it does not matter if you start the printing with a thin block, such as a photoengraver's plate, or a thick one, such as a piece of plankwood. Your decisions with regard to the *order* of printing will be made on other grounds. Light colors for example, may need to go down first on the sheets, so the blocks or plates for these colors will be the first to be printed.

The open block method is likely to prove of particular worth in schools and colleges, since the student has often much to gain from an exceptionally open form of study, and the use of materials in great variety. In the course of this work, the student makes many discoveries. For one thing, he will find that an enormous range of objects can be printed, objects never before thought of for this purpose. He may indeed have the luck to stumble on a new order of response within himself, to open up an unexpected dialogue between his materials and powers

of conceptual thinking. Should this happen, his walks in the country or along the seashore will take on a new character. His eye will be alert and searching for objects and materials — even for fragments glued to the city pavement under hurrying feet, or flattened on the highway beneath the screaming tires of passing trucks.

**Divided Block Method**

The divided block technique is used for printing several colors from a single block at one operation of the press. The principle consists in dividing the block along the contours of the different color areas, so that each color area can be inked separately, and reassembled for printing. In theory, a hundred piece puzzle could be printed in this way; but in practice, the method has a much more limited application, since few images break down naturally into distinct and separate fields of color. Within its limitations, however, the method has certain advantages. There are no registration problems. Properly cut apart with a jigsaw, or with some other tool, the block can be accurately reassembled. Inking the separate sections of the block, with the needed colors, is also a straightforward operation. Cut from a single piece of material, moreover, the different sections share the character of this surface — in the case of wood, a lineal structure that may flow over the whole face of the block.

In the past, wood has been the preferred material; but metal sheet, linoleum, hardboard, plastic, and cardboard are all practical materials to use. The electric jigsaw is an effective tool for cutting wood. In using plywood and blockboard, there are no problems of cross grain splitting. Thinner materials can be cut with scissors, or with a knife; metal sheet can be cut with snips or with the electric jig.

In printing a divided block made from any heavy material, such as a thick wooden plank, the "vertical" register is used, as described earlier in this section; or the block can be shaped to leave projections (at a lower corner and the bottom edge) to align the margins to the block itself. When no margin at all is needed, the paper is registered directly on the block, at the left hand corner and along the bottom edge.

Edvard Munch is the outstanding exponent of this

Two Cultures,
*intaglio and surface print
from built up metal plate
(30" x 22"), 1967,
by Agathe Sorel.*

method. The blocks, in his case, were cut either from plankwood — often the thin sheets then used for mirror or picture backs — and more occasionally from plywood. The cuts are made chiefly with a round gouge, and the blocks appear to have been divided with a fretsaw. The turns and angles of the contours are sometimes too sharp to have been cut with a hacksaw.

## Caustic "Etching" on Linoleum

I gave some account, in an earlier book, of what was then a new technique: etching on linoleum. The process owed its discovery to the fact that my wife had cleaned the shelves of the cooking oven with a patent cleaner, and left them on a linoleum covered table top to drain. On wiping the table clean, an hour or two later, we found a number of clearly etched drip marks on the linoleum. The cleaner, it appeared, had contained a high proportion of caustic soda.

Since then, the printmaker and teacher, Trevor Allen, has carried through a research program into this technique, working with his students at Brighton College of Art. This exercise has been very complete; I have used the Brighton research material throughout this section. Trevor Allen himself supplied a set of notes for this text.

Caustic soda (sodium hydroxide) is the effective agent in etching linoleum. This alkali attacks the oily content of the linoleum, eating away the smooth surface crust, leaving a slightly lower plane of rough grained texture. The depth of the bite depends upon how long the caustic is left to attack the material before being washed away. Inked with a roller, the bitten surface of the lino prints much like a coarse aquatint; the deeper and more open the bite, the lighter the tone appears on the printed image. Trevor Allen has found that the bitten lino could also be used for intaglio printing, relating the process more directly to etching on a metal plate.

Allen experimented first with conventional forms of resist to fix his image on the block, employing materials such as the quick drying varnishes used in etching. These were found unsatisfactory, largely because a thick varnish — even a quick drying one — applied to an unheated surface is always slow to harden. He next tried working with wax crayons and these, he found, made a more effective resist. Ordinary household candles proved a readily available source of wax; these he melted down in a saucepan, applying the mixture directly to the linoleum with a brush — much as batik designs are "painted" on cloth. Now Allen has established heated paraffin wax as the standard resist in using caustic for the printmaking courses at Brighton College of Art. The hot wax is normally applied to the lino with house-painters' brushes of various sizes. After use, the brushes need not be cleaned; the wax left in the hairs melts on reheating, and mixes with the fresh wax prepared in the saucepan.

Very fine lines can be etched by using an engraving tool to cut through the wax. At the other extreme, very coarse lines can be made by using a blunt ended tool to clear a channel through the wax.

Allen believes, with some logic, that the use of caustic and wax is of considerable importance to printmaking, since the application of wax with a brush wins back something of the gestural freedom of the painted mark.

*Preparation of the block:* The lino should first be thoroughly cleaned by wiping the edges and surface with a rag soaked in denatured alcohol (methylated spirit). Elmer's glue, Unibond, or some other form of white glue, mixed with a little water, is next applied to the underside and edges of the lino. You should make sure that the burlap (hessian) backing is thoroughly impregnated with the glue. Once dry, the coating will be hard and transparent, an effective protection against foul biting.

*Mixing caustic (sodium hydroxide) and water:* Measure sufficient water into a plastic or polyethylene (polythene) beaker, or an old glass jar; an average quantity would be three or four tablespoons. Now add the sodium hydroxide, a single spoonful at a time — stirring the flakes into the water. Add caustic until it becomes slow to dissolve; this will indicate that the mixture has reached the state of a saturated solution. The chemical reaction of sodium hydroxide to water causes the mixture to reach a high temperature. It should be left to cool before use. Finally a little denatured alcohol (methylated spirit) is added to allow the mixture to spread evenly when applied to the linoleum. A saturated solution of sodium hydroxide constitutes a powerful etching agent; it will attack hardboard quite as effectively as linoleum.

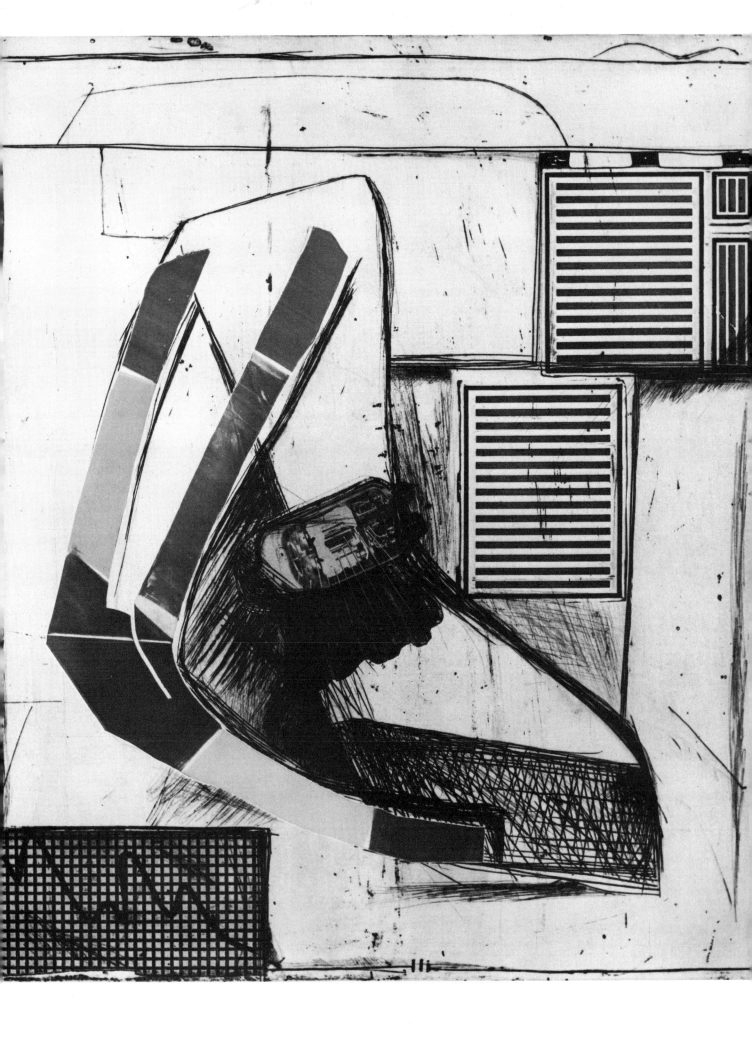

*Preparation and application of the wax:* Allen uses ordinary household candle wax, melted in a saucepan. While working on the lino, however, he finds it convenient to employ only a small quantity of wax, held in a lead ladle, at any one time. The brush is dipped into the wax — which should be very hot — and painted directly on the linoleum. While in use, the wax must not be allowed to cool: it will turn opaque, should this happen, and fail to adhere properly to the block, allowing the caustic to run under the wax and attack the surface beneath.

If a quick drying varnish is used instead of paraffin wax, it should contain no alcohol (methylated spirit). Extremely fine lines can be drawn and etched through this type of resist.

*Applying the caustic:* With the application of wax, the block is ready for etching. To prevent accidents, place the linoleum on a sheet of plate glass, a polyethylene (polythene) sheet, or inside a large acid etching tray. The caustic is applied liberally, using a nylon brush or a fragment of absorbent cotton (cotton wool) or lint, fastened with a rubber band to the tip of a stick. While using the caustic, you should wear rubber gloves, protecting the skin from the possible burns caused by splashing or stray drops. Carelessly used caustic soda can be dangerous, producing severe burns, and care should be taken in using it. For this reason, the technique described is quite unsuitable for work in younger groups. If caustic comes into contact with the skin, the hands should be washed immediately with soap and warm water.

*Controlling depth of bite:* A shallow bite — one that gives a halftone or aquatint effect — takes two or three hours; a deeper bite takes four to six hours. A very deep one will need a whole day, or should be left overnight. During a long etch, the action of caustic grows progressively weaker. It is advisable to wash off the tired caustic from time to time and apply a fresh solution. This should be done with great care to avoid harming the wax resist. With warm water, the old caustic is gently removed, using a swab or soft brush. Any remaining liquid is dried off with blotting paper, and fresh caustic is applied. It is not easy to check the actual depth of a given

bite without printing the block, since different types of linoleum differ considerably in their reaction to caustic. Old, hard lino, for example, is more difficult to bite than the softer body of new material. However, if an area of the surface is rinsed, blotted, and tested with the fingertip, the tooth or roughness felt will give an approximate indication of the depth of bite.

*Cleaning the block:* Immerse the block in a sinkful of warm water and use a plastic scrubbing brush, or nylon toothbrush, to wash away the caustic. The scrubbing should be done vigorously, changing the water as needed. The loose grains of linoleum will cloud and discolor the water as they come away from the block. Once the eroded linoleum is completely cleaned away, the wax can be melted off with a blowtorch (blowlamp) or propane torch at low pressure. Finally, while the block is still warm, it is rubbed over with mineral spirit (turpentine substitute or white spirit).

*Inking and printing the bitten block:* For surface printing, the etched block is inked in the normal way; but if the etch has a fine tooth, a soft roller should be avoided.

An etched block can also be printed for intaglio; in this case, the ink is forced down into the tooth of the etched portion by dabbing with a tampon, with a pad of rag, or with etching gauze. To print effectively, the tooth or grain of the block should be filled with ink, while the surface should be wiped clean with the palm of the hand, with a pad of rag or gauze, or with a piece of tissue paper, in the final stage of cleaning; this is a similar method to the one used in printing an etched metal plate. If a stiff ink is used for the intaglio, and a thinner one of different color for a surface inking, both colors can be printed simultaneously in the press, as in the now traditional method devised by S. W. Hayter. It is obvious enough, however, that linoleum, being flexible, lacks the precision possible with the metal plate. Intaglio work on linoleum is still largely in the nature of research. It is difficult, at present, to assess the consequences of the Hayter technique as applied to this medium.

Where both intaglio and surface inking are used together, the medium oil, added to the surface inking, will give sufficient viscosity and prevent the second inking from picking up color from the intaglio areas. But if

three colors are to be used, the block itself should be bitten in three different ways. In addition to an intaglio area, Allen has succeeded in biting and printing two separate levels: a lower one designed to be inked by a soft roller, and an upper one, receiving ink from a hard roller. In printing this type of block, a stiff ink is first stippled into the intaglio with firm dabbing or rotary gestures, and the surrounding surfaces are wiped clean with the hand or with tissue. The second color, mixed with added medium oil, is now rolled over the surface, using a large, soft roller, spanning the width of the block, and of sufficient diameter to cover the whole area in one rotation. (If the roller is taken again over the surface, the two films of ink are more likely to mix.) Finally the topmost portions of the block are wiped clean — and the third color is added with a hard roller, using a stiff ink.

In inking for intaglio, the linoleum can be gently warmed to soften the ink.

The paper must be dampened for this form of printing. A piece of soft etching blanket is used in the press, above the block, to give added flexibility and "squash" to the packing.

The dabbers, or tampons, can be made from old etching blankets cut into strips, 4" or 6" wide. These are tightly rolled and secured with string, bound round the blanket, an inch from either end.

*Special items needed for caustic etching* include the following:

A gas ring with two burners

Polyethylene (polythene) beakers

Plastic or nylon pastry brushes

Plastic or nylon scrubbing brushes

One or more lead ladles

Caustic soda (an alkali)

Paraffin wax

Elmer's glue, Unibond, or a similar white glue

Plastic spoons

Denatured alcohol (methylated spirit)

Protective gloves

## Deep Etch Metal Relief Blocks

If large surfaces of a metal plate are etched away in some depth, the result will be a metal relief block that can be surface printed, much as a woodblock is printed. Zinc, copper, soft steel, and stainless steel have all been used for this type of etched block. With all of them, however, a difficulty remains: to bite the metal to a sufficient depth, the acid must be strong; hence the resist used in making the plate tends to break down under its attack. The metal must also be left in the acid for some considerable time, since the relief must be relatively high to take a surface print. A 16 gauge plate, for example, will need to be bitten down to roughly half its thickness.

Zinc is a good material, since it bites in acid more quickly than most other metals; copper bites more slowly than zinc, but should give a fairly dependable result. Soft steel, stainless steel, and iron have also been used.

The method is to coat the plate with a resistant varnish on those parts of the metal that are to be retained as its printing surface. The strongest obtainable resist should be used, and those based on asphaltum varnish are generally considered the best. The metal must be scrupulously cleaned with a grease dissolving agent, such as mineral spirit (white spirit), and finally wiped over with denatured alcohol (methylated spirit). The image is then painted on the surface with asphaltum varnish; the ordinary liquid hard ground used for etching, which is basically asphaltum, is convenient to use. The back and edges of the plate should also be protected from the acid. The printmaker, Buckland-Wright, considered that Dutch mordant and perchloride of iron are the safest acids, as their action is slow and gentle. Perchloride of iron can be used at full strength; but the plate is placed face downwards in the bath to allow the sediment to drop out. Nitric acid is used in the proportion of two parts water to one of acid, or a weaker solution if the varnish shows any tendency to break down.

The commercial platemaker (blockmaker) employs a method known as four-way dusting, using a powder known as dragon's blood to dust across the plate in four different directions during the process of biting. This is to give extra protection to the resist, and prevent the bite encroaching on the lines making up the image.

Metal plate, polished and prepared, can be bought from the printmakers supplier, but the cost is fairly high. If unpolished metal is practical to use, this should be obtained direct from the metal supplier; but the gauge of sheet should be stated. For a relief print, 16 gauge is a good medium thickness; 20 is a rather thin one, only suitable for work on a restricted scale.

## Built Up Metal Relief

Another type of block is made by building up from the surface of the metal plate. This is done by using industrial resins, such as epoxy, to bond together various pieces of sheet or other metal components, aluminum foil, brass sheet, wire mesh, expanded metal grids, etc. These are all easily cut with tin snips and, once attached to the plate, will form a base for engraving, punching, etc. Thin, 30 gauge brass sheet is obtainable in rolls 6" and sometimes 8" in width; this will cut as easily as paper, and can be bent or interwoven before attaching to the plate.

For a "positive" stencil to print in color, separate pieces of metal sheet can be inked up and merely placed in register on the plate beneath.

Variously patterned, perforated, and stamped aluminum and copper sheet can be used where small repeat systems are wanted. Many such pierced and expanded metal grids are produced for television and radio equipment. Sheet metal repeat systems are widely used in industry for grading different products: fruit, potatoes, coke, etc. Made from steel sheet, they have hole, slot, and slit systems in every conceivable combination. Those printmakers specially interested in multiple repeat systems should certainly try to get a comprehensive catalogue of these remarkable products, though manufacturers often tend to be tardy in sending them out to the individual buyer.

Epoxy resin can also be spread directly on the plate to form an adhesive plastic base for working thin aluminum sheet, such as kitchen foil. If the plate is slightly heated, the resin rapidly becomes more plastic. The foil can be manipulated with the hand and fingers, or scored with a point, and will also accept the impress of almost any small, flat object.

To give a full relief, metal blocks of the kind described are printed with several layers of soft blanket on the etching press. In assembling metal sheet or other components on the plate, care should be taken to avoid rough edges, or too abrupt changes of plane, that may well tear the sheet or damage the blankets as the plate passes through the press. The platen press will also print an image from these blocks, but a thicker inking is necessary, and a layer of some resilient material — foam rubber sheet or blanket — should be used for packing. This method, known as "soft pack" printing, is described in more detail in section 10. The paper may need dampening before use, whichever type of press is employed.

For inking the built up block, a soft roller is used, since its surface should be flexible enough to adapt itself, to some extent, to the changes of level on the surface of the plate.

## Built up Relief on Linoleum

Built up relief has two distinct aspects; blocks can either be coated with a plastic material — a substance that can be shaped or molded to provide the relief — or covered with more structural materials, such as metal plate (a subject discussed in the previous section).

With regard to relief where a plastic substance is used, we approach a subject of some difficulty. Since its inception, this type of block has led to effects that are often foreign both to the carved or engraved nature of the relief block, and to its structural character; I refer to those prints whose only interest — if one can call it that — is based on the exaggerated use of texture.

Though I have since given up this method, some of the first editioned plastic relief blocks produced in England were made and printed in my own studio around 1955 — though it was likely that many artists would have recognized, at about this time, that blocks could be made by applied or built up surfaces as legitimately as by cutting or engraving into the body of the material. Certainly in etching, with the use of wire and metal sheet soldered to the plate, some such development had already taken place with the work of Rolf Nesch in Scandinavia, and certain engravers working in Holland, and no doubt elsewhere.

For my own blocks, plaster of Paris and carpenter's glue were mixed into a stiff paste and spread over the uncarved areas of the linoleum with brush and palette knife. To do this, carpenter's glue (animal glue) is melted down in a double boiler (one saucepan inside another that contains hot water, or better still, an ordinary carpenter's gluepot) and the plaster is slowly added until a workable consistency is reached. While it is being used, the mixture should be kept warm. In a few hours, this glue and plaster "gesso" dries to a hard, hornlike surface which can then be sandpapered, scraped, or scored in the final stages of work. The surface dries with a distinct tooth, and should be lightly sandpapered before inking up.

Glue gesso is a rather primitive method. Since 1955 (when the technique described was used) many more practical materials (such as acrylic modeling paste) have come into the market, and are easily obtainable from artists' supply stores. The essential point is that the block should be absolutely clean before any of these materials are applied. Normally, the surface should be scrubbed with hot water and scouring powder; finally, a coarse grade of sandpaper can be used, giving an added tooth.

### Built Up Relief for Children

In the hands of young children, built up relief has obvious advantages. The method is attractively simple and direct. Every sort of material can be employed. Plastic glues will combine almost any materials used; leaves, feathers, string, pieces of leather, cardboard, metal foil, wood veneer, etc. Fragments of this kind can be collected anywhere; from the attic, backyard, beach, forest, farm, or city building site.

The section on soft materials hardened in section 6 describes how textiles can be toughened to the point which makes a printed impression possible. The P.V.A. adhesives, Unibond, Elmer's glue, and other white glues are capable of sticking any absorbent material to a backing. They are also fairly clean to work with. For older children, resin glues can be used for built up blocks where tougher materials are likely to be employed — such as sheet metal, wire netting, and small machine parts. The method is to glue the objects to a cardboard, hardboard, or plywood backing, taking care to keep an

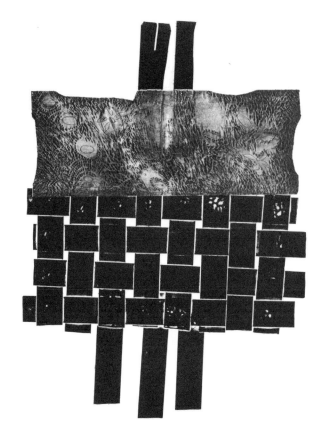

The Artist's Skin, *intaglio and surface print (30" x 22"), 1965, by Agathe Sorel.*

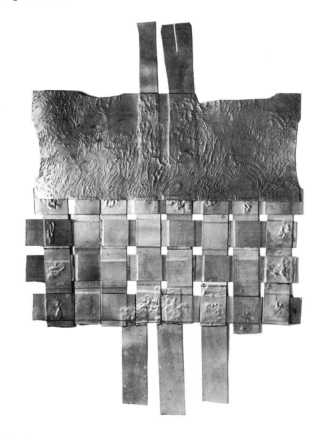

Metal plate, *partly made of interlaced brass sheet for printing in both intaglio and relief, by Agathe Sorel.*

over-all surface of low relief, with no particular component projecting too abruptly from the general level. Such blocks are printed by hand burnishing, or in a press, if their surface is sufficiently level.

In this method, choice is so wide that it is best to guard against diffusion of ideas by condensing study around a series of specific objects or materials. The teacher's job is to set a sequential scene, helping the child or the student to relate one thing to another, and to articulate the different stages of work into a related sequence. A set of studies, for example, could be limited to images printed from various types of packaging, using foil, paper, cardboard, and plastic containers to build up the block. Prints from flattened out cigarette packages or opened out cartons take on distinct and novel shapes, forming an image capable of making sense both as design and (in this case) as social comment. Other studies for young children could be based on blocks made from small machine parts taken from discarded mechanical toys, construction kits, or broken clocks; others, again, from some particular type of found material — different objects taken only from the beach, for example, or from a farm, or machinist's or carpenter's workshop.

## Printing From a Latex Rubber Cast

For several years past, Tadek Beutlich has been well known for prints in which large pieces of wood and other materials — generally of big and irregular format — have been directly and boldly used to structure his image. These fragments gave a powerful and organic surface to the film of printed pigment. Now he has devised a most original method of working from these wild materials, using a latex rubber cast for a new method of relief printing. For this purpose, a layer of liquid rubber (latex) is poured over the surface to make a negative cast. At normal temperatures this sets in a matter of four to six hours, when a second and thicker one is poured over the first. This second layer is poured shortly after the first has set, or at least within a few hours. (If two or three days pass before the second application is made, the two coatings refuse to meld and can be pulled apart.) On average, Beutlich finds a layer of Latex 1/8″ to 1/4″ makes a cast thick enough for printing. Taken directly from a surface, this sort of cast produces a negative impression of that surface, the raised forms of the original becoming depressions on the cast. The printed image taken from such a cast is thus a reverse image. If, on the other hand, a positive impression is needed, a positive plaster cast is made from the negative latex one.

The small divisions and cracks found in wood and other open surfaced materials may cause the latex coating to stick, making removal difficult. In this case, a layer of plasticine is first pressed into the surface, forming the negative cast, and from this a positive latex impression is taken. Sometimes Beutlich places the material to be cast in wooden trays, pouring the latex in two stages, until the coating is level with the tray edges. The leveling up of the material means that the final cast, when reversed for printing, stands level on the printing table, or on the bed of the press, giving a more convenient surface than the first method described.

The printing paper is placed on top of the inked cast, and rollers of various size and weight are rolled over the back of the sheet to take the impression in Beutlich's very personal method of printing.

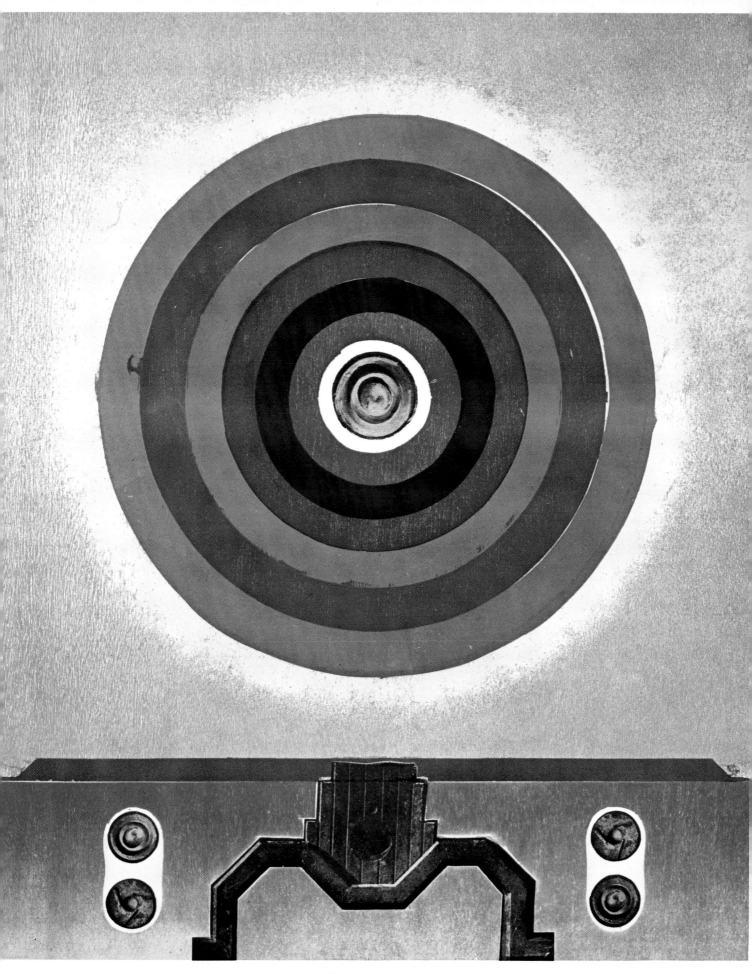

Circle (Black Centre), *mixed media (30" x 23"), 1968, by Michael Rothenstein.*

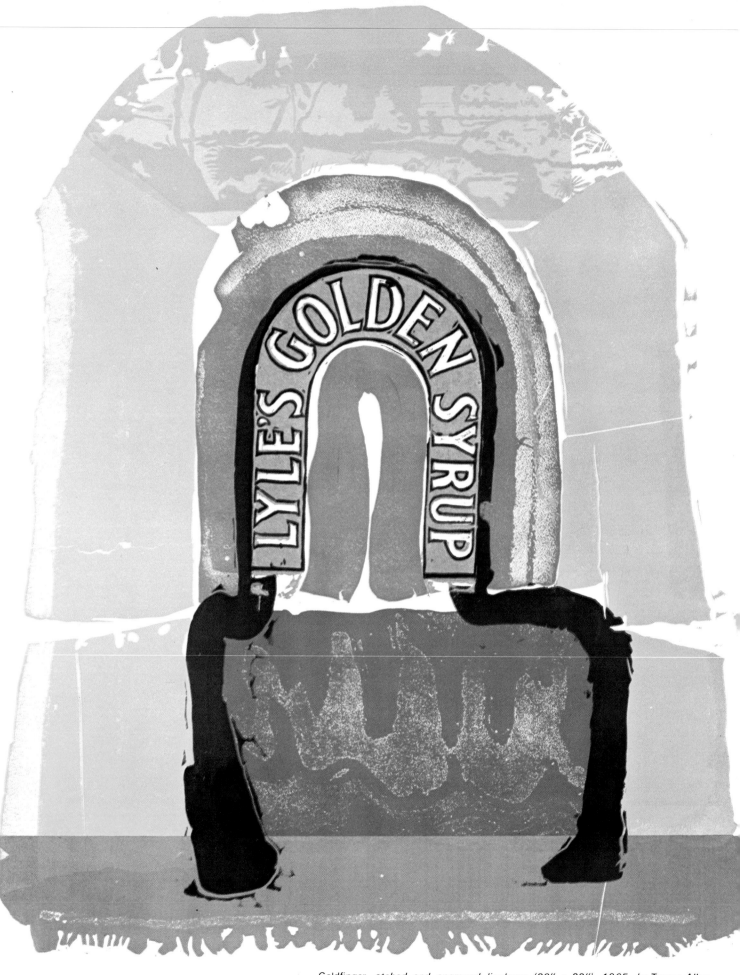

Goldfinger, *etched and engraved linoleum (30″ x 22″), 1965, by Trevor Allen.*

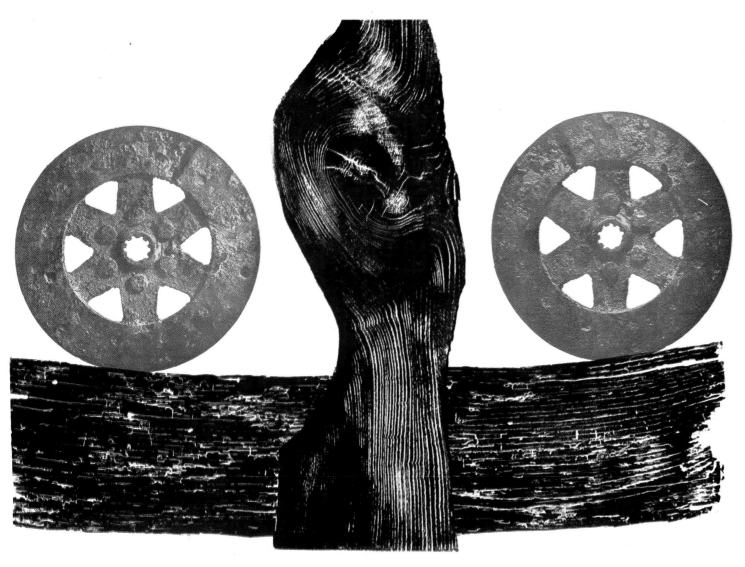

Red Wheels, *woodcut and letterpress halftone (23  1/2 x 34''), 1968,* by Michael Rothenstein.

Wittgenstein in New York, *photo silk screen (32″ x 22″)*
*from* As Is When, *1965, by Eduardo Paolozzi.*

Fauns and Goats, *linoleum engraving in four colors (21″ x 25 1/4″), 1959,*
*by Pablo Picasso, courtesy Mr. and Mrs. Norton Simon, Los Angeles.*

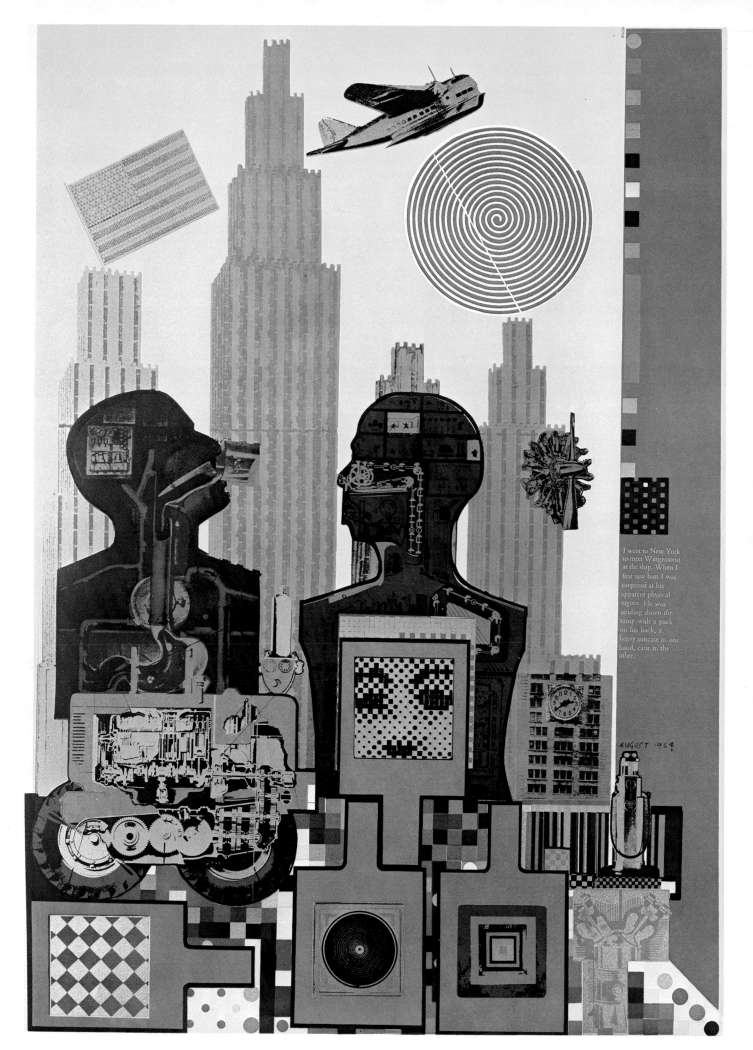

I went to New York to meet Wittgenstein at the ship. When I first saw him I was surprised at his apparent physical vigour. He was striding down the ramp with a pack on his back, a heavy suitcase in one hand, cane in the other.

AUGUST 1964

Circle (Violet and Yellow), *mixed media (30" x 23"),*
*1969, by Michael Rothenstein.*

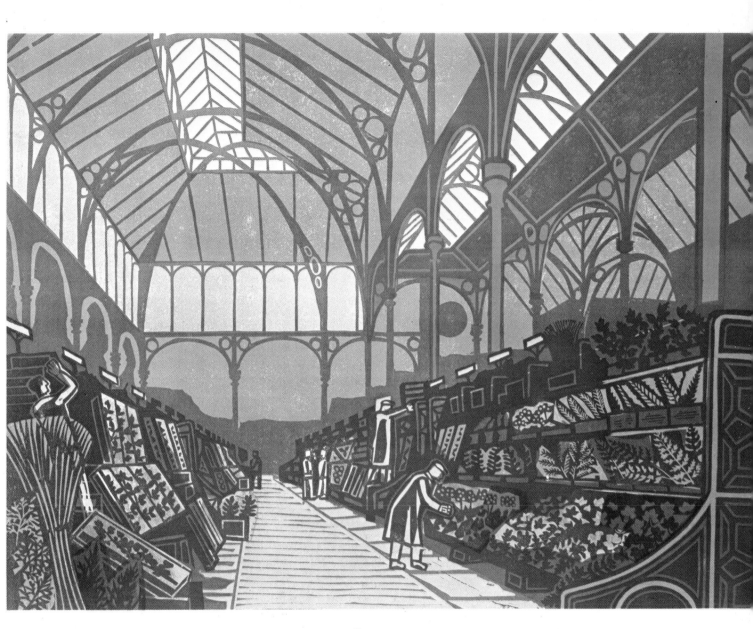

Covent Garden, *linoleum engraving (18" x 24"), 1967, by Edward Bawden.*

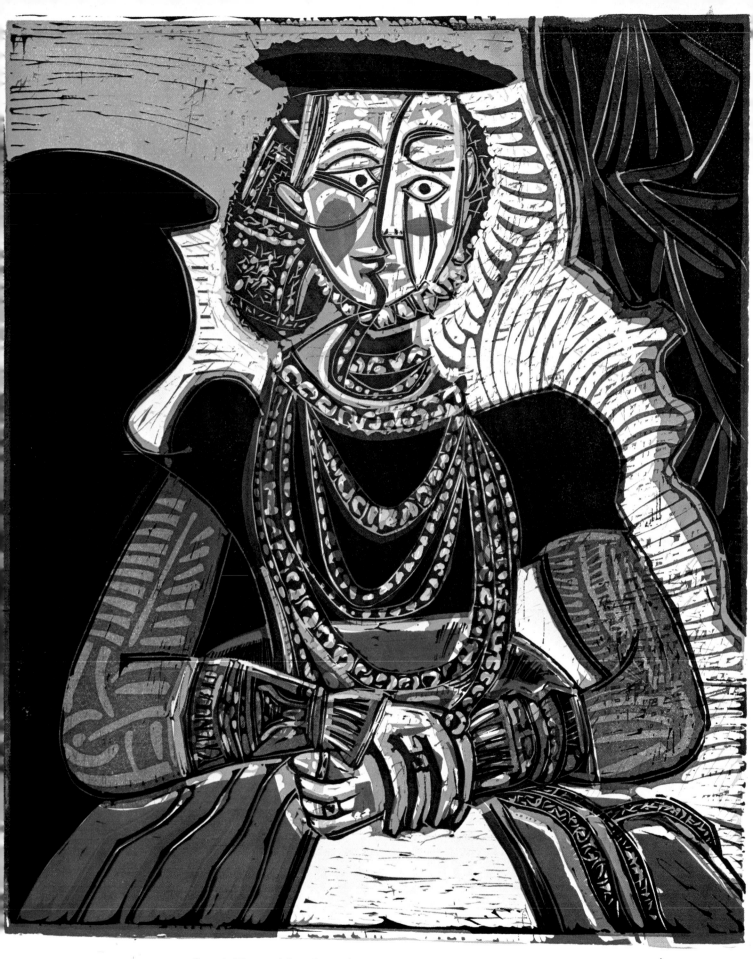

Seated Woman (after Cranach), *linoleum engraving (30 1/4 x 22 5/8")*, 1958, by Pablo Picasso.
*Collection The Museum of Modern Art, New York, gift of Mr. and Mrs. Daniel Saidenberg.*

# 8

# PAPER

The "invention" of paper is — perhaps arbitrarily — credited to a Chinese court official, Ts'ai Lun, a eunuch, in the year A.D. 105; but for many hundred years, writing had already been recorded, with dyes and pigment on barks and grasses, materials we may consider already closely related to paper. Centuries later, with the development of the powered press, and the rapid growth of machine-print technology, paper was needed in enormous quantities; the original materials used in the orient and later adopted in the west, linen and cotton rags, became quite inadequate as a source of supply. Hence, early in the eighteen hundreds, the search for new sources of vegetable fiber became intense. But wood pulp, the main material for paper, was hardly produced in quantity until the middle of the last century.

## Sources of Paper

Few trees and plants provide cellulose in economic quantities for paper making. The plants are flax, hemp, jute, sugar cane, straw, esparto, and cornstalks. The trees are spruce, balsam, fir, jack-pine, hemlock, southern pine, poplar, and cottonwood. Cotton and linen give the most lasting fiber; chemically processed wood pulp, straw, and mechanically prepared wood are favored in that order. European handmade rag paper — and more recently, Japanese handmade paper — is generally favored by printmakers in the west. Many Japanese papers, however, are difficult to get, while supplies of handmade European rag paper get scarcer year by year. The printmaker is thus driven to seek other sources of supply (such as the filter papers made for industry) and to look again at some of the better machine made products.

It is not easy to assess the relative qualities of the handmade sheet, individually formed in a mold, with machine made paper, flowing forward in a continuous web. A main advantage of handmade paper would appear to lie in the small quantity of carefully prepared material used at any one time, as against the bulk quantities that feed the machine. Dard Hunter believes, however, that if a machine were loaded with an identical material to the pulp used for handmade paper, the machine might well produce the same strong, long lasting material of the handmade sheet.

It is doubtful, in laboratory testing, if the effects of time and environment can be fairly simulated. In judging paper endurance through the centuries, we have only the evidence of the ancient trade. In the main, modern machine made papers are overcharged with additives, with bleach and chemicals, for rapid and cheap operation. Their structure, on the other hand, has a more perfect and regular formation than, say, paper made by hand in the fifteenth century.

## A Note on Permanence

The idea of permanence, relative to the handmade sheet, has sometimes been given an importance it hardly deserves. Even a paper of average quality is likely to carry the artist's message over many generations. I have, for example, a collection of children's drawings, both in color and black and white, made in the sixpenny and twopenny drawing books of fifty years ago. But the paper, a cheap cartridge stock, remains in excellent condition. If even these poor wood pulp papers are kept with reasonable care — and rough handling, a damp atmosphere, and bright sunlight are all avoided — I believe that they are capable of lasting for many years. It is certain that the better qualities of machine made paper will have a far longer survival value. Improvements in photo-reproduction, color slides, and finally the "photo information banks" already in sight, are certain, in time, to alter our attitudes to the uniqueness of an "original print." Even supposing that some outstanding talent produced all his images on the poorest woodpulp paper, the increasing excellence of photo-technology could still preserve almost everything of value. If a work of exceptional fragility is highly valued, the museum, in any case, will take exceptional measures to safeguard its preservation. Prints, moreover, with their high definition, reproduce more faithfully than oil paintings, where the directional impasto in the pigment itself is impractical to translate in a flat reproduction.

Wood pulp paper is chiefly used for printmaking in the form of newsprint. It is so cheap that schools can absorb reams of this material without much expense. Better qualities of paper — such as study drawing (cartridge) paper, and offset printing stock — are widely used for proofing in the professional artist's studio and for runs of student's prints. But these materials are not normally employed for relief print editions. Japanese and European handmade, mold made, and other machine made rag papers make up the bulk of all workshop editions of artists' prints at the present time.

The paper industry, with the enormous demands made upon it, becomes more sophisticated year by year; its technicians are constantly devising more "elegant" combinations of the basic materials, with bleachers, coatings, and other additives to make a stronger, whiter, more opaque and durable sheet. Increased whiteness, for example, may be attained (as it is in laundry work) with the addition of blue, and occasionally pink, to the bleach to alter the natural grayness of the pulp.

## Types of Paper Used

In relief printing, ink is transferred to paper by pressure: either by hand pressure, by the force of the press platen descending on the block, or by the action of a roller, as in the proofing press. Since only thin films of ink are normally used, leaving the white paper partly exposed, the paper itself must be considered an integral element of the print. The clarity of the printed image will depend on the softness, whiteness, absorbency, and smoothness of the paper. Any sheet possessing these qualities is likely to be excellent for your purpose.

Four types of paper are used in relief printing: handmade European, handmade Japanese, machine made rag for editioning; and machine made wood pulp papers for many general purposes, such as trial proofs. But many machine made papers, hardly exploited till now, are proving of increasing interest to the printmaker.

As the present generation of skilled paper makers die out — the "vatmen" and "couchers" who form the handmade sheet — few young men are trained to take their place. The printmaker, in consequence, must turn to other sources for his material, such as machine made rag paper, high quality mold made paper (cartridge), and so on. The cheap ground wood papers, such as newsprint, are used for a dozen

humble, but valued purposes in both the print studio and the school; and between them, many good machine made papers find a place for proofing and students' editions.

## European Handmade Rag Paper

European handmade paper, together with high grade Japanese paper, is still considered the finest material for editioning. It is expensive and is becoming difficult to get. In the best papers, only white linen rag and cotton rag are used. The sheet is formed either in a hand held mold (handmade) or in a machine operated mold (mold made). The material, made from unadulterated plant fiber, is shown to have great strength and remarkable lasting properties.

The process involves boiling and macerating the rag, while leaving the fibers long enough to form a tough, durable sheet. A wooden mold with a wire mesh floor (or "cover") is then dipped into the liquid pulp contained in the vat. A sheet is formed by shaking the mold. Once the pulp is partly set, the mold is turned over, leaving the newly formed sheet to drain on a layer of felt. The sheets of paper, formed into a pile interleaved with felt, are next subjected to great pressure, which squeezes out excess moisture. It is next left to dry, hung up on ropes inside a ventilated drying loft.

## Sizing

At a later stage, the sheets are sized, the amount of size determining the hardness or softness of the sheet. For handmade paper, only animal size is used: size, that is, from the hides, skins, hoofs, or bones of various animals. Like carpenters' glue, pearl glue, or rabbitskin glue, this is a water soluble material of great strength. The best paper is tubsized; this may be indicated in the maker's list by the letters TS or ATS (to denote "animal" tubsized). The paper chiefly used in printmaking remains unsized; this is known as "waterleaf" in the case of the handmade sheet; other papers used have a low size content and are known as "soft sized."

## "Hot Pressed" and "Not" or "Cold Pressed"

Finally, the sheets are placed between highly polished plates, and pressed with heavy metal rollers. For the smooth finish favored in printmaking, the paper is "hot pressed," the plates, in this case, being steam heated before the sheets are put between them. This grade is known by the initials "H-P"; the rougher grades, not subjected to this process, are known as "not" or cold pressed. The "not" indicates that no hot pressing was involved in the final stage of manufacture. The "not" surface is the familiar, textured roughness of many watercolor papers.

## Laid and Wove

The body structure of handmade paper is either "laid" or "wove". A laid paper is made in a mold where the brass wires, forming the "cover" of the mold, run parallel to its length. Faint lines may show on the surface of the sheet; or lighter strips may show in its body when held against the light. Wove paper, on the other hand, is made on a cover of woven wire and no directional texture will show on the sheet. If the paper is watermarked, the watermark, too, will have been formed in the sheet by a wire figure or symbol stitched to the cover, and these too will show as lighter tone when held to the light.

## Fiber Structure

In the handmade product, the mold is shaken in four directions, causing the fibers to cross and recross in the body of the pulp. In the machine process, the wire web that carries the pulp is shaken only from side to side; hence the fibers lie in a more uniform direction. The machine made material, in consequence, has a directional structure and will tear more easily *with* the grain than *across* it. The handmade sheet, in contrast, tears evenly in any given direction.

## Japanese Handmade Paper

Japanese handmade paper is made from vegetable fiber supplied by the inner bark of various trees: the kozo,

gampi, mitsumata, etc. These papers are made in hand molds with a bamboo, grass, or hair cover, replacing the brass wire used in Europe. Outside Japan, I doubt if any paper makers have such consummate skill in mixing the pulp with colored threads, plant seeds, straw fragments, or fragile wisps of many other materials to vary and enliven the surface of the sheet. The plain papers, however, are normally those most useful to the printmaker; and here the Japanese are able to make light, smooth, silky paper, while preserving long, strong fibers in the body of the sheet.

Four main types of plant material are used: the kozo tree, whose inner bark gives strong, malleable, and absorbent fibers; the mitsumata, another Japanese tree, offering a soft and absorbent fiber; the gampi, a shrublike plant with a strong, but less absorbent fiber; and finally woodpulp, from western conifers. This is employed to make the paper soft, thick, and pliant.

Kozo, in combination with wood pulp, is used for the fine Hosho papers imported by dealers in the west. Mitsuma and gampi are the plant materials combined to make another excellent paper, torinoko, widely known and used by western printmakers.

Unlike European handmade paper, the Japanese handmade variety is still extensively manufactured. Judging by the different catalogued samples available, many hundred different kinds are on the market; many are expensive, but many others are still remarkably cheap. However, difficulty is met in ordering; an unknown language tends to block access to the needed information. In England, apart from limited stocks held by the dealers, there is likely to be at least a three month time lag before an order is received. The origin of some papers, moreover, is difficult to trace; finally, they may have to come through agents, rather than directly from the maker.

Japanese sheet sizes are different from those used in the west; but many fine papers come in the large sheets so welcome to the printmakers of today.

## Machine Made Filter Paper

In England, over the last ten years, filter papers have found increasing use in print studios and art schools. Produced for industrial filtering, they are mostly made from pure cellulose, inert and passive in character, and contain no acid or alkali. This paper is manufactured in quantity, and once a source of supply is discovered, there should be little difficulty in obtaining it.

While lacking the hand crafted attributes of a deckled edge and slightly irregular form, filter paper has certain advantages over the handmade sheet. It has, indeed, many of the qualities of good waterleaf paper: softness, smoothness, absorbency, and whiteness. It can be supplied, moreover, in continuous rolls of various widths; hence, in planning the format of an edition, the sheet may be cut to the correct size. For the large scale silkscreen and relief prints now being produced, filter paper fills an essential purpose. A 4' roll, for example, provides a wide printing surface of any required length.

## Other Machine Made Papers:
## Newsprint, Cartridge, Offset, Etc.

Machine made paper feeds a vast industry; hundreds of different kinds are made, using every possible mix of the basic materials from ground wood (the cheapest) to white linen and cotton rag (the most expensive). The best of these papers are likely to have the highest content of rag; the most inferior have the highest content of ground wood.

Through its availability and cheapness, newsprint (a ground wood paper) is widely used for prints at every educational level. With time and exposure to light, this material becomes brittle, discolors to a light tobacco brown, and thus returns to the tone, color, and texture of its sprucewood origin. Although absorbent, the sheet is thin and cannot take up much ink. While it will proof a black and white or single color image effectively, it leaves an overprinting unattractively glossy.

Better quality machine made papers come under many names; cover paper, cartridge, twinwire, precision, offset, etc. A number of these will take a good black or single color image from a relief block, but, like newsprint, they are insufficiently absorbent for multi-color printing. Some of the best use esparto grass as a main ingredient. In the maker's catalog the letters WF may be used to denote a paper free from ground wood pulp.

## Paper Sizes

Until standard international paper sizes, based on the metric system, are generally adopted, paper sizes will remain in some confusion. ISO sizes, as they are called, are the agreed sizes of The International Organization for Standardization. Only a few progressive firms use this system. So far, however, it has failed to touch commercially produced handmade sheet sizes; hence, the proportions are still based on ancient practice, and carry names appropriate to the handcraft origins of a now remote agrarian and feudal past: Grand Eagle, Antiquarian, Large Crown, Foolscap, etc. Writing in 1957, Dard Hunter discovered that 240 different paper sizes were being manufactured at that time. Handmade paper, in any case, can be made in any desired dimensions, depending on the sizes of the molds. The following, however, are the European handmade sheet sizes most useful to the printmaker.

*Royal:* either 19" by 24" or 20" by 25"

*Modern "variants"* of this sheet size: 19 1/4" by 25 1/2" or 20" by 26"

*Imperial:* 22" by 30"

*Elephant:* 23" by 28"

*Double Elephant:* 26 3/4" by 40 "

The 18" by 24" size of some American papers will be found restrictive by present day printmaking standards.

Certain modern machine made papers can be obtained in continuous rolls. The advantage here is that sheets can be cut to size, and large format images can be printed on single sheets. Machine made filter papers, such as 3MM (British) is supplied in rolls, 24", 30", 40", and 42" wide; "Tablean" rag paper (American) is supplied in 40" rolls.

## Whiteness of Paper

If a very pale color scheme is used for an image, common sense will indicate that the paper chosen should be of an exceptionally pure white. A cream surface will make it impossible to obtain a very light, clear blue, or even a bright, cool pink.

## Ordering Paper Supplies

Obtained in bulk, paper is always less expensive than paper bought a few sheets at a time; it is rather less costly bought by the quire (20 or 25 sheets), and much less so bought by the ream (500 sheets). The large distributors have now standardized the ream at this figure; a few years ago, it would have been 480 sheets for handmade paper. Thickness of sheets is indicated by weight per ream: 60 lb., 90 lb., 140 lb., and so on. This figure, however, is expressed in terms of weight per ream according to the size of sheet. A small sheet of 90 lb. paper will be thicker than a large one of the same weight.

Although the weight of paper determines its thickness, two papers of similar weight, but different density, will vary slightly in thickness; thus a hard, tough, dense sheet might well be thinner than a soft loose textured one of identical weight. Handmade papers in any given ream are never of *exactly* identical weight, since it is impossible for the vatman to judge — with absolute accuracy — the amount of liquid pulp lifted in the mold. Further, although the wooden mold is made with precision, the handmade sheet, formed from a coating of liquid pulp, is never perfectly square; hence, if whole sheets are used in printing a large image with narrow margins, the correct alignment of the edges may prove difficult.

All handmade rag paper is expensive, but you can sometimes get sheets with minor defects from the paper mill at much reduced cost. It is not unusual for the makers to discard up to 20% of their output owing to hairs from the felts, tears, water drops, bubbles, holes, and rust from the vat. The best of these defective sheets are sold as "retree" or "outsides"; the rest are sent back to be re-pulped. "Retree" is normally only slightly blemished and is reduced 10% in price. "Outsides," which may be torn and badly damaged, are reduced up to 50% in price. A package of "retree" is marked XX; "outsides" are marked XXX.

In ordering paper, the quantity, maker's name, name of paper, size of sheet, type of surface, sizing, and weight (per ream) should all be stated. The following would be a typical order for an English handmade paper, giving the items in the order above:

4 quires

Barcham Green

"Crisbrook"

Imperial

Hot pressed

Waterleaf

140 lbs.

This may well sound complicated and confusing, but as you get to know your supplier, and he gets to know your needs, these exchanges take on the easy verbal "shorthand" of familiar habit.

While the professional printmaker and art teacher are likely to explore paper supplies in some depth, getting in touch with makers as well as with agents, the amateur is in a different case. He should go to the art supply dealer since without further search, he is likely to find that the dealer can supply him with all the material he needs. Where practical, it is always best for the printmaker to pick up his own supplies. Paper damages easily in transit, sent either by post or rail.

Paper should always be stored flat, and where inspection is unnecessary, it should be left in its original packing, to keep it free of dust or the marks of handling. If open shelves for storage are used in the city, workshop or studio, polyethylene (polythene) sheets, hung from the top shelf, provide a measure of protection.

## Paper for the Edition

In preparing a quantity of paper for the edition, the following points should be found useful. If, say, an edition of twenty-five is to be printed, thirty or more sheets will be needed. This allows some five sheets to be "wasted" through the general hazards of the operation, such as incorrect register when color blocks are used. Some further sheets are needed if the artist's proofs are to be printed on the same paper as the edition; in this case, thirty-five sheets may well be required, apart from the original series of working proofs. But the number of sheets for proofs and waste, over the edition size, will

obviously vary with individual studio practice.

European handmade and mold made papers are normally double sided: there is little difference between the back and front of the sheet and either can be used for printing. If sheets are watermarked, however, the side from which the figures are read is considered by the makers to be the proper side for printing. Japanese handmade paper, on the other hand, is often one sided. The back of a sheet of Hosho, for example, may be rough; only the front is silky and smooth. Many machine made papers have a front and reverse side; in these, the printing surface may show little perceptible grain, while the slight mechanical texture of the wire web may show on the back.

Sheets prepared for the edition are generally stacked face down to save turning them over when placing on the inked block. Handmade paper generally has an irregular deckled edge; in this case the right hand corner of each sheet — viewed from the front — is trimmed with a pair of scissors, to make it fit snugly into the register stubs.

A heavy steel L is a useful instrument for trimming paper to size. In cutting sheets from a continuous roll, it has only to be aligned along one edge, and the width or depth of the sheet marked out, to trim the paper accurately. Cut from a roll, however, the paper has a strong tendency to curl; ideally, it should always be cut and laid flat several days before use. For immediate use, it should be rolled in a reverse direction and kept in this position, secured with rubber bands, until before printing begins. Paper for proofing can be ripped to size by pulling it sharply across the edge of the steel L or straight edge. In the past, printmakers nearly always chose to preserve the deckled, irregular edge of the handmade sheet. But the choice here lies in the value of the total format: the value of the white surrounding the image, relative both to its outside proportion and to its internal space and color. In traditional framing, a mat (mount) covered the borders of the print; but modern methods, using sheets of acrylic or glass held flush to the backing with clips, reveal the whole sheet. For present day prints, this is surely the proper solution, since the artist's intention is sure to allow for the proper interaction of color and space relative to the whole sheet.

## Damping Paper

Relief print editions are printed on either damped or undamped sheets. In England, these editions are now generally made on dry paper; in America and Japan, the paper is often damped in the course of printing. The damping of the sheet is done in various ways: total submergence may be used in the case of very strong papers; or indirect methods, where the sheet receives moisture from the presence of damped interleaving, may be used in the case of fragile papers. Adding moisture to paper makes it softer, more absorbent, more receptive to either oil based or water based ink, and allows the action of the platen or roller to press the softened sheet closer to the surface of the block. A humid surface gives a fuller impression of the image, sometimes slightly richer and deeper in tone. But where large sheets are used, the process may be impractical, since in a state of humidity, such sheets are difficult to handle, and may "flop" on the block — off register — in the attempt at correct placement. Damping and drying large sheets is slow and laborious; when dry, moreover, the surface may sometimes become wavy and cockled.

In the indirect method, the sheets are damped and made into a "book" by interleaving with moistened paper. This is done by laying blotting paper or old newspapers — not freshly printed ones where the ink may not be fully dry — on some nonabsorbent surface such as plastic, glass, or an old lithographic plate. The blotting paper or newspaper is then sponged over with water, and one or two sheets of printing paper placed on top. The sequence of wet interleaving and dry printing paper is repeated until the required number of sheets is in the pile.

The wet sheets used for interleaving should be big enough to extend beyond the printing sheets, or a plastic sheet can be wrapped around the pack to prevent moisture from escaping. This will prevent the edges of the printing paper from drying before the main body of material in the center of the pile. Irregular drying will cause buckling or cockling of the paper. Finally, a sheet of metal or plate glass, with a heavy weight on top, should be placed above the pile to press the sheets together and speed consistent damping. It is best to leave the sheets in the book several hours before use, or even overnight. Left for a space of days, however, they easily become subject to mold.

This method of damping is used for the more delicate Japanese and waterleaf papers that cannot withstand direct immersion — or even rubbing over with a sponge — without damage. Tougher sheets can be put in the sink in cold water, or sponged over on the back, before interleaving by the method described. Sponging should be evenly done; dip the spong in clear water and squeeze most of the moisture out; then take it lightly across the back of the sheet in even sweeps, first from side to side, then up and down.

## What Papers Are Needed?

For use in elementary and secondary schools, and on the art school and university level, an immense variety of cheap and medium priced papers are on the market. Many different papers may be found useful; these include newsprint, poster paper, offset stock, student grade drawing paper (cartridge), and imitation Japanese.

For color printing, the paper should be absorbent; the simplest test here is to lick the corner of the sheet; if the paper sticks to your tongue, the material is sufficiently absorbent. Another test consists in putting a single drop of water on the surface; if it spreads and disappears, the paper is suitable for printing.

The papers used for print editions at advanced art school level, as well as by professional artists and established graphic workshops, are mainly handmade European and Japanese papers, and machine made rag paper. Barcham Green (in England), Arches and Rives (in France) are the best known producers of handmade sheets in Europe, though a few other, smaller firms supply some excellent papers. Japanese handmade papers are produced in much greater quantities and variety, though many of these may be found difficult to get. Some are of unrivaled quality for relief printing, such as the thick white Hosho, now in regular supply in England and America.

Machine made papers, as we have seen, are now coming into more frequent use. These include mold made (cartridge), filter paper, and other types of unsized,

machine made rag paper. Some of these are obtainable in continuous rolls, as well as sheets.

Since all kinds of paper find a use in the classroom and the print studio — for proofing, press packing, and setting off, as well as editioning — the following items are listed together, starting from the least expensive, most readily available, to the more costly materials supplied mainly by the specialized dealer. The task of listing — for a largely American public — has been complicated by some of the different names and terms used in England. I hope the appended notes will help clarification.

*Newsprint.* "White" newsprint is the name sometimes given to newsprint of superior quality.

*Brown or colored wrapping or packing paper.*

*Poster paper.* Very general term (common in England) for smooth, cheap papers.

*Blotting paper.*

*Construction (manila) paper.*

*White drawing or cartridge paper.* Many types are available. The best is mold made cartridge.

*Offset* printing stock or offset cartridge.

*Cover paper,* another general term used for cheap and medium quality papers.

*Imitation Japanese.* Some are of good quality. Especially useful, owing to their thinness, for collaging together in making working proofs.

*Basingwerk.* A very smooth paper used for proofing detailed blocks.

*Hammermill Index.*

*Acme Index.* A cheap and useful paper, like the above.

*Filter paper.* Sold either in sheets or in continuous rolls, this is an excellent printing paper of particular value for large prints. Barcham Green filter paper LR52 (English) is a good paper for proofs, but becomes creased if rolled for transit.

*Mold made paper.* Made from good quality pulp with rag content. The sheets are made individually in a machine held mold, as the name indicates.

*Handmade Japanese.* Hosho, Kozo, Mitsumata, Mulberry, etc. These papers are made in great variety and constitute the bulk of handmade artists' papers now produced. Many are of superb quality.

*Handmade European.* Rives BFK and Arches (French); Barcham Green and Saunders Waterleaf (English). These are among the finest quality European papers; they tend to be in short supply and are expensive.

# 9

## INK

Printing ink is made of coloring matter ground in boiled linseed oil, with drying agents added. In the modern ink industry, hundreds of ingredients are used; the most important fall into three groups.

*Pigments* give color and consistency.

*Vehicles* are chiefly linseed oil, though varnishes are added. This is the fluid portion that carries the pigment grains, giving binding power and helping the ink to dry.

*Driers and reducers* speed drying, reduce stickiness, increase transparency, or extend covering power.

Materials for ink making were originally taken from the earth; deposits containing iron were found the richest source. Prehistoric man already used earth color — yellow ochre, umber, sienna — and these, many thousand years later, were still the materials of the artist. Such earths were washed, dried, and powdered for printing ink, and finally ground in oil. To produce changes of shade — deeper, browner, redder tints — they were burnt. For black, soot was used. These are known as "natural" pigments; they are still used in the manufacture of certain colors.

A second group of pigments we may call "organic". This we may take to mean colors connected with the organic processes of living things: the ink discharged by the cuttlefish; cochineal, the brilliant pink taken from a tropical insect; or the madders and indigos obtained from certain plants.

The chromes, another group of colors, come from minerals such as lead, chromium, iron, etc. The metal chromium produces chromium oxide greens; iron produces reds, browns, bronze blue; sulphur and mercury give vermilion; zinc produces white. The aniline dyes, coming from coal tar, are a recent addition to the printmaker's palette. Certain blue and green pigments, cyanine blue in particular, a color of great permanence, have proved of particular value.

### Water Based and Oil Based Inks

Both water and oil based inks are used for relief printing. Among professional printmakers, oil based inks are now

general practice in the west, though formerly the water based inks were often used. In the present context, oil inks are recommended with the following exception.

Water based inks are invaluable for primary groups where children under eight years of age engage in printmaking. This is owing to the relative cleanness of these inks in use. The color can be quickly and easily cleaned from rollers and ink slabs; it is also much less harmful to clothes.

In Japan, water inks are still largely used by professional artists, their transparency and liquidity being specially suited to the hand printed image.

Art schools in England and America generally stock both types, though the oil inks are most often used, being much more controllable — particularly for press printing — and are capable of producing solid color effects of great brilliance. Ordinary oil color mixes with oil printing ink. The artist or student, already provided with oil color, may need only a few extra tubes or tins of printing ink for proofing his first images.

In England, art schools are often generous in providing ink and other materials: in America, this is less usual and the student more often buys his own.

Although normally it is found an economy to order ink directly from the maker, in starting work it may be more convenient to get a limited supply from the art materials dealer. Printing ink is sold by the manufacturer in various forms: letterpress, offset, halftone, lithographic, and so on. For relief printing, letterpress inks are used; but most oil based inks will serve — to some extent — when letterpress ink is unobtainable. Certain ranges of inks made specially for the artist's use are found in Paris. Color for color, however, I have not found them notably better than other makes. In the United States, the printmaker is probably better served with specialized inks for relief and other autographic media.

Ink is an expensive commodity; in the art school, about a third of it goes to waste, not only through the wastage of ineffective work and through ink tins being left without lids, exposed to the air, but also through the student's inexperience in economic mixing. The color he mixes may be wrong for his purpose, or he may mix too much. In stocking the art department, a quantity of cheap jobbing inks should be ordered, as well as a restricted range of the more costly ones. For the trial proofs, even the professional should buy some of the cheaper inks; in the productive studio, proofing alone will use a large quantity of ink over any given year.

**Ordering Ink Supplies**

For the professional, it is a fairly simple matter to order ink from an art supply dealer or a printmakers' supplier. In the main, they will understand his needs, though it may not be possible for any one dealer to supply a complete color range.

The specialized dealer sells inks that are often closely related to the artist's palette: cadmium yellow, vermilion, ultramarine, etc. To any artist or teacher, the various items on the dealer's list make sense, whereas the manufacturer's list, which uses a different terminology, might almost be printed in a foreign language. This illustrates the wide gap that exists between the specialized dealer, whose products are geared to the printmaker, and the manufacturer, whose products are mainly designed to service a huge and highly diversified commercial printing industry.

The maker's inks are manufactured for the main functions of print: books, newspapers, magazines, posters, packaging, and so on. At some point, however, the printmaker or teacher will want to cross this gap and order color from the manufacturer — partly because here he can acquire sound color at much reduced cost; partly because the manufacturer produces a very large variety of inks and related materials, many of which are proving of considerable interest and value to the printmaker. The artist can do no better than send for full information on the manufacturer's products, which he should then attempt to master before making his own trials of the inks supplied.

Ink is normally bought from the maker in one pound or larger tins. For the amateur, however, who is likely to need smaller quantities put up in tubes, the best course is to order directly from the specialized dealer in printmaking supplies.

## Basic Palette

In ordering ink for the first time, the following may be found a useful palette. It represents a basic, commonsense approach. A wide range of variation is produced by mixing the appropriate colors, adding reducing medium where a transparent film of ink is needed.

Black (should be of stiff consistency)

Titanium white

Vermilion or permanent red

Mid chrome or mid cadmium yellow

Ultramarine

Transparent reducing medium

*To this range can be added:*

Alizarin crimson or madder lake

Burnt or raw umber

Pale chrome or pale cadmium yellow

Emerald or viridian green

Monastral or phthalocyanine blue

## Notes on Colors

The following are brief notes on some leading colors used in printmaking, together with a mention of other (possibly less familiar) pigments regarded as sound by the printing trade.

*Black:* a stiff, intense black ink is recommended. Black can be mixed with either red or blue, making a warmer or cooler tint without much reducing its density. Black ink is made from carbon, either by burning natural gas — called American gas black in Britain — or by the ignition of creosote and coal tar oils. Black should be ordered in double quantities. It is always needed more than any one color. (White and reducing medium are normally used less than black, but more than any single color.)

*White:* titanium dioxide — titanium white — is a brilliant and permanent pigment. Owing to its opacity, it is of special value in overprinting. Flake white, on the other hand, has little opacity. Zinc oxide — Chinese white — is reputed not to keep well after mixing with driers. It has been claimed that mixing color with white reduces fastness to light.

*Red:* vermilion is a permanent, opaque red of great purity and brilliance. Due to its opacity, it is of special value in overprinting. It is regarded as unsound, however, to mix vermilion with colors containing lead, or to use it for printing copper blocks or plates. Alizarin crimson, crimson lake, and madder lake are cool, dark, purplish shades of red, of value for transparent printings, but of only fair light fastness. The following are some of the reds regarded as sound pigments by the ink industry: para red, helio red, permanent red, naphthol red, lithol red.

*Brown:* the permanent and beautiful earth colors — sienna, ochre, and umber — are no longer favored by the ink maker for commercial printing, owing to their coarseness and variability. Yellow ochre, for example, can be anything from dirty, greenish yellow to brownish orange. These colors, however, can still be obtained in the range of inks made specially for the artist's use; they include raw and burnt umber, yellow ochre, and raw and burnt sienna. Red shades of brown may be made from hydrated iron oxides.

*Yellow:* the cadmium yellows, among the most beautiful, go from a clear, pale primrose to a strong, warm yellow of great intensity. Lead chromate is more typically used in modern ink manufacture. Chromes may be mixed with Hansa yellow for increased transparency. Chrome yellows may darken gradually on exposure to light. Recently produced grades have improved resistance to darkening. Other yellows recommended are benzidine yellow and Hansa yellow.

*Blue and green:* the main blue and green pigments, made from basic dyes, are called Victoria blue, rhodamine, methylene blue, malachite green, and brilliant green. At full strength, their light fastness is considered good. The iron blues — bronze, Chinese, Prussian, and milari blue — are considered sound pigments and are widely used in ink manufacture. Ultramarine, is the strong, warm blue common to the painter's palette. Monastral, phthalocya-

nine, or cyanine blue is the most permanent and beautiful of the cold blues; it is called by all three names.

*Reducing mediums, tinting mediums,* and extenders are all colorless materials used to reduce the opacity of color. Some are clear and jelly-like, of the consistency of vaseline; others are a stiff white paste. Any desired quantity can be mixed with any given color. A fuller description of these materials is given in Chapter 10.

## Color Permanence

Color grading for permanence is in some confusion, as no agreed standards exist that apply throughout the trade. The art supply dealer sells a number of inks of known permanence; the large ink manufacturer, however, while he grades his ink for light fastness, uses terms that hardly apply to the conditions of printmaking. He may use the letters FL to indicate a fully lightfast tint. The grading here means that the manufacturer expects the ink to hold its color for at least three months of outdoor exposure; it is a "standard" that applies to the inks needed for posters and other types of full daylight display. Another maker may use some rating like the British Standard Blue Wool Scale. This is a range of eight dyed blue wools, each with a graded light fastness, from 1, very fugitive, to 8, very permanent.

In certain cases, a maker will put up a special order of known permanence — yellow ochre, cadmium yellow, cyanine blue — and some printmakers, naturally preferring such color, will go to some trouble to obtain it. Makers' color names are more or less arbitary: coronation red, kingfisher blue, mid-Celtic green, or brilliant fuschia purple, for example. It is impossible to judge the ingredients of any given color from its name, as one can in the case of artist's color, for the range of inks specially made for artists is based on a much more limited range of substances, each having traditionally recognized qualities.

Ink making is now big business, with its own immensely sophisticated technology. The ink requirements of art schools or artists are, by comparison, a trickle, a thinly threading stream drawn from the vast river of printing ink that flows continuously to feed an immense industry. One can only trust the products of an ink maker of repute, having first checked the grading of the chosen color from the details given on his list.

Finally, with regard to permanence, the relief printer has a certain advantage: the color film he uses is likely to be thicker — sometimes much thicker — than the color used in some other forms of printmaking, notably etching and lithography. This, in itself, is an assurance of relatively greater lasting power; the thicker the layer of pigment, the more slowly will it respond to the bleaching action of light.

## Color Transparency

Colors vary in their qualities of opacity or transparency. Transparent colors are "see through" colors that allow the ground or paper on which they are printed to shine through. Opaque colors, by contrast, tend to block out the white paper, or the color beneath in the case of overprinting. Particles of transparent color hold and absorb more of the colorless vehicle carrying the grains of pigment; hence the color grains are more thinly suspended in the ink film.

Chrome yellow and vermilion are opaque colors; magenta, crimson, and viridian are transparent ones. Printed on a dark ground, semi-opaque color looks cold and smoky; printed on white it gains warmth and clarity — hence the law of all turbid media governs its behavior. Even an opaque color, used on a dark underprinting, turns cooler, thus behaving in accordance with this law.

## Ink Drying

**Printing ink dries in four different ways: by absorption into the paper; by exposure to air; by the addition of driers or by chemical change such as oxidation. For most purposes, no special problem arises. The print dries when it is left exposed to the air. Placed near a heat source, it dries fast; left in a drawer, or covered by a second sheet — excluding the air — it dries slowly.**

**When drying is to be speeded up, driers are added to the ink — a small quantity of paste is mixed into the color with a palette knife. Driers are used for a**

first printing when a second one is to be printed shortly after; they may be necessary, too, when a color sequence is printed during editioning, and when work must proceed without interruption. They are employed sparingly, however, since driers added to ink already on the slab may make it sticky and unusable in the course of three or four hours. Ink should be balanced to stay soft enough for use throughout a working day.

The account which follows gives a fuller description of the materials and methods involved with the speeding, or arrest, of the drying process, and discusses the preservation of color held in stock.

If paper is very absorbent, like blotting paper or cleansing tissue, it picks up liquid, absorbing it instantly, leaving the surface dry. Like blotting paper, many printing papers have a similarly unsealed surface; the web of their open fiber is laced with thousands upon thousands of tiny air holes. Printing ink is rapidly absorbed by such papers, capillary action causing the liquid content of the ink to run along the narrow spaces between the interlaced fibers. Size hardens paper, coating its surface and filling the air spaces. Hence, only unsized paper — Japanese, newsprint, waterleaf — will quickly dry a film of ink by direct absorption. But when ink is printed thickly, the air spaces fill; they become clogged and incapable of soaking up further pigment. Unabsorbed color then remains on the surface, where oil and varnish in the ink may well produce an unpleasant shine. In overprinting, the same effect occurs: the first layer of color coats the pores of the sheet, leaving a sealed surface underlying the second color — a surface that is no longer able to draw the liquid from the ink. Hence, if colors of similar properties are used, a first printing will always dry faster than a second one.

The linseed oil used for ink making (taken from flax seed) has about the consistency of thin cream. When the oil is boiled, the oil molecules link up into larger groups, giving it the proper thickness for printing ink. Taking oxygen from the air, it dries by chemical action, oxidizing to form a solid. Since even a thin film takes several days to dry, driers are added to speed up this process. The color you get from the supplier will have some driers already added. Sometimes too much is added; in a well

heated studio, the color will dry too fast. The ink maker or dealer should supply you with ink having a low-normal level of driers, giving you the option of *adding* driers. The trade uses many kinds; but the paste driers — made from rosin and the metals manganese, cobalt, and lead — in my experience, are the best. In most cases, they speed up the drying process to a few hours; at high temperatures drying takes much less time. Only small amounts are added. If a quantity of color has been taken from the tin, or mixed for an edition, driers are added only to that portion ready for immediate use.

Circulating air is the other main factor in drying. If possible, prints are always laid or hung where air can circulate over the sheet. A mobile radiator — that can be run under the drying rack — is used in my own studio. This sets the sheets swaying in a rising current of warm air. When two or three of us work continuously at an edition, this is an arrangement of considerable service.

**Preserving Color in Stock**

Oil based color is normally ordered in tins containing one pound (or more) of ink. Some manufacturers will supply half pounds, and will put the color in tubes to special order. If color is used a little at a time, tubes are certainly a convenience. Screwed firmly down, the cap keeps the ink in a tube from drying out; but once a tin is opened, a large ink surface is exposed to the air. In use, the disc of greaseproof paper beneath the lid should be kept in position as long as possible; the color can then be taken from the side of the tin and the protective paper pressed down as ink is removed. When ink is halfway (or more) down the tin, the air contained in the tin itself tends to dry out the remaining color. If the tin is then filled with water to a level a little above the ink, it should seal it effectively against exposure to outside air. When ink dries between the rim and lid of the tin, the lid is hard to remove. Clean away any ink from the rim to prevent this happening again and wipe vaseline (petroleum jelly) inside the lid before replacing.

**Arresting Ink Drying**

Additions of vaseline, a slow drying oil such as poppy oil, or even kerosene (paraffin) may be used to arrest the

drying of ink already taken from the tin. Aerosol containers of anti-drying agents are obtainable from printers' supply stores. These are used either for spraying over the surface of color, partly used and still contained in the tin, or for protecting ink already rolled out on the ink slab. These measures are sometimes necessary in hot weather, or in an overheated room. Particular conditions may make such pigment "doping" necessary, though normally this should be avoided.

## Extending and Reducing Mediums

Extenders, reducing and tinting mediums, are colorless materials used to extend the ink, making its tint paler while keeping its body stout enough to roll on the block. Some are a transparent, clear jelly in paste form; others are cloudy, like condensed milk. From ink makers of repute, reducers can be safely mixed with color in any desired proportion — they will turn a dense black to the lightest tint of gray. Reducing mediums have a secondary function: being less costly than printing ink, reducers are sometimes mixed with solid color for economy. First proofs of a large print take a great deal of ink; by extending such color, the more costly inks can be saved for the edition.

These mediums have wide variation. The best course is to state your needs to the ink maker or dealer; he should then supply you with the materials most suitable to the range of inks you use.

## Liquifiers and Thinners

If ink is too stiff to work easily, a thinner is added. In practice, a drop or two of linseed oil should give your color the right consistency to be spread evenly with the roller. Boiled linseed oil is considered the proper medium, but normally so little is necessary that any refined linseed should serve your purpose. If too much is used, it could bleed round the edge of the printed color, where in time it would oxidize, showing as a slight yellowish halo along its contours, or it might seep into the body of the paper,

marking the back of the sheet. Linseed or boiled linseed oil is certainly better, however, than the commercial thinners used in the trade.

## Water Based Inks

Up to the age of eleven, children tend to work freely, messily, and happily. At this study level, water based inks are used, being much easier to clean up then a heavier and stickier medium. They are also comparatively clean in use, and this, together with their high speed drying, makes water based inks of particular value in schools for young children.

These water based printing inks consist of dyes and pigments ground with a mixture of glycerine-dextrine and gum. The pigments and coloring matter are like those used in oil based ink manufacture. Such inks dry partly by evaporation, partly by penetrating the paper. Like oil based inks, they are used on unsized paper: construction paper, newsprint, waterleaf, or filter paper.

## Metallic Inks

This form of printing is done either by inking the block directly with metallic ink and printing it, or by printing a sticky medium on the sheet, which receives gold or silver powder while still wet. In the latter case, metallic powder is dusted lightly over the tacky surface and any excess grains are brushed away. A special medium is manufactured for use with metallic powders, but in practice we find that almost any oil based ink will make a base, provided that it leaves a tacky impression on the print. Dusting powders consist of either bronze (gold) or aluminum (silver), ground into tiny particles; the same metals are carried in the vehicle when used in the form of ink. Rightly used, this metallic coating — which takes the light so differently from pigment — is capable of producing effects of great brilliance. Gold powders are usually marketed in the following shades: pale, red shade; rich pale, mid-gold shade; rich extra-pale, green shade.

# 10

# PRINTING

In contrast to painting, the different tools and equipment used in printmaking make clearly defined demands on the user. A paintbrush can be employed in many different ways; it is a highly adaptable tool, giving the artist a great deal of freedom. But in regard to a printmaker's tools — the gouge, the roller, the press — this is no longer true; each imposes its own gestural pattern. There is no "correct" way of using a brush, but a roller needs to be exactly and correctly handled.

In printmaking, a fairly high degree of gestural formalization must always exist. Hence, the different work situations tend to be structured and sharply profiled. (To achieve fifty matched impressions of a color print would be impossible without a high degree of order in setting out the work, and muscular rhythm in pulling the press.) But beyond this formalization barrier, the printmaker has an infinitely extendable range of choices — like the painter, he is creatively free. It is clear enough that creativity, as such, can never be directly taught, while any intelligent and practical student can be shown how to print — and print well — just as any form of craft discipline can be clearly demonstrated and taught. A number of students in my own studio have worked as trainee printers; in a short time, and with hardly a single exception, each of these students went away an excellent printer-craftsman.

Proofing and printing — printing, that is, in the sense of pulling matched images from a completed block — are substantially different activities. Proofing from a partly cut block is a single step in a diversified sequential process. It may well be quite informal. Printing from a completed block, on the other hand, is aimed at achieving an identical series of images, and may be a highly formalized process.

A further distinction is made between printing in black and white (or in one color) and printing in several colors. One color printing is generally a simple enough process; printing in several colors is more complex. In the first case, the print is taken from a single block; the image is seen in its entirety. In the second, the print is observed as a broken mosaic, and only a part of the image appears on any one block.

Pulling the Press. *In printing, the weight of the body does nearly all the work. It is generally impossible to pull the handle of a large press with the strength of the arms alone. The proper action is to grasp the handle with arms extended, to push hard against the floorblock with the right foot, while throwing the weight of the body backwards. The left foot controls the balance. In printing an edition, an experienced printer will exactly repeat his movements each time he pulls the handle. A repeated repertory of movement is the secret of avoiding strain. Once a smooth, rhythmic action has been built up, it can be sustained for many hours without fatigue. It may need great pressure to print a large surface effectively. A second printer, standing at the far side of the press, can help by pushing the handle forward as the first printer pulls it back, a procedure sometimes followed in my own studio. It is possible to print a block longer than the platen by repositioning it on the press carriage, and taking the impression at more than one operation. Although the space between the sides of the press frame sets a limit to the width of any block used, a block longer than the longest measurement of the platen can still be printed by unscrewing and removing the tympan and printing it as indicated above. A difficulty remains, however, in that "steps" may appear on the print — areas of stronger tone — where the image received the greatest pressure from the platen.*

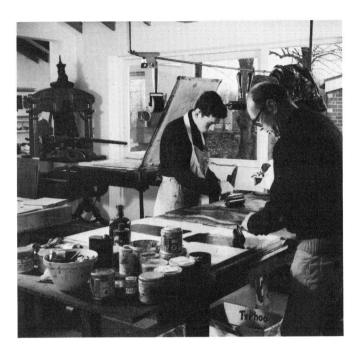

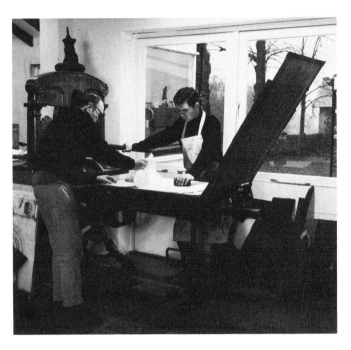

Inking Blocks *in part of the author's graphic workshop at Stisted. Printers working at opposite sides of the table are inking two separate blocks to be printed together. As in all such cases, the work has been set up to reduce the number of steps between each operation: placing blocks on the press, handling the sheets to be printed, and finally hanging them up in the drying rack. Rollers and rags are hung on the bar, within easy reach of the printers. The studio drying rack is situated immediately behind the inking table, out of view in this photograph. The boards, needed to adjust the level of the press carriage, are kept against the side of the press.*

Inspecting a printed sheet. *The printer on the far side of the press has placed a weight on the back of the sheet. This is to prevent the image from going out of register when the sheet is turned back.*

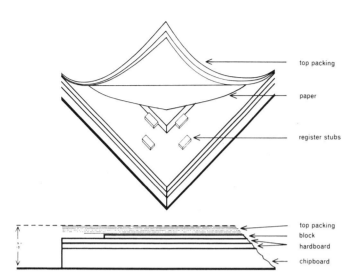

top packing

paper

register stubs

top packing
block
hardboard
chipboard

*Smooth surfaced blocks require only a few sheets of top packing.*

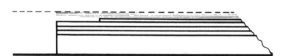

blanket

*An etching blanket is used for exceptionally strong textures.*

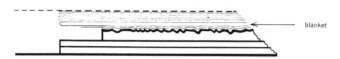

*Halftone letterpress plates need smooth top packing.*

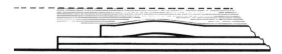

*A warped woodblock may need selective packing to equalize the distribution of ink. This method is also employed to increase depth of tone in any particular area of the print. The selective packing is used either with the top sheets or it is Scotch taped in the relevant position under the register.*

## Packing the Press

The presses discussed here (with the exception of the lithographic and etching press) are adjusted to print from blocks approximately 9/10″ in thickness. This is known as *type high*. It represents a general norm or standard of height for both the type and plates (blocks) used in letterpress printing. English type is 0.917″. As a general rule, presses cannot be adjusted to print plates or blocks thicker than type high; but when a block or plate is thinner — such as plywood, linoleum, or unbacked letterpress plates — the height can be made up by using boards placed on the bed of the press.

A piece of 1/2″ fiberboard (chipboard in Britain), with some sheets of hardboard and cardboard cut to fit the press bed, should give you any combination needed for height adjustment. By removing or adding one or more of these boards, the printing level can be quickly raised or lowered; but this procedure is for the main adjustment only. The fine adjustment is always done with thin packing on *top* of the block. Top packing consists mostly of thin material — such as manila boards, cardboard or paper of varying thickness — while in special cases, a piece of cloth blanket, rubberized blanket, or foam rubber is used. In the more sophisticated methods of printing, packing may need to vary from job to job. Paper or thin cardboard, however, built up to give the necessary pressure, will serve all the basic needs for top packing for most purposes. Soft packing is used only in special cases; in the art school, this method should be used with discretion. The increased bulk of packing needed may raise the tympan frame, causing it to strike the edge of the platen, and so damage the press when the carriage is run in.

In either private studio or art school, space should always be found for the proper storage of packing materials beside the press. It is rare, in the art department, to find allowance made for this arrangement. In my own workshop, boards are conveniently stored against the side of the press, while paper and other packing is laid on a table top within easy reach.

## Counter Block

The platen of the Albion, Columbian, and Washington press has a pivotal action that gives a certain degree of

tolerance; it can thus adapt to a small change of level as it descends on the block beneath. Sometimes a block has to be placed off center, particularly in the case of the open block method; in this case, some adjustment is necessary, as the platen may rock when the proof is pulled, giving a graded tone in the print, light at one side, dark at the other. When a block stands off center, the counter block is used to balance the action of the platen, keeping it level. This consists merely of a blank block — a piece of wood, hardboard, or linoleum — placed on the press bed at a point opposite the printing block. It should be of equal height or a fraction lower. If the contour of the counter block shows as an indented shape on the print, the edge should be rounded with a rasp or the block can be put on the back of the paper instead of the press bed.

### Setting up the Work

Working alone in his studio, the artist is free to interrupt or vary the normal routine used in printing or pulling proofs. In the art school, however, an unvarying work sequence should be set up, and recognized, by every member of the working group. Otherwise, a shared printing area quickly turns to chaos. ink, for example, is always mixed *after* basic preparations are made; otherwise, paper and packing become marked with fingerprints. This would be a sensible work sequence to follow:

(1) Paper is trimmed, damped where necessary, or otherwise prepared for use, and placed face down in convenient reach of the press.

(2) The register backing is prepared and put on the bed of the press, or on the printing table, in hand printing.

(3) The uninked block is tested in the press for height. The packing is checked for the necessary printing pressure.

(4) The color is mixed and where necessary, matched to an original. The color is rolled out on the ink slab and transferred to the block.

(5) The impression is taken: but *before* removing the sheet from the block, a weight is placed in position on the sheet and the print is partly turned back for inspection before removal.

(6) When the run of proofs is completed, any remaining color on the ink slab is packaged. The student should keep an airtight tin for filing his own color. When work on the print continues, this system not only saves time but frees the printing area from the unnecessary and wasteful clutter of remixing ink.

(7) Color slab and rollers should be cleaned immediately and put away.

(8) The register backing is replaced in the student's own job file. Any special packing used for printing is also kept in the file for future work.

### Printing Procedure

To pull a proof in black and white, the ink should be of average viscosity. If you pick it up on the palette knife, the ink should slide slowly from the metal. The ink is laid in a flat ridge at the top of the ink slab, and a small quantity is detached by the roller in a narrow strip. The ink is rolled into a thin, even layer, lifting the roller frequently to insure good distribution. The ink is now transferred to the block with smooth and level movements; the roller action is described in greater detail later in this section. From time to time, the ink will need picking up with the knife and re-spreading. If this is done regularly, the ink is kept to an even strip, and the roller takes an equal quantity, along its whole width, at each re-charging, saving a good deal of unnecessary labor.

At first, it is hard to judge the needed amount of ink to put on the block. A thick, soft, absorbent paper takes up much more pigment than a thin, less absorbent one. (Thick Japanese Hosho papers and heavy European waterleaf are generally the most absorbent.) A first proof, in any case, takes deceptively more ink than later ones; this is because ink is spread on the slab and taken up by the roller before any is spread on the block or transferred to the proof. A side grain block, used for the first time, absorbs more ink than a block already in use; the material itself soaks up ink, which dries in the fiber of the wood and later seals it, preventing further absorption.

### Mirror Image

Once the proof is pulled, it appears as a reverse of the block: a "mirror image." This is something peculiar to

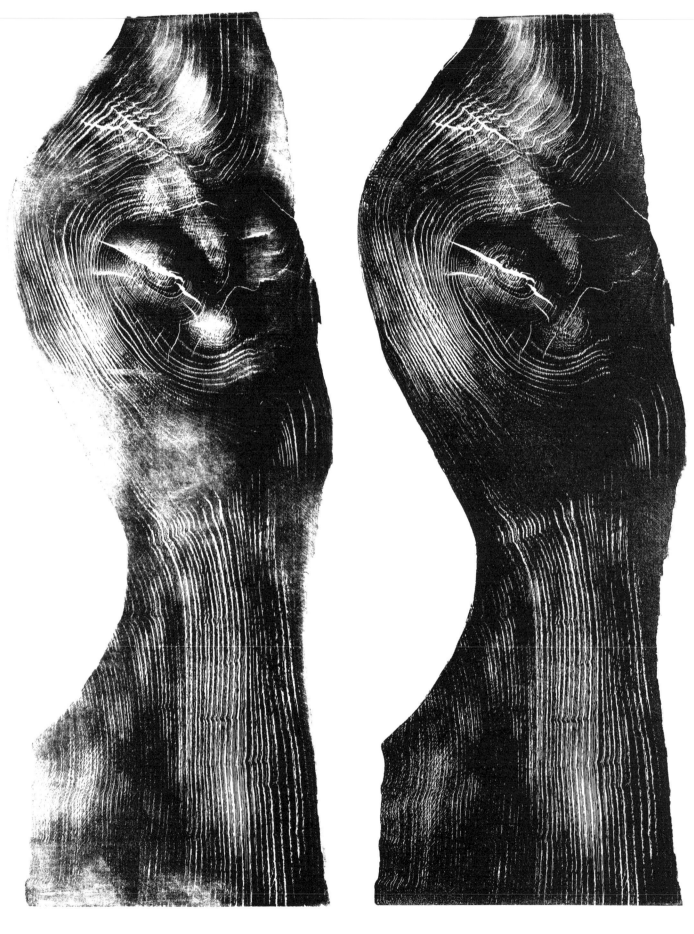

Plank of wood printed with hard packing, *consisting of four sheets of manila board.*

Plank of wood printed with soft packing, *consisting of an etching blanket and unsized paper. Both this and the facing image were similarly inked.*

printmaking. At first, it may be found disconcerting and may offer a good deal of difficulty to the beginner; but if the proof is taped to the window and viewed from the back, it can be compared directly to the block or original.

## Color Proofing

With experience, you are unlikely to attempt a completed proof of any one block before the mosaic structure of the entire color scheme, taken from the different blocks, has finally emerged. When color expression has been attained, you are likely to find that the proofing, carving, and correction of the block have gone along together; there is no clear point when the block is cut and the proofing begun; both are part of a single and sequent process.

We have to recognize that color harmony, particularly in printmaking, is always difficult to attain. When a good proof has been pulled, one of the problems which later arises is the matching of color to this proof when an edition is wanted. In making the original proof, a series of colors are set out in response to your ideas. As you work, these colors may react to each other in a particular way and place a harmonic scale within your reach. Under these conditions, you tend to create new colors from those already spread out — much as a painter would do. This is in sharp contrast to the work of editioning, where colors are put down separately on all the sheets in turn, sometimes making these nuances difficult to recapture. However, if different samples of the original color are wrapped in polyethylene (polythene) or waxed (grease-proof) paper, and kept in an airtight tin, this problem should be partly overcome. More detailed suggestions are given in the section on color mixing.

With any alteration of the printing order, the color of your proof may be entirely changed. The common procedure, however, may well be found the best: light colors first, dark ones last. In this case, the final dark printing will appear darker and richer because the earlier printings have already sealed the paper and made its surface less absorbent. Hence, the last colors to go down may dry glossy, depending on how much of the oil and varnish content of earlier printings remains on the paper, unabsorbed.

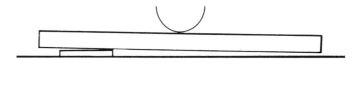

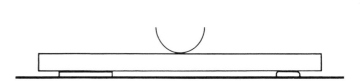

*The platen has a pivotal action. If a block is placed to far to one side, the platen will tilt. A counterblock is used to steady its action.*

Light colors printed over dark ones possess their own peculiar quality. Bright, opaque pigments — cadmium orange, French blue or vermilion — printed on black, take on remarkable solidity and depth. For off register printing, the light on dark relation may produce certain illusionistic effects with remarkable results.

## Printing Pressure Necessary

The following are the basic factors governing the pressure needed to print any particular block, given in their order of importance:

(1) Area to be printed.

(2) Amount and viscosity of the ink used.

(3) Softness or hardness of the block material used.

(4) Smoothness or roughness of the block's surface.

(5) Position on the press bed if block is placed off center.

The other factors concern the printing paper itself: its softness or hardness, the roughness or smoothness of its surface.

In relief printing, the ink is picked up from the top surfaces of the block. If the sum of these surfaces is small, the pressure needed for printing will be light; if it is large, the pressure will be heavy. A block measuring 2' by 2' will take roughly four times the amount of energy to pull the press lever than if it measured 1' square. Small blocks of open texture are the easiest to print.

Blocks using large areas of solid color are the most difficult. On this type of block, inking faults are clearly shown, such as the unevenness caused by imperfect inking or damaged sheets used in packing. A graded patch of lighter tone, occurring in the center of the image, is a common fault. This is generally caused by the uneven wear of the platen surface. If the platen has serious distortion, it may well need regrinding by a repair specialist after removal from the press.

Any unevenness caused by packing or platen will be repeated through the run of proofs. When this occurs, the packing should first be carefully checked for damaged sheets: but if the platen is at fault, the remedy may not be easy. One method of correction is to turn the block around on the press bed, without removing the proof from the block, and to reprint in the new position; this should be of material help in distributing pressure more evenly over the face of the block.

If, however, unevenness in the print is caused by the faulty inking of the block, the defect will vary from print to print. A large size roller, repeated rolling, and cross rolling, in spreading the ink, are all helpful factors in attaining a solid, even field of color. A liquid ink is more easily printed than a stiff one. Thick ink, being comparatively inert, needs considerable pressure to remove from the block. A liquid medium, slippery and loose in texture, needs much lighter pressure. Stiff ink is therefore avoided in printing large areas of plain color. But a stiff or medium consistency ink is favored for a detailed image, where hard contours and intricate texture must be reproduced successfully.

A soft material prints more easily than a hard one. New linoleum, for example, is often resilient and flexible, and offers an element of squash or bounce, aiding the removal of ink from its surface; linoleum grown stiff and hard with age is normally much more reluctant to yield up the pigment.

If you find it hard to get a good flat color printing from wood, metal or linoleum, this difficulty can be largely overcome by the use of thick, soft packing placed above the block, a method that should help to supply the missing "squash factor," and remedy the fault.

When solid, unbroken tone is wanted in the print, a smooth surface is needed in the block. Linoleum, for example, sometimes possesses a slight texture that tends to hold the ink. The print, in this case, will have an open, grainy look. When this occurs, the linoleum is either scraped smooth with the edge of a razor or mat knife blade, or covered with a thin coating of polyurethane varnish, or some other type of hard drying varnish. This should be resistant to ink vehicles and cleaning media (such as mineral spirits or white spirit) once the varnish has dried out.

As regards the block's position when placed off center on the press bed, see the text headed "Counter Block" and the adjacent diagram earlier in this section.

## Gasoline or Petrol Spray

A petrol spray is a useful piece of equipment in the print studio — though this inflammable liquid should never be brought into the art school. To form the spray, the metal fitting of an ordinary charcoal fixative atomizer is used. It can be easily adapted by merely driving it through the cork of a bottle filled with gasoline (petrol). Try blowing the solvent evenly over the back of the sheet if there is difficulty in getting a rich enough print. The block should be printed before the gasoline (petrol) has time to evaporate. This should produce a darker, clearer impression, since the solvent tends to liquefy the ink as it sinks through the back of the paper — a method obviously more effective with a thin, absorbent paper than with a thick and dense one.

The spray can also be used to blow the solvent directly over the inked surface for ease and speed in proofing a difficult block. This device has obvious value when ideas for different color schemes must be caught and recorded while the true sensation of their presence lasts.

## Half Packing

Large areas of plain color are often difficult to print on the platen press and, in this case, the resulting impression may be open, grainy, and irregular. But if you consider the enormous pressure that needs bringing to bear over every square inch of surface, this is hardly surprising. A large block disperses the power of the press. But if you reduce the area to be printed at any one time by using half packing, a more effective impression should be gained. Half packing is merely packing that covers only half the block at one time; in this case, you print first one half of the image and then the other, using two operations instead of one for the completed print.

All sorts of thicknesses and sizes of packing are needed for the various jobs accomplished at the press. In my own studio, a wide shelf is reserved, under one of the printing tables, to store this material.

## Inking a Light, Transparent Color

When a very light, transparent field of color is needed, the proper procedure is to spread a very large area of the wanted color on the ink slab. The roller is then charged from this film of ink and the block is rolled up normally. But each time the block is inked, take care to feed the roller from ink already rolled on the slab, never directly from the pool of solid pigment. The lightest shades of transparent color can be printed by this method without showing evidence of the "steps" or marks of the roller's direction.

## Tone Control

When blocks are printed in black or in strong colors, it may be necessary to lighten or darken the tone in given areas of the image. This can be done on the block itself, by slightly lowering the surface; or when the block is printed, by using an overlay with the packing.

The first is accomplished by shaving down the surface of the block with the edge of a razor blade or scraper, or by using sandpaper or a sanding disc held in a power tool. The result here is that neither the full amount of ink is taken from the roller, nor the full pressure of the press received by the block.

The second way consists of using discarded proofs, fixed to the tympan of the press in register with the print, to form an overlay. Pieces are cut from the proof where lighter tone is wanted, or added where a darker .tone is needed. Several proofs can be used for a thick overlay, or scraps of paper added to increase pressure over the relevant portions of the block, using the proof itself to indicate their position. For this method, the register backing should be taped to the press bed, keeping it in register with the overlay.

I tend, myself, to work with a good deal of freedom. Instead of working out a formal overlay, I use all sorts of shapes and thickness of packing to do the job, from torn newspaper to strips of thin cardboard or manila board. I put the board under the register backing, for example, if the print is weak to one side; or I build up the center of the bed with torn newspaper if the image tends to fade in the middle. I use, in fact, any device of packing that does the job effectively.

## Printing a Block of Very Open Surface

A surface of exceptionally open character may give trouble in inking, since the points to be printed are small

*A soft roller has a flexible surface and squashes into the irregularities of the block.*

*A hard roller spans the topmost portions of the block, the irregularities receive no ink.*

but separate shapes on the face of the block. Hence the roller gets too little support, and easily inks up the background or the cut away portion of the block. In this case, it is best to cut the block from a fairly thick material (if linoleum is used it should be the thickest kind you can get) since this can be deeply cut away between the separate points to be printed. To ink these blocks properly, strips of wood or linoleum of equal height to the block are needed. They are placed at either side, so that the roller is supported at both ends in traveling over the surface.

A difficulty remains, however, with blocks too large to be treated by this method. Large rollers are heavy to handle and expensive to acquire. It may be easy enough for the art school or university department to stock the big, hard surfaced rollers necessary to do this job, but the profits of the private studio are generally too small to support a great deal of such expensive equipment.

## Soft and Hard Rollers

Different types of rollers have been discussed earlier in the book. Size, diameter, length, hardness or softness are all characteristics that sharply affect the inking of the block, and the consequent printed impression. It is not only convenient, but often essential to have several types of rollers available: small rollers, for printing several colors from a single block; large ones for printing large color areas; and soft ones for blocks of uneven surface; and so on.

Hard and soft rollers used together will increase the possible tonal range. This is because a hard roller inks only the topmost portions of the block, while a soft one tends to squash into the depressions. If the inking is to be done in two stages, but with a single color, the block is first inked thinly with the soft roller, giving a half strength tone. At the next inking, the hard roller is employed, using the same color at full strength. If a two color print is wanted, the block is inked with the first color, using a soft roller under heavy pressure to squash and press the ink into the relief of the block and a print is taken. The block is then cleaned and re-inked with the second color, using the hard roller. The second printing should be done in exact register with the first. The

separation of two color films can also be aided by using inks of different viscosity; some further information is given below.

## Viscosity of Ink

Inks of different oil content have a tendency to reject each other. If kerosene (paraffin) is sprinkled on the slab, for example, and color is rolled over the area of the spilt patches, the thin, oily solvent will always reject the stiffer ink which the roller attempts to spread. In certain cases where fullness, richness, and depth are needed in the print, this behavior pattern of viscous ink is used in relief printing. The antipathy existing between media of different oil loading is a subject that has been examined in depth by S. W. Hayter and his associates. I would refer any specially interested reader to the published work of this printmaker.

## Sheath Printing

In sheath printing, a technique recently devised in the studio at Stisted, the ink is carried on a thin plastic sheath, placed on top of the block. Under pressure from the press the sheath conforms to the surface shape of the block, transmitting a broad, soft image to the print. As the process may be a little difficult to understand, I will describe it step by step.

(1) Cut a piece of plastic, such as a section of discarded fertilizer bag, rather larger than the image to be printed. The plastic used should be soft and flexible and about as thick as a sheet of strong paper.

(2) The block to be used in combination with the sheath is put *face down* on the plastic and the outline of the block is traced with a felt pen. Trim the plastic 1/4" larger, all around, than the trace of the block. When a free form block has an intricate outline, it is both quicker and more accurate to offset a black impression of the block on the plastic sheath, rather than to trace it. The offset image is then dried with powder and trimmed.

(3) Ink the plastic thinly and evenly with a large, medium-soft roller. A weight is placed on the plastic to hold it firmly in position while the inking is done.

(4) Register the uninked block on the backing in the correct position for printing. Place the sheath, inked side upwards, on the block; the edges of the sheath will slightly overlap the edges of the block.

(5) Place the paper face down on the inked sheath, while still in position on the block, and print in the ordinary way. Soft packing, such as a pack of unsized paper, is generally used; its purpose is to drive the plastic into the surface conformation of the block.

In the case of blocks of deep texture — corroded metal, or weathered boards, for example — the print is taken with an etching blanket, a foam rubber sheet, or some other form of soft packing. The impression taken from the sheath gives a "soft" version of the image that the block itself will yield and is generally used as an underprinting. The print, *Through,* provides a case in point. The sheath was inked, using a medium soft roller, with silver pigment. The plastic was then placed in position on the block and printed with soft packing. Once the silver was dry, the block itself was inked with a hard roller, in blue gray, giving the final printing. If this section is read together with the section on soft and hard rollers, a fuller insight should be gained into the remarkable effects this technique is capable of yielding.

## Other Uses of Plastic Sheet

Heavier plastic (acrylic or acetate) sheet is used as well in various other ways. Trimmed with a scissors or with a cutting knife, it is a practical material for printing free form color shapes. For a small shape, the sheet is thin enough to ink and place over a large block, giving a second color at a single operation of the press. The edge of the second color area, in this case, is marked by a white line on the print, caused by the step between the level of the two surfaces. Polished plastic can be unpleasant to ink up, as the roller has a tendency to slip; but with a frosted plastic surface, this difficulty is overcome.

Durability is a main advantage of plastic sheet (as well as precision in cutting), as compared with the cardboard commonly used for this purpose. Plastic is inert, nonabsorbent, and comparatively tough; hence it remains unaltered through repeated use in printing. In

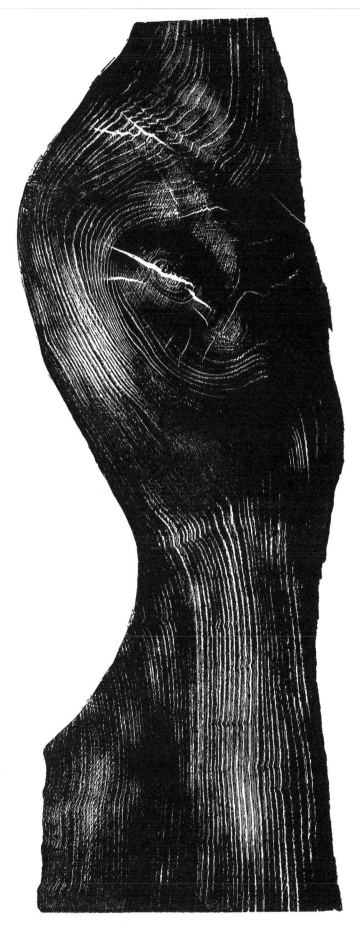

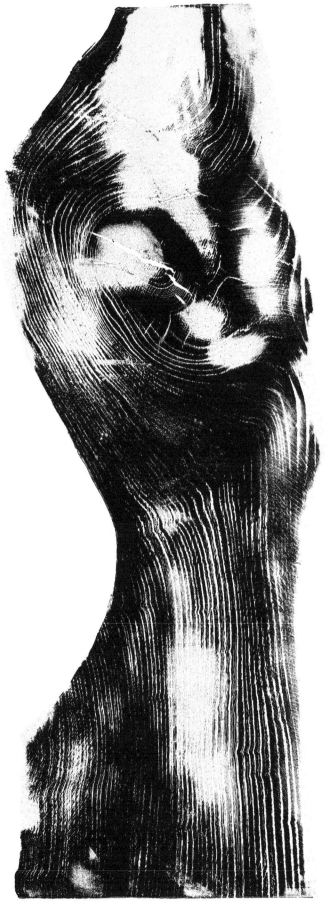

Plank inked with soft roller.

The same plank inked with hard roller.

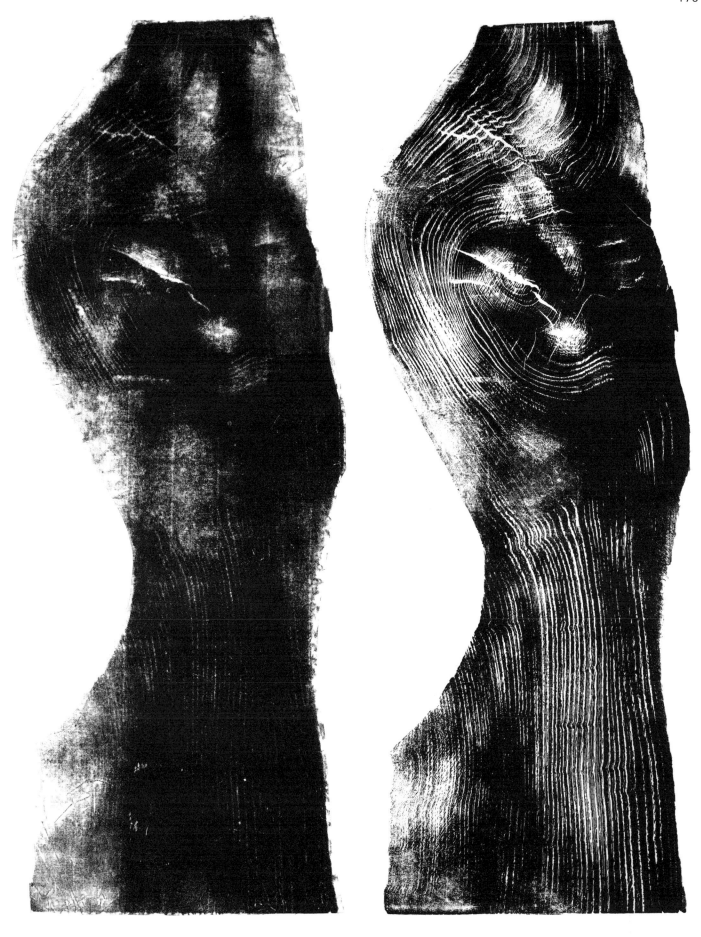

Proof of inked plastic sheath *placed over plank*.

Same plank printed without sheath. *Both the plank and the sheath were inked and printed under the same conditions*.

180

Through, *an incomplete proof of a mixed media print by the author. To get this impression of a wood surface, thin plastic, cut to the contour of the block, was inked and placed on top of the block. In printing, the thin, flexible plastic conforms to the surface shape of the block beneath, yielding a "soft" impression of its surface.*

Through, *woodcut and photo lithograph (31" x 23"), 1968, by*
*Michael Rothenstein. Completed image. The plank has now been*
*printed in register over the first printing taken from the sheath.*

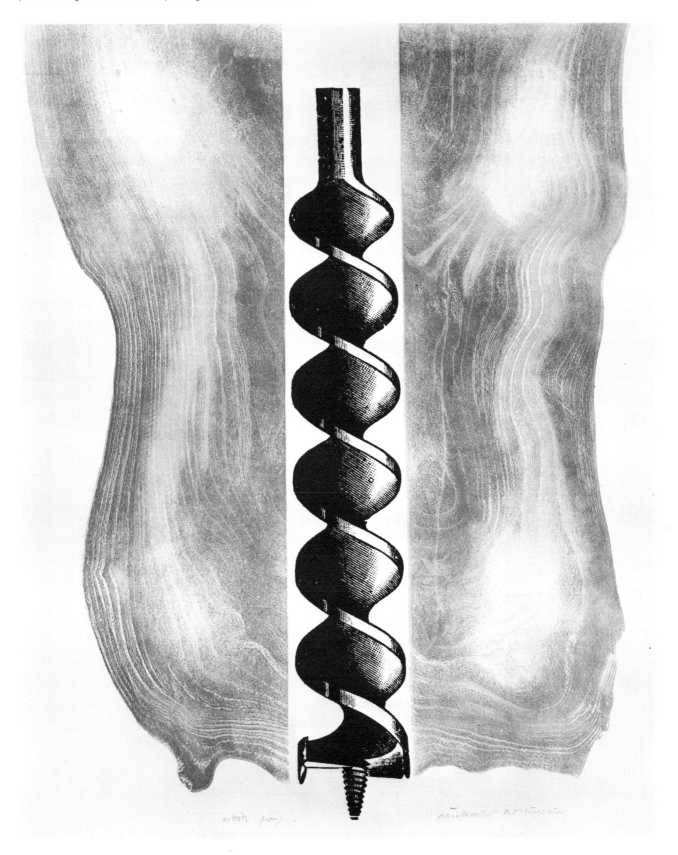

contrast, cardboard blocks have a short life, and are mainly used for student printmaking, where availability and easy working properties make it an excellent material.

## Soft Pack Printing

In soft pack printing, a pad of some resilient material is used to pack the press. Like any other type of packing, it is placed in position on top of the work to be printed. The material used will vary according to the job in hand; it can be employed either as packing, on its own, or in combination with the other types normally used, such as manila board, waste proofs, etc.

The soft pack method is used when you want to drive the paper more effectively into the block's relief than a harder and thinner form of packing would allow. Hence, this method may often be considered essential in printing from found objects, and many other materials of rough, wild, or irregular surface, as well as for blocks engraved or cut from warped or unevenly planed plankwood.

Although this procedure can be employed, to some extent, with the proofing press — adapting the method to the type of press used — the vertical downward thrust of the Albion, Columbian, or Washington provides a more effective instrument. It will be obvious that the etching press, too, can be adapted for this purpose, since the method owes its origin to the soft blankets used to force the paper into the bitten line of the copper plate in intaglio printing. As a matter of fact, in introducing this procedure to the relief print studio, we cut up pieces of old worn etching blanket to form the packing, and here we were merely adapting for our purpose a principle already in existence for many hundreds of years.

Rubber, foam rubber sheeting, an etching blanket, a thick pad of unsized paper, or any pack or pad of soft material with a smooth enough surface can be used, provided that the pack, once in position, allows the press carriage sufficient room to run under the platen. The softer and thicker the pad, the more effectively the paper will be driven into the depressions of the block. A pad that is thick and springy enough can indeed force the paper into its hollows to a point where the sheet will be damaged and torn. A thin paper is least likely to bear this strain; a thick, soft, unsized paper will bear it best. A heavy sheet of Japanese or European handmade paper will take up the conformation of a highly textured surface without tearing. Certain types of paper have been specially manufactured in Paris for this work; sheets that are capable of producing a white image, in considerable relief, from the uninked woodblock or metal plate.

## "Double Deck" Block

When a block is cut from a thin material, such as thin plywood, a second block, placed underneath, will transmit its form *through* the upper block under pressure from the press. The result is a strong print obtained from the upper block where it is supported by the lower, but only a faint impression where it is unsupported. The stiffer the material of the upper block, the more slowly will it bend to conform to the shape of the lower one, hence the softer the image transmitted. Conversely, the *thinner* the upper block, the stronger the transmitted impression will be. This method has obvious uses if a soft or graded edge is needed in the print. The illustrations show a block of this kind and a printed impression from such a block.

## Mixing and Matching Color

Ink is easily wasted through careless mixing, although to sustain the dynamic of a work sequence, quick and wasteful methods are sometimes necessary.

For normal practice, a small sample is prepared before committing any quantity of ink to the mix. This is dabbed out with the finger along the edge of a scrap of paper, and placed directly over the appropriate color of the original design handy for matching. A correct sample indicates the balance of ingredients in the mix; on this basis, the amount of ink to be taken from tubes or tins is judged. The following suggestions are time saving and economical.

Since dark tints lower the tone of a given color more easily than pale ones lighten it, you should start by mixing the bulk of ink rather lighter than the needed tint, adding the dark colors *slowly* until the proper depth is attained. Here is the mixing sequence:

Double-deck block *from the back*.

Proof showing the background of a circle image *taken from plywood*.
*The edge of the circle has printed with an ungraded tone*.

Double deck printing. *The plywood shown in the preceding illustration has now been printed with a second block, cut with a larger hole, placed beneath. In this case, the upper block is unsupported by solid material around the edge of the circle. Hence, it deflects under pressure from the press, giving a graded or halated tone. The lines on the face of the block are formed by the open surface structure of the plywood. This provides an instance of the remarkable variety of "found" surfaces available to the printmaker.*

Double deck printing. *The plywood shown in the preceding illustration has now been printed with a second block, cut with a larger hole, placed beneath.*

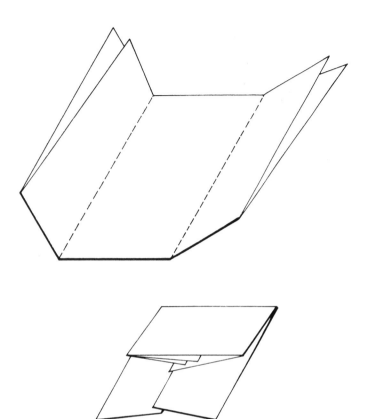

Waxed (greaseproof) paper *folded to preserve a swatch of color.*

(1) Light colors are mixed first.

(2) Dark ones are added.

(3) Extenders and reducers are added when necessary.

(4) Thinners are added when necessary.

Finally, the color is rolled out evenly on the slab and a scrap of paper is pressed into the ink film with the fingers. This is again matched to the original, and this time acts as a guide to the ink thickness needed in printing the block. A more exact form of test is to ink a small area of the block, and to print it, under correct pressure, on a sample of the actual paper to be used.

The matching of color to the first proof, or to a second or third run when a print is editioned in different batches at different times, is always a difficult matter. Some excess color should be mixed when making the first proofs, so that ink left over can be packed in wax paper, greaseproof paper, or plastic sheet, and filed away. This will help in later remixing, since it is always better to match the new color to a solid ink sample than to color already printed.

The method of wrapping the color for future use lies in folding the paper so that air, leaking in slowly, will seal the package round the sides. The paper is first folded double over the color sample, and each of the three remaining edges folded tightly forward in turn; finally, a rubber band is snapped around the package. When the color is again wanted — perhaps weeks or even months after the ink was wrapped — a corner of the pack is snipped away with scissors and the color squeezed out like an ordinary tube of paint. The little plastic bags commonly sold in American food markets (to wrap sandwiches or fruit) would no doubt prove equally effective for this purpose.

The color and tone of a given impression will be "correct" only when the block has been correctly inked and packed. A sensible precaution, when uncertainty exists, is to remove a sheet or two of the packing. This lightens the pressure on the block, giving you the option of deepening the tone by replacing any packing removed. You will find it more effective to darken a weak color already printed, than to lighten one already too dark by the process of stripping, described later in this section.

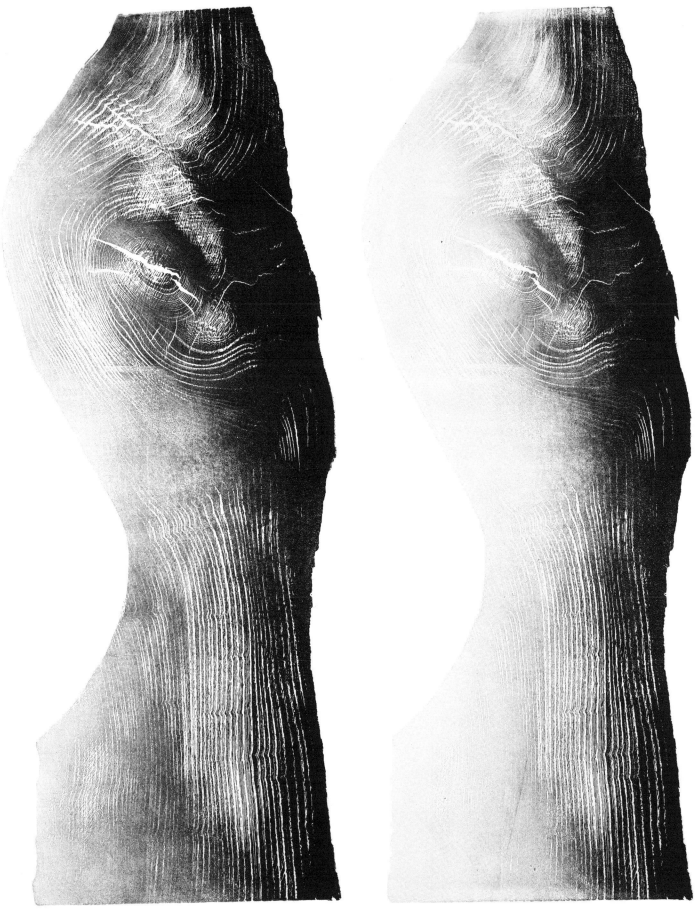

Medium grading.

Light grading.

To check the color of your print against another color, already printed, small viewing holes are cut from pieces of white paper, one is placed over the newly printed color and one over the color to be matched so that each is seen relative to the white of the surrounding paper. Since all color is influenced by adjacent color as it is perceived in the retinal mix, this isolation is necessary for any accurate judgment to be made.

## Graded Color Printing

For graded color printing, using two colors, the inks are picked up from the ink slab at opposite ends of the roller and the colors on the slab must be set out accordingly. As the roller turns (provided that you run it back and forth in a single direction) a mixed color band is formed in the center, separating the purer color at the two extremes. Either for inking the block or for charging the roller, this single direction must be maintained. More than two colors can be used for this method, provided that a neutral band is built up between the "pure" colors on the roller.

When a large surface is to be inked, a large roller is necessary, since the roller must span the whole width of the printing area. In many art departments, rollers 8" x 24", 10" x 24", or 8 x 30" are in general use. These are made to order to the required proportions, and covered with any of the materials used for the smaller hand rollers discussed in section 4 on "Tools and Equipment."

## Graded Printing in Black and White

Black and white graded printing is done on the same principle as graded color printing; but, in this case, the ink is fed from one end of the roller only. Ideally, the roller should span the width of the block, just as in using color. A long, narrow block, the shape that follows the run of the roller, is the one that lends itself most readily to this type of inking.

## Color Rejection

Sometimes color dries on the paper with an exceptionally hard surface, showing a tendency to reject further color in overprinting. This sometimes happens when work has been interrupted, and printing continues only after a lapse of some weeks. In this case, the first colors printed may have formed an impervious skin, offering no foothold to a subsequent printing. An excess of driers in the ink may also cause rejection, the driers acting on the ink to cause a crusted, horny, and sometimes glossy surface.

Three methods are used to overcome this difficulty:

(1) Dusting with French chalk. This tends to matt the existing color surface, helping it to accept a fresh layer of ink.

(2) Wiping over with a diluted solution of oxgall used in a swab.

(3) Mixing some mineral spirit or white spirit with the color used for overprinting. This should act as a solvent on the existing surface of ink.

## Stripping

The process whereby excess ink is removed from a freshly printed sheet is known as stripping. It is used for reducing either a too heavily printed color, or to reduce unwanted gloss on a film of freshly printed ink. Stripping is done by placing a clean sheet of absorbent paper upon the block (which is left in position on the press carriage) the print is next laid face down on the blank sheet, and again run through the press. The greater the pressure used, the more ink will be taken from the print; and if the surface of the blank sheet is first sprayed with gasoline (petrol) the action of stripping can be drastic in its effect, reducing a heavy color to a considerably lighter shade.

Care should be taken if newspaper is used: freshly printed newsprint will "offset," leaving a gray impression on the surface of your print. Tissue paper, newsprint, imitation Japanese paper, or the backs of discarded proofs, are all effective materials to use.

When stripping is necessary to remove gloss from a heavy overprinting, care should be taken to avoid unduly weakening the color. An experienced printmaker will know just how much to overink the block, when printing it, so that, in stripping, the color intensity will be brought down to the needed tone.

A color printed on highly absorbent paper is generally difficult to reduce by stripping, since the paper itself will

have drawn most of the ink into the body of the sheet.

Stripping can, of course, be done by laying the print face up, putting a sheet of absorbent paper on top, and rubbing vigorously with the fist, or with a clean roller; but compared to press stripping the pressure used is comparatively light; though gloss can be removed, it is difficult to reduce tonal value by this method.

## Dusting

The gloss of oil ink (overprinted color is sometimes unpleasantly shiny) can also be reduced — just as in lithography — by spreading talcum powder, or powdered (French) chalk on the wet, newly printed, ink. The powder is spread liberally, but lightly, over the ink film with cleansing tissue, absorbent cotton (cotton wool), or a soft hair brush. Excess grains are brushed away by flipping with a clean rag. Dusting will effectively dull the surface of glossy color; but it will make it lighter in tone and more opaque in appearance.

## Hand Printing

**Whatever improvements take place in the print-maker's equipment with the increased mechanization of presses or the growing sophistication of photographic or other aids, direct manual methods should never be neglected. For the relief process, hand printing is one of the basic procedures — as basic as the method of applying paint to canvas with a brush. Hand printing, in any case, allows us to get impressions from objects we cannot put in a press: objects too large or irregular, or objects that have a curving main face. We can also take the needed materials (ink, paper, and burnishing spoon) to locations where no presses are available, and thus get impressions of objects "in situ": a gear wheel, the worn boards of a floor, the graffiti scratched on an ancient wall.**

**Hand printing is clearly invaluable in any school where children or young students are first introduced to printmaking. Equally, it is necessary to the summer school held in some outlying district, and more significantly still in states or countries where press facilities of any kind are lacking.**

## Hand Method

For hand printing the paper is placed face down on the inked block, and a heavy weight put on top to grip the sheet firmly in position. For large blocks, two weights are necessary. They should weigh anything from seven to ten pounds, or more. (I have found that old counterweights, the sort once used for sash windows, are excellent for this.) As work proceeds, the weights are moved, allowing each part of the block's surface to be printed by turn.

Spoons, burnishers, and Japanese barens are used in hand printing; choice is a matter of personal convenience and the type of work involved. For printing large blocks, a wooden spoon is generally used: a hardwood salad spoon — the kind bought almost anywhere in markets and housewares stores. A spoon of this sort is comfortable to hold, and has a broad, rounded under-surface, becoming polished with wear. The more use it gets, the more effectively it prints, so that old spoons become favorite tools.

The Japanese baren has a still broader surface, and hence exerts less pressure in any given spot; it prints effectively enough, however, when a fairly fluid ink is used. For the present day Japanese printmaker, often employing a fluid waterbound pigment (as well as oil ink), the baren is a favorite printing device. It is useful, in any case, whatever pigment is employed, to speed the preliminary hand proofing of a large block.

Common sense will indicate that the smaller the block, the smaller the burnisher required. For a small, finely cut block, an agate, bone, or metal burnisher is used though some printmakers prefer the rounded handle of a silver teaspoon. Various types of burnishers are obtainable through the printmaker's supplier.

For hand printing, the block is inked rather more thickly than for press printing and, as a general rule, the ink used should be normally fluid rather than stiff.

A large block should be placed at the corner of the printing table for the convenience of work. Once the paper is firmly locked in position beneath the weights, burnishing can be started at any chosen portion of the block. The spoon handle is held with the right hand, (assuming the printer is right handed), while the fingers of the left hand press into the bowl.

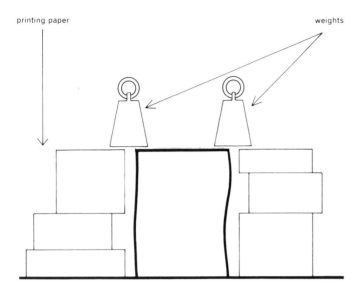

printing paper

weights

If you want to print a section of a treetrunk, *or a block of a similar unwieldy form, you should build a platform at one side, or better still at both sides. This will give stability to the block and will allow more room to reposition the weights as you burnish.*

To insure an even distribution of pressure, the strokes of the spoon should be smooth and even, using consistent systems of parallel, angled, or rotary strokes. The spoon should become an extension of the fingers, feeling out the surface of the block as the work proceeds. This process of "feeling-out-by-touch" applies especially to the printing of found objects, or to any blocks of irregular or heavily textured surface. In printing a hand worked block with widely spaced lines, the angle of the wooden spoon should be kept as low as possible. This should prevent picking up ink from traces left by the roller on the cut away portions of background. To get a full impression from an exceptionally uneven surface, the spoon can be turned at an angle, using the edge and tip as well as the belly. The fingers, thumb, or a pad of rag can be used to drive the paper into the pits and hollows. If the block is very uneven, the paper may "walk," or shift beneath the weights, with the movement of the spoon or burnisher. If this danger is present, finish each section as the work proceeds, to avoid a blurred or doubled image. When the edges of the block are reached, alter the position of the stroke until the spoon is at right angles to the edge; otherwise the spoon may slip, tearing and damaging the paper.

Place the weights to one side of the block, and lift the free half of the proof when the work needs to be inspected. The weights are moved again to examine the remaining half of the print. But never remove them altogether until the image has been properly checked, since if the print needs repositioning on the block for further work, the image is likely to go out of register.

Though a well used spoon gets polished with wear, there may still be difficulties when burnishing on certain kinds of paper. Filter papers, and some Japanese papers, may have a slightly rough reverse side, making the movement of the spoon sticky and difficult. In this case, a trace of beeswax is put on the underside of the spoon; for the same reason the Japanese may put a touch of camelia oil on the baren before starting to print. If waxing the spoon does not answer the purpose, a piece of thin, smooth paper is put on top of the print during the process of burnishing. If the block is rough in texture, and wild in contour, this protective sheet may be needed in any case. This is because the protective sheet becomes

polished wherever the spoon has been used; so the glossy areas act as a guide, showing where pressure should be applied, and where the ins and outs of the contours are. This will speed the process of burnishing, and help to avoid tearing the paper if the spoon is pressed too far across the edges of the block.

Hand burnishing can, of course, be used in combination with press printing, a method yielding some of its most effective results. In certain cases, burnishing allows added control over the image; a given area of color, for example, can be intensified by burnishing *after* the print has gone through the press; or a fuller image can be made from a rough block by burnishing the paper into the surface hollows even when the impression has been taken by the "soft pack" method.

Sometimes, in the summer school, we have been tempted to take prints from cross-sections of tree trunk. Up in the woods at the Haystack Mountain School of Crafts, off the coast of Maine, and equally at Voss in Norway, where the school is close to pinewoods by the shore lake, we have taken ink, rollers, and paper to locations where we knew that trees had been cut down. On some of these trips, the hot summer sun of Maine, and the absorbency of crosscut timber, became our two enemies, the heat of the sunlight drying and stiffening the ink and the spongelike grain sapping it up before the print could be taken. Only by locking the paper in position with a heavy stone, and re-inking the block, section by section, as work went on, could we get a strong and clear impression of these remarkable forms.

## Foot Printing

Since block cutting and printing are often done by individuals or groups, where no press facilities are within reach, we should not overlook any methods that may provide some practical result. These are likely to prove their value in the country summer school, the poorly equipped primary and secondary school, and in many of the new university art departments in the developing countries in Africa, Latin America, and elsewhere.

Large linoleum blocks can be printed by the simplest of all methods: by using the weight of your own body, controlled by the pressure of your foot. In this procedure, the sheet of paper to be printed is placed face upwards on the floor, with a thick pad of newspaper (twenty or thirty sheets) beneath. The printing paper is placed on top of the pack, and the inked block lowered face downwards upon it. Pressure is applied by standing with both feet on the back of the block, stamping with the flat of one foot, while keeping the other stationary to grip both block and paper in position. It is the pad of newspaper, providing a minimal factor of bounce, that enables your weight to take more ink from the block than would otherwise be possible. When several blocks are used, registration is done by sight, using two opposite corners of the first impression as a guide.

Perhaps surprisingly, this method gives effective results, certainly for large and broadly cut images. The ink must always be thickly applied to the block. In the case of overprinting, the color is likely to have a glossy, enameled look, occasionally slightly mottled, but with a glossiness of surface capable of providing great richness of effect.

## Roller Printing

Roller printing is another basic printing technique, widely used in schools for young children. In this method too, the block is thickly inked, but pressure is applied by pressing an uninked roller backwards and forwards across the back, of the sheet, which is placed face downwards on the inked block. The paper is held steadily in position with the left hand; but for large blocks, weights should be used to lock the sheet firmly in position. A thin, highly absorbent paper will show the progress of printing through the back of the sheet.

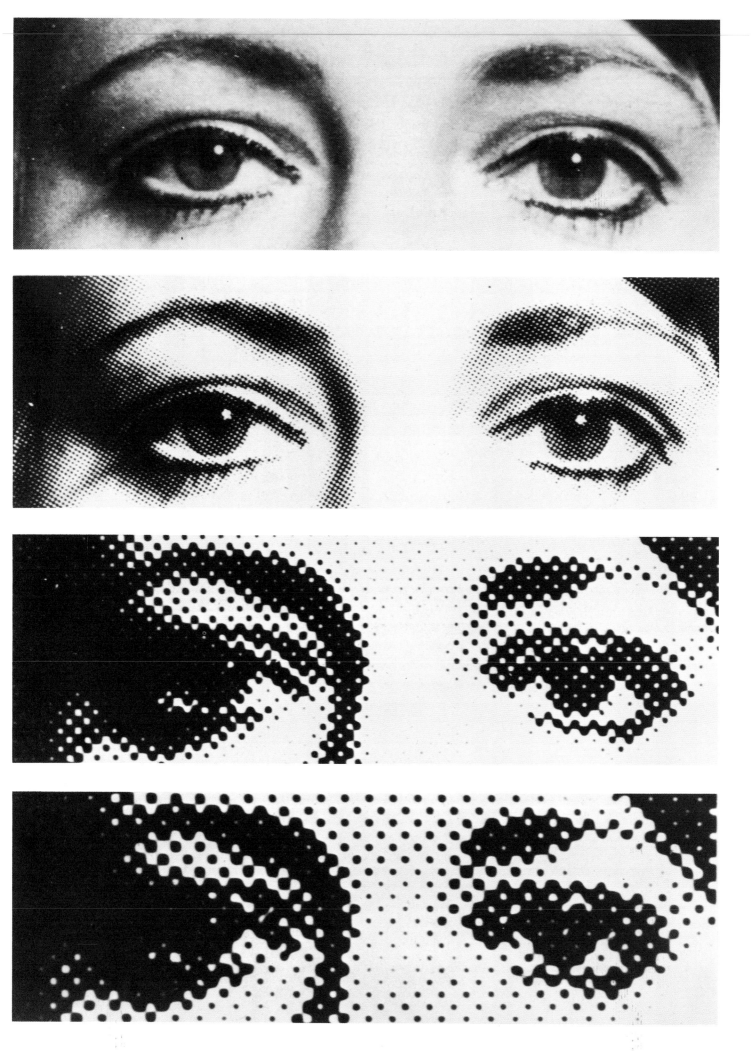

# 11

# INDIRECT PRINTING METHODS

By using certain photographic techniques in combination with relief printing, the frontiers of the operation are enormously widened. The technology of photographic printing is one of the outstanding innovations of this century, and certainly the one affecting the printmaker most immediately. Many fine printmakers will, I know, object to these procedures, believing that to destroy unity of means is finally destructive of unity of message. Such confrontations — between the hand crafted image and the photo-aided one — will be fought out by each printmaker in the privacy of his own mind; for my part, however, I believe that we can hardly afford to leave the potential of the "combine" and photographic techniques untried, committed, as some of us find ourselves, to regarding potency of message as taking absolute precedence over any notions of unity or purity with regard to techniques.

For many of the processes discussed, it is essential to be familiar with darkroom practice, so that original thoughts on the photographic process will grow up naturally as work proceeds, just as, at the press itself, ideas are sometimes generated by the interest and diversity of the processes involved.

In the long run, the artist's images are always likely to benefit from the excitement of personal discovery. In this sense, the present day student has been given a unique advantage over his seniors. In many schools and colleges, he is able to work with sophisticated equipment, and with the expert help of professional photographers. There must be few printmakers over thirty-five who share with the student this highly specialized form of experience, experience certain to prove essential to printmakers of the future.

## Line and Halftone

A photographic screen for screen printing, or a metal plate (called a block in Britain) for surface printing, is prepared for the printmaker in the form of either line or halftone.

Line means that the forms are interpreted in terms of black and white alone, without intermediary grays. There is, of course, no limit to the detail a line image can give, or to the intricate structure of its marks, provided only

Progressive dot screen enlargement.
*(Research and photography by Graham Clucas.)*

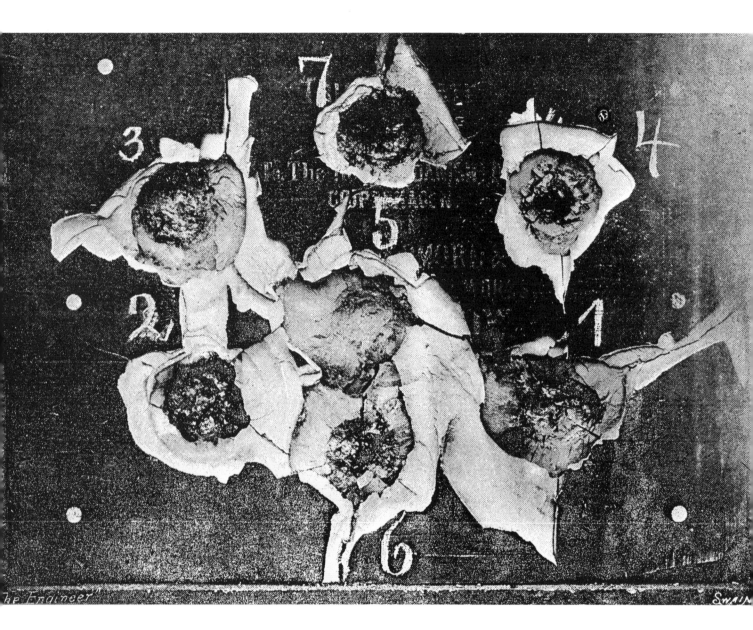

Three different halftone interpretations of the same image.

that the black and white interpretation is retained throughout.

A halftone reproduction, on the other hand, as its name suggests, will interpret grays as well as blacks. It does not directly imitate the original, but turns it into something entirely different: a mosaic image made up of minute dots. It is true that this may not always be an undesirable result, a matter we will return to presently. On the other hand, the dot structure may deaden the image. The original, for example, may have areas that contain no marks, where the white paper itself adds its own quality of brightness; but in the halftone interpretation, these areas will be reduced to light gray, the tonal range of the original image slightly flattened and leveled off, and the white speckled over with tiny points of black. However, a more expensive dropout halftone will delete the dots in the white areas.

In dot screen reproduction, more sophisticated photomechanical methods are called for than in the case of line. What the process camera sees, in the interpretation of an image, is different from that which the eye sees. Everything in this case is broken down, as we have noticed, into a mosaic of tiny dots: small and widely separated for the light parts of the image; large and close together for the dark parts. Under a magnifying glass, the structure of the image is thus seen as a closely organized system of points, densely or thinly grouped according to the tones of the original.

How this mosaic is formed is not always predictable, even to a photographer or photoengraver of experience. Hence, it may be best to have more than one version of the original to hand, and to consult the photo technician before deciding which of them to use.

In the case of screen printing, the Kodalith film, from which the printing screen is made, will always produce a slightly coarser grain of tone than appears in the original; and again, this interpretation of the image will be fractionally coarsened in the resulting print. But this slight coarsening is not necessarily a disadvantage. Much can be lost in small modulations of tone, or sharpness of detail, without detracting from the potency of the total image as it is optically received.

Richard H *(27″ x 30  1/2″) from a set of five photo screen prints,* Richard Hamilton, *1967, by Harold Cohen.*

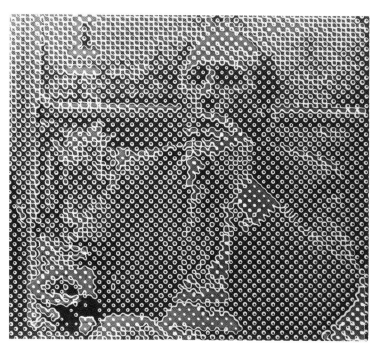

Richard I *(27″ x 30  1/2″) from a set of five photo screen prints,* Richard Hamilton, *1967, by Harold Cohen.*

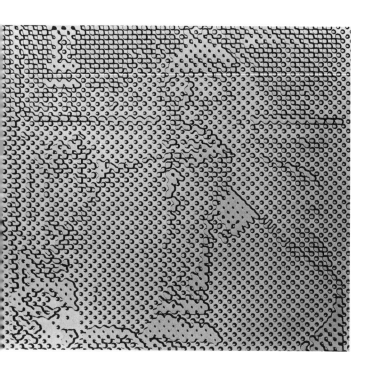

Richard IV *(27″ x 30  1/2″) from a set of five photo screen prints,* Richard Hamilton, *1967, by Harold Cohen.*

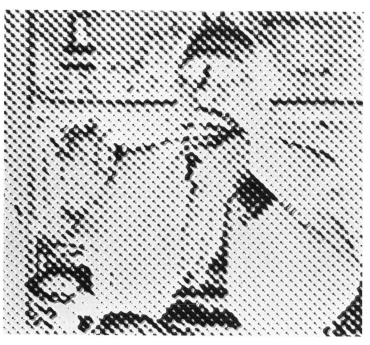

Richard V *(27″ x 30  1/2″) from a set of five photo screen prints,* Richard Hamilton, *1967, by Harold Cohen.*

## Screen Interpretation

The dot screen, clearly enough, belongs to the general character of photo-reproduction. It is often acceptable, even attractive — in certain cases, the coarser the screen, the more attractive. The dot screen has the beauty of a consistent and brutal proposition, consistently translating the lights and darks of the original into its own terms. In viewing a fine screen halftone on the other hand, we tend to "find" the image behind or beyond the screen — the brutality is entirely lost in a field of graded, silky tone. The fine screen interposes a mesh of nearly invisible dots between our eyes and the objects represented. A coarse screen has the opposite effect. It breaks down the original picture in terms of an obvious and insistent mosaic. Caught in this powerful mesh, the objects are brought forward, and hung flat on the surface of the page.

The contact screens used for making continuous tone negatives or positives for silkscreen printing are normally made in fine rulings from 65 up to 133 lines to the inch. These dots, almost invisible to the eye, are often impossible to screen print by hand. They can, however, be enlarged at will by putting the dot screen onto a small negative, which is then enlarged before making the Kodalith.

The cost of large glass or plastic screens limits both their size and numbers in the art department. Thus, a large image may well have to be reduced in order to fit the screen, and subsequently enlarged; this again will automatically increase the coarseness of the dot. If the original is drastically reduced, relative to the dot structure used, an extremely coarse mosaic will result in the subsequent enlargement. In other cases, where the screen is smaller than the work to be used, two or more sections of Kodalith must be joined together in making up the image.

The artist, Harold Cohen, has used enormously coarse screen ruling of only four lines to the inch. Cohen has discovered that contrast in the size of dots can produce optical effects of great richness and brilliance in color printing. Cohen himself devises these dot systems in his own darkroom; this puts him in a strong position, since directing the operations of a professional phototechnician is a method tied permanently to secondhand control.

## Screen Printing

The technique of screen printing is in a state of evolution. This is in sharp contrast to relief methods, which are dependent on equipment and procedures largely unchanged. Under the stimulus of wide commercial application, the textiles, stencils, printing media, and photographic aids of screen printing show steady and rapid improvement. Relief printing, too, shows certain benefits from the expanding rate of technology, particularly in the field of improved printing rollers and some new kinds of paper; but the platen press remains fossilized — stuck fast in a primitive state of evolution. Though we are now introducing some more modern presses — proofing and combination presses — we still suffer from a disturbing dependence on outdated equipment. Thus, screen printing, in spite of its ancient stencil origins, is more open to reflect various sophisticated developments particularly in regard to photo-technology.

The relief printer can now avail himself of many of these advances with the use of the mixed media print, processing the appropriate parts of the image in either screen or relief printing, as the case may be.

For a relief and screen combination print, the image is partly processed at the screen printing table and partly at the press. Those parts of the image that are screened, however, will show no indentations on the back of the sheet — the slight relief marks that a relief block gives. This is because screen printing is a planographic process, meaning that the image is taken from a flat surface (the stretched mesh of fabric on the wooden frame) and that the sheet of paper remains entirely flat during the operation of printing. Squeezed through the tiny holes between the fibers of the fabric, the grains of pigment are deposited comparatively lightly on the paper, while the relief block, under the pressure of the press, tends to force the ink down into the body of the sheet.

Screen inks, however, have greater covering power. The coating left by the screen may be dense and opaque, and this capacity of the ink film enables you to print a light color over a dark one — white on black for example, or bright yellow on deep blue — while still preserving the brilliance of the overprinting. This is an effect generally

Moonstrips Empire News,
Secrets of Internal Combustion Engine,
*photo silk screen (15" x 10"), 1967,*
*by Eduardo Paolozzi.*

unobtainable in relief printing, where the dark ground color will always tend to grin through, turning the white to a tepid gray — the translucent gray of skimmed milk — or a yellow overprinting, on blue, to a sickly green.

Screen ink is capable of great brilliance — a dazzling brilliance when transparent, fluorescent color is used. It can also be printed with clean, perfectly tailored edges, achieving a sharp, enameled brightness — cool, inert, and textureless. These properties accord triumphantly with an artist such as Vasarely, whose ordered, clearcut, and powerful vision calls for just such qualities in the printed image. Further, the consistent covering power of opaque screen inks carries certain practical advantages. Vasarely, for instance, has numbers of sheets screen printed with a standard color range. These same colored papers are used, cut into fragments, to form the collage maquettes for his screen images. Hence, in using an identical range of inks, the printer is able to attain an absolutely accurate color match.

While the relief process demands the use of highly absorbent surfaces, screen prints can be done effectively on both absorbent and nonabsorbent ones. The screen image can, indeed, be used on virtually any material: wood, metal, glass, cardboard, acrylic, plastic, etc.

Screen inks are either oil, cellulose, or synthetic based — the synthetic inks consisting of various plastic compounds.

When transparent screen ink is printed on absorbent paper, a large quantity of the liquid ink is taken up and absorbed by the sheet. If several such printings are superimposed, an effect of great depth and brilliance is attained.

## Photo Stencil

There are two methods of preparing work for making a photo stencil: the most direct way is to use a transparent film bearing a black image for transfer to the screen; the other way is to make an opaque original in black and white that can be photographed and thus transferred. The latter is simply a black image on white paper or board, which may include lines, brush-marks, or marks of any other kind, including impressions from found materials or halftone plates — any black mark, indeed, which the camera is capable of picking up on film.

At the moment of writing, I am preparing an opaque black image for a photo stencil that includes relief impressions of pierced and perforated metal sheet and two (much enlarged) pulls from photoengravers' plates, as well as elements painted by hand.

A great many factors are involved in photographing the original image and in the photographic work involved in making the photo stencil. For those students or professionals who wish to study the subject in some depth, two books are available: *Photographic Process Printing* by Albert Kosloff and *Techniques in Photography for the Silk Screen Printer* by Robert O. Fossett. As regards the more general run of procedures described in the short account following, the reader can do no better than to consult *The Complete Book of Silk Screen Printing Production* by J. I. Biegeleisen for a much fuller description than would be suitable for inclusion here.

The simplest way of transferring a relief image to a screen is to take a pull on a stable plastic material or acetate sheet, such as Kodatrace, with a stiff, dense black oil based ink. The ideal black image for making the photo stencil produces the blackest possible image on the clearest possible film. Taking a surface print of this kind, however, presents some difficulties. For one thing, the plastic sheet is entirely nonabsorbent; as a consequence, the pigment has a tendency to squash and blur under the needed pressure for effective printing. Being nonabsorbent, the plastic draws no ink into the body of its material, so that dense blackness must be achieved with a surface coating alone, though dusting the wet ink with a dark powder color should certainly increase the opacity of the ink film. To test the blackness of your print, hold it up against clear daylight. Should it still remain a dense black, you may safely assume that it will make an effective positive for the photo stencil.

Used on acetate, printing ink dries slowly unless a strong drier is added. Failure to add driers may mean that ink will remain wet for days, or even for weeks. Further, being tough and perfectly smooth, acetate sheet is difficult to use on a rough, wavy, or warped surface, such as corroded metal or weathered wood. In this case, it will tend to slip in printing, and parts of the image will be out of register.

The black pull is the positive from which the photo

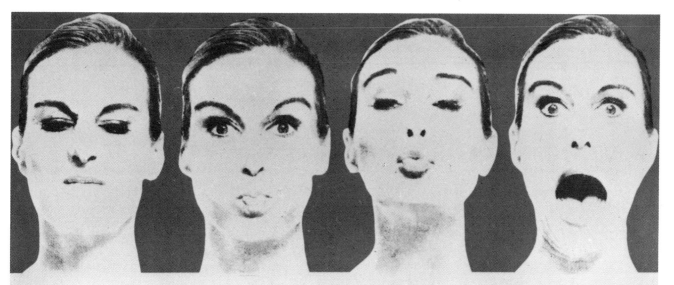
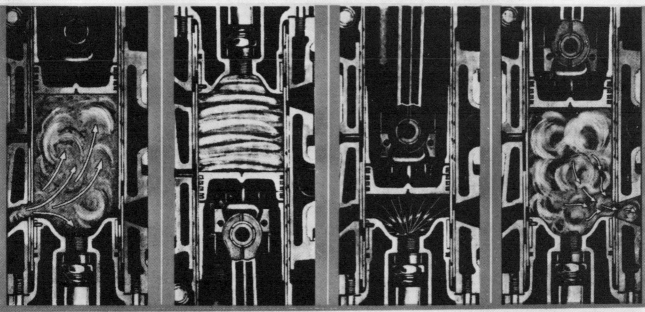

stencil is made. From this point, there are two basic methods of making a photographic stencil: one is the direct method, the other the transfer method. In the direct method, the screen itself is sensitized with a liquid solution, placed in contact with the positive, and exposed to the light source. It is then developed and washed out, so that the stencil is created directly on the screen. The transfer method involves much the same steps as the direct method, but in this case the photographic gelatin coating is sensitized and developed while on a temporary plastic support. The gelatin layer is then transferred to the screen and the plastic backing peeled away.

There are several ways of varying the basic methods described. But only one has been selected for description here as being of very general use in considering the potential of the photo stencil method relative to the relief "mixed media" print.

To continue: The black pull is placed upon the glass platform of a lightbox so that it faces you, appearing the same way round as it will appear when finally printed. The photo stencil film, which is cut 1" larger all round than the positive, is now placed on top of the black positive, with the emulsion, or matt side, upwards. This leaves the backing side of the film in direct contact with the positive, and facing the source of light below. It is difficult to give accurate rules for exposure time as this will vary with the different factors involved: the type of positive used, the nature of the image, the distance from the light source at which the work is done, and the type of light employed. As a rough guide only, Biegeleisen gives an exposure time of ninety seconds at 36" from a 35 amp single arc lamp for "average" conditions. Exposure time must remain a matter of experience and careful judgment. Making a test before large scale or important work is always a sensible precaution. But a positive that includes very fine detail — particularly fine detail isolated against a clear background — should be exposed for a shorter time, about half the time of normal exposure. If the positive has been made on semi-opaque material, such as thin tracing paper, about double the average time should be allowed.

To qualify the particular recommendations made here, and to suggest principles that can be more generally applied, the following may be taken as useful guides.

(1) The more powerful the light, the briefer the exposure time needed.

(2) The more transparent the positive, the briefer the exposure time needed.

(3) The finer the detail, the briefer the exposure time needed.

When exposed in the lightbox, in contact with the photosensitive film, the black pigment of the positive blocks the passage of light, protecting the emulsion against the hardening process that occurs as the result of the exposure. Hence, the areas below the opaque areas of the black positive remain soft, and are eventually washed away with water to form the stencil through which the printing ink passes. The clear parts of the material, on the other hand, allow the light to pass through, hardening those parts of the emulsion left unprotected, a process that is always exactly proportionate to the amount of light received. Hence, if the exposure to light is too brief to penetrate the full depth of the emulsion layer, only a thin coating will be left when the unhardened portions of the emulsion are washed away. In consequence a thin and fragile stencil is produced; one that is unlikely to stand up to the repeated friction of cleaning, if inks are changed often in the screen when the image is finally printed.

After processing in the lightbox, the film is immersed for one minute in a solution of one part hydrogen peroxide to four parts water. "Autotype" powder activator can be used as an alternative agent. The procedure further fixes those areas of the film already hardened by the action of light. The film is next sprayed with warm water, at a temperature no hotter than 110 degrees. The spraying is done from the top edge of the film, working downwards, stage by stage, as the film clears. Washing for too long should be avoided or adhesion to the screen mesh may prove difficult. After rinsing with cold water, the film is laid, perfectly flat, on the underside of the screen; the film sticks to the screen as the emulsion is soft, and when the screen is rubbed with the roller, the nylon threads are pressed right into the emulsion.

Before the film is laid, the fabric is degreased with a 2% solution of caustic soda. If a nylon screen is used, it

should also be lightly scrubbed with scouring powder. The screen is now placed, film side down, onto a sheet of newsprint: another sheet is put on top; and the interleaved film is rubbed lightly over with a roller. This will remove excess moisture, a process that should be repeated at least three times, when all the moisture should have been absorbed. The photo stencil film must now be left to dry. After approximately one and one half hours, the backing sheet can be peeled away and the film will adhere. A cold fan will hasten the process of drying.

## Size of Screen Mesh

These are the factors to be considered in the choice of screen mesh. For fine detail, or halftone, a high mesh count is necessary; otherwise tiny sections of the stencil film (or in halftone, some of the dots themselves) will fall *between* the threads and will therefore fail to print. Transparent color, too, requires a fine mesh, with small spaces between the threads.

It should also have a high "snap-off" distance. "Snap-off" distance is the name given to the space between the taut mesh and the paper beneath; this is normally about 1/4". Hence, the only part of the mesh touching the print will be the part pressed down by the sharp edge of the squeegee in printing. It will be in contact with the paper for only a fraction of a second, as the squeegee is passed across the screen, allowing time for only a minute quantity of ink to run through the mesh.

If you need a thick deposit of ink, however, or need to cover a dark color with a light one, you should use a gauge of silk, nylon, or terylene with plenty of space between threads. This will allow a large quantity of ink to be deposited on the printing surface. Stainless steel mesh is another possible material; the actual thickness of the sheet in this case will insure a heavy coating of ink, though recent developments in this type of screen will also allow an extremely high mesh count.

## Lateral Reversal

There is no lateral reversal (no mirror image) in screen printing: the print appears the same way round as the original. This will be considered a particular advantage in the case of hand drawn lettering. If you want to combine screen and relief, a sheet of transparent acetate can be placed over the original, and a drawing made for those parts of the image to be screened. The black drawing is used as a positive to make a photo-stencil as already described.

## Scale of Screen Prints

There are few limits to the size of screen prints. Very large frames can be constructed to carry the fabric and since the screen is placed face downwards on the paper, the sheet has no need to travel between the posts or sides of a printing press, a factor that usually sets a limit on the width of paper used. Standard vacuum printing tables are made that will print an area up to 40" x 6'; but to get even pressure over a screen of this size, a one-arm squeegee should be fitted to the frame. Should you consider going beyond this size, a limit of about 10' is set by the practical length of a squeegee which two people, working at opposite sides of the printing table, could handle effectively. A very large table could, of course, be constructed for printing, provided only that its surface is made absolutely smooth for its entire length.

An image of masterful size can be made up from smaller screens, a method employed in both the textile and wallpaper industries. In this case, the size of your print is limited only by the size of your paper, or other type of printing surface.

## Halftone Plates: First Trials

I started using this type of image by making trials from the old halftone plates (known as blocks in England) in a printing department storeroom, with the help of my students at Camberwell School of Arts and Crafts. We made a number of pulls from various types of plates, on different types of paper, and soon found that on a smooth enough surface, and with careful inking, even fine texture screen plates would give a good impression on the hand presses we used.

In using photo plates for the first time, one has the feeling of entering a new world: a world that conforms no longer to the old frontiers of the possible, but one that places an "impossible" referential range suddenly within reach.

Negative and positive. *Once a photographic negative has been made, photography offers a direct exchange between positive and negative. The negative can be converted either way. A negative produces a positive print. But if this positive is made on film, this can produce a negative print. Reversal can also be achieved by printing a halftone letterpress plate intaglio. On the left is an enlargement of a halftone letterpress plate. On the right is an enlargement of the same plate, printed intaglio.*

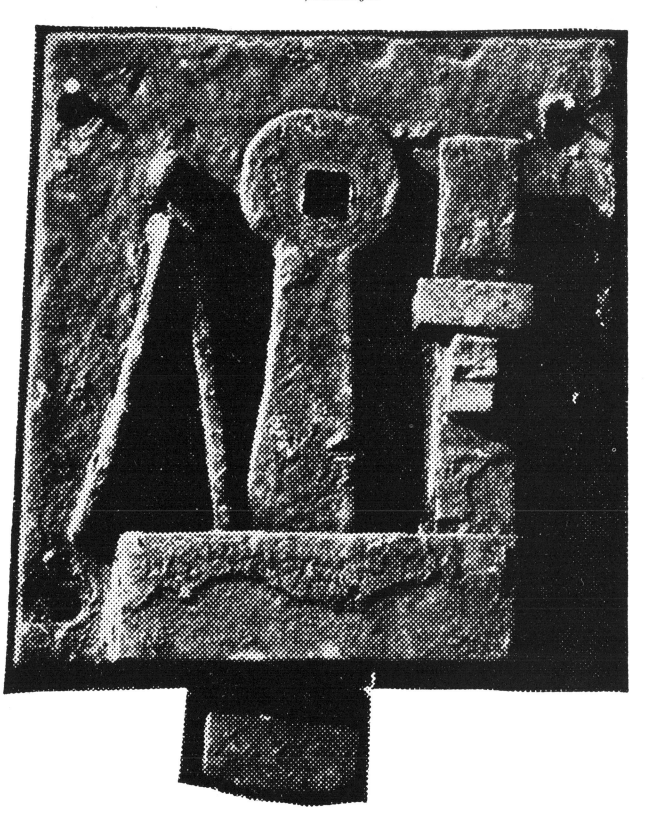

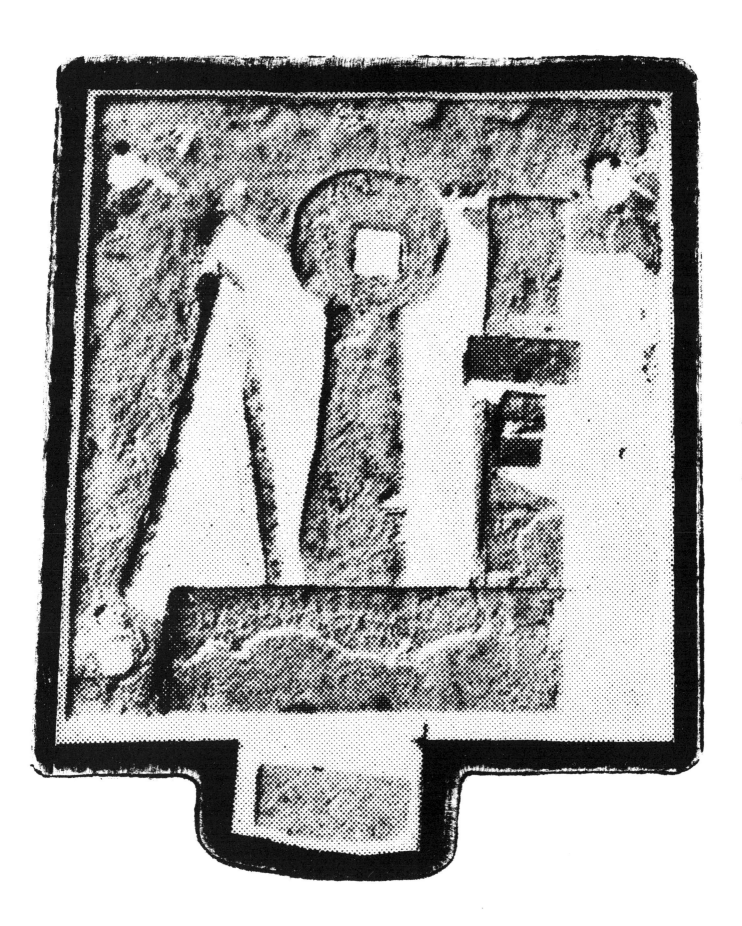

Since I began employing this type of block, I have developed a particular feeling for it. Firstly, I find that the halftone plate, with its dot system of graded tone, acts as a foil, sharply contrasting with the hand worked block. When gouges and knives are used on sidegrain timber, the natural scale of the block is often fairly large, and the optical impression of color printed from these blocks tends to lay particular emphasis on breadth and flatness. Where lines are cut or carved, the effect of these lines is often hard, vigorous, and open in the resulting image. The halftone plate, where it is used with these techniques, introduces an abrupt reduction of scale; between the two methods, a gap is set — often a very wide one. There is an emphatic change of pace, a quickening, an intensification; the image moves into a higher, and perhaps a shriller key. I find this very exciting.

The second reason concerns a very basic technical point. Like the woodblock, the letterpress plate yields a direct surface print. However different in character it may be from the hand carved block, it still belongs, finally and in a special way, to the values of surface printing. Used with other types of relief blocks, it has a rightness, a sharpness, a particular emphasis, that neither screen printing nor lithography is capable of giving.

There is also a practical advantage. The letterpress plate is immediately available to the existing work facilities of the relief print studio — to the rollers, inks, methods of packing, and the different ways of setting up the press.

Only if certain imperfectly smooth papers are employed, a difficulty arises, since the halftone plate, with its close system of dots, needs a smooth surface to achieve its full effect. However, on most of the papers normally used for relief print editioning, a coarse screen halftone will print effectively enough.

## Work Method

The ideal screen size for hand inked plates, printed on a hand operated press, is 55 lines to the inch, though it will be obvious that a more sophisticated type of press will print effective images from plates of finer texture. Screen size indicates the number of dots to the inch; in a 55 line screen, there are that number of dots to the inch, the relatively coarse screen size used in most newspaper reproduction until a few years ago. But improvements in the quality of the newsprint now available make plates of finer texture practical for the picture reproduction in our daily papers. With these developments, the 55 line screen has gone out of fashion, and not all platemakers in England or America carry the necessary type of screen to make plates of such coarse texture. The 65 line plate, which is generally easier to obtain, gives a good deal of trouble when inked by hand and printed on the handmade or other heavy papers used for editioned prints. In this case, the dots of the screen may merge, giving a smoky, patchy effect, particularly in the darker tones.

It is best to use a hard or fairly hard roller, since this will ink only the top points of the metal. A soft one should be avoided; it tends to deposit ink over the edge of the upstanding shoulders of metal, and this will automatically over-ink the block and cause the resulting impression to be partly filled in. It is equally important to use a large roller when this is available; ideally, the roller should be long enough to span the full width of the metal. But when the plate or block to be inked is small, it is also helpful to place two metal plates (of equal height to the printing surface) at each side, giving extra support to the roller. This device should insure a level action as the roller moves backward and forward over the face of the plate.

## Ordering the Plate

In ordering a plate from the photoengraver, the photograph (or other material) is first pasted down on stiff white paper or cardboard with rubber cement (cow gum); the adhesive used should contain no moisture, as this will swell the paper and prevent the work from remaining flat. A perfectly flat surface will enable the photoengraver to get sharp and equal focus over the whole image. The dimensions of the wanted plate (either height or width) are clearly marked to one side of the image, together with the screen size necessary.

If a plate is to be contoured to the free shape of the work to be reproduced, it is ordered as a "cutout." In this case, the metal is trimmed to the edge of the image.

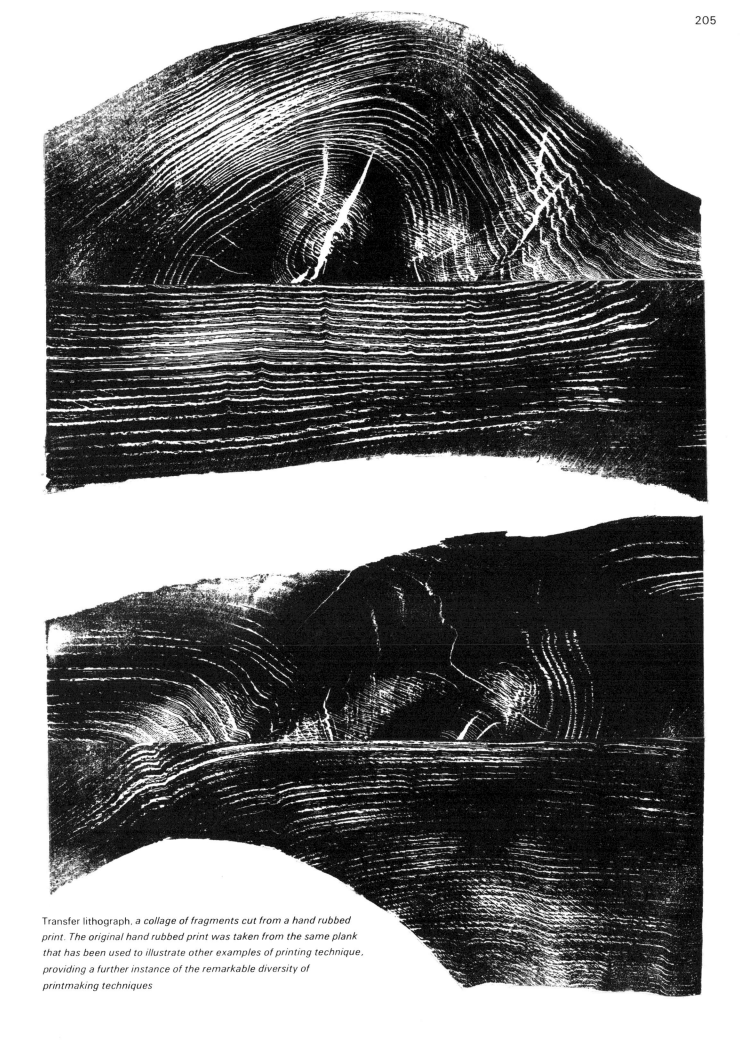

Transfer lithograph, *a collage of fragments cut from a hand rubbed print. The original hand rubbed print was taken from the same plank that has been used to illustrate other examples of printing technique, providing a further instance of the remarkable diversity of printmaking techniques*

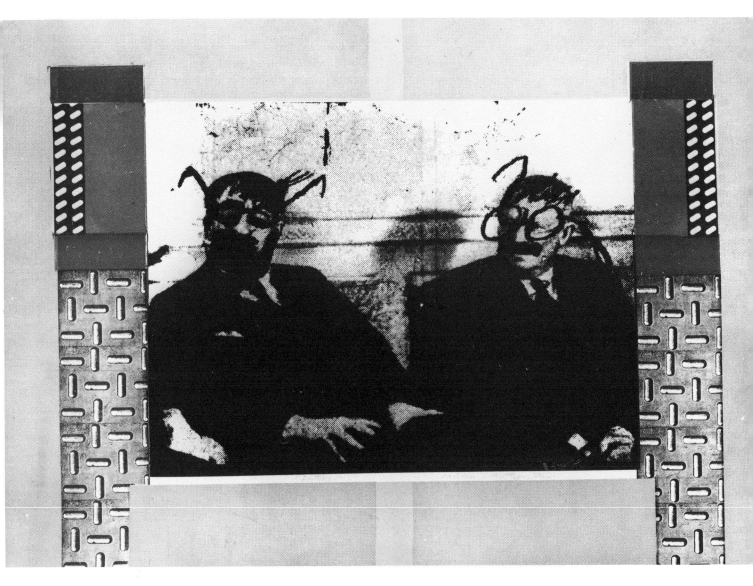

Fathers, *photo screen, letterpress halftone, and relief block
(22" x 30"), 1969, by Michael Rothenstein.*

When an enlargement of an *existing* halftone image is wanted — such as an image from a magazine or newspaper — this is easily produced by the platemaker in the form of a line reproduction; and in this case a type of plate is used which simply reproduces the image "dot for dot" to the size enlargement required. In this instance, even if the plate concerned is made with a fine line screen, the process of enlargement should provide a screen size coarse enough to print on a heavy paper.

Normally, a halftone plate is mounted "type high" by the maker (approximately 9/10"). This means that it is backed with a wooden block, bringing it to the necessary height normally used for commercial letterpress printing; but for the artist's purpose, it is generally better to order the halftones unmounted. Only the plate is required; for the unmounted metal is thin enough to lay and mark directly on the backing, in register with the other blocks needed.

The halftones I use myself are based on photographs, mostly of single objects that have interested and attracted me. Some of these were found very compelling, and as I could not print them directly, and felt no impulse to draw or engrave them (I liked them so much "as they were"), I had recourse to photographing them. From these photographs, halftone plates are made by the ordinary commercial platemaker.

Doing one's own "seeing" with the camera has obvious advantages. I try to do all my own photography; the aluminum tripod is stacked in the same corner as the paint spattered easel.

Only occasionally have I had recourse to photography at secondhand, when the record in question could be obtained in no other way, "programming" the image, in this case, by letter, phone call, or verbal message. Last year, for example, I called at the house of a friend immediately before leaving the city of Athens, Ohio. There I noticed an old iron wheel lying abandoned in the grass of his front lawn. This particular form of wheel was something I had been looking for, a wonderfully clear expression of a spoked, circular form. It had a simplicity that placed it outside time, right out of context with both place and period. The wheel in question was heavy and impractical to take away; but I found it too compelling to leave without record. Fortunately, through the good offices of Ohio University, a role of film was taken after I had left. It was based on verbal instructions given to the artist, Donald Roberts, and sent back to my studio in England. From one of these shots, a halftone plate was made and later used in the print, *Black Wheels*.

## Transfer Lithography

I first came across this method in a relief print exercise, while running a printmaking course with Bernard Cheese at Goldsmiths College, London. We started work by searching round the school buildings for any material we could find: pieces of metal, bits of broken furniture, or machine part oddments from the engineer's storeroom. Very little work in relief printing had, in fact, been done there before, whereas the lithography department already had a long and justly established reputation as a particularly good one. Familiar with the process of lithographic transfer, the students were soon laying down their hand burnished prints, taken from the various pieces of found material, directly onto lithographic plates, running them through the press and producing good black pulls very much more quickly than by the slower process of further handprinting. Taking a number of impressions, each student was able to amass a pile of materials, later to be cut up and reassembled to form a large printed collage. A number of interesting, inventive, and even ambitious images were produced.

The advantages of very open print study of this kind have been dealt with elsewhere in this book. What struck me, on this occasion, was how much could be gained by employing a method that made a series of matched images so immediately available, when the alotted time for print study was necessarily limited, as in the present case.

A further feature of the transfer method consists in this: the set of proofs, taken from the lithographic plates, can always be cut up and laid down for transfer on a second plate. In this case, the original images are treated merely as so much source material, to be dismembered, restructured, and transformed in any way the student desires. Some such transformation can, of course, be done within the strict terms of relief printing itself. The student, for example, can always cut his block of wood, metal, linoleum, or plastic sheet into so many separate

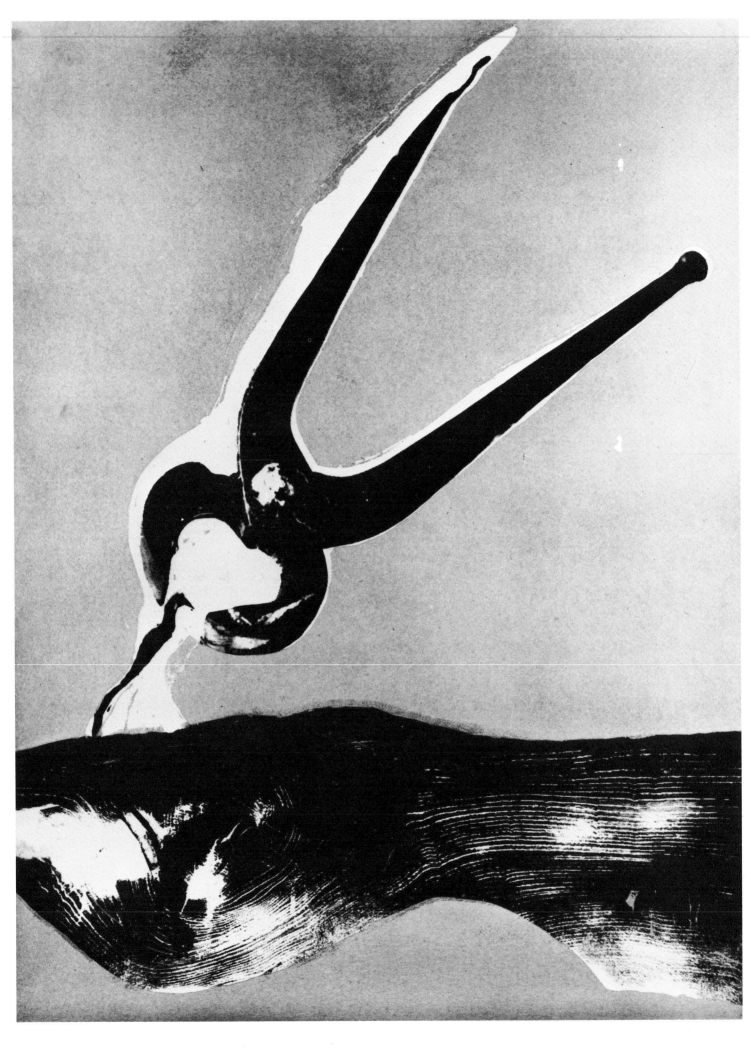

pieces, and then recombine these pieces in a new arrangement to produce the needed transformation. If his purpose can be served by such straightforward procedures, it is quite unnecessary for him to have recourse to methods less direct. But it must be conceded that litho transfer normally allows much greater latitude in all such operations, since the cutting, or tearing up, of a proof can obviously be done with considerable freedom, while the cutting-up and reconstruction of solid materials may offer a good many difficulties.

The transfer method itself is based on a tradition of long standing, used in the printing trade long before the use of photographic aids became universal. It was mainly employed for the transfer of type and musical notation onto lithographic stones, and more recently onto zinc plates. It proved of great economic value wherever a number of small images, such as bottle or carton labels, could be grouped together on a single large plate, which was capable of producing several dozen versions of the image at a single operation of the press.

For the lithographic transfer method, the chosen surface of the found object or block is fairly thickly coated with a stiff transfer ink, and a print taken on "Everdamp" transfer paper; this is a standard coated paper, moist and dimensionally stable. The impression can be taken by any of the hand burnishing or press printing methods normally employed. Weights or scotch tape can be used to attach the paper to the surface from which the impression is to be taken. The impression is then laid, face down, on a clean lithographic plate or stone. A piece of damped newsprint is laid on the back of the transfer, and other backing sheets are added as needed. The plate or stone is then pulled through the press, several times, under fairly heavy pressure. With this operation, the transfer ink should be stuck firmly on the plate once the backing is removed. The backing paper should now be soaked for several minutes with clean water, before gently peeling away — leaving the inked impression on the plate. The plate is then de-sensitized and processed in the normal way.

If a number of separate pieces of the transfer are used for the collage technique described, you will find it necessary to fix them lightly onto a newsprint backing with touches of water soluble paste (gum must not be used). This enables you to keep the various pieces in proper relation when the sheet is finally laid face down on the plate or stone for transfer.

The impression taken on the transfer paper is a mirror image (a lateral reversal) of the original surface — just as in direct relief; when the transfer is put on the plate, the image is again reversed, and the resulting impression reads the same way round as the original. If the plate is printed by offset, the image is again reversed, and reads as a mirror image of the original.

Transfer paper should be kept in a plastic bag to prevent its drying out. For outside work, the sheets should be protected from direct sunlight; otherwise they will become too dry to take an effective impression.

Clench,
*relief and photo screen print, 1969,*
*by Michael Rothenstein.*

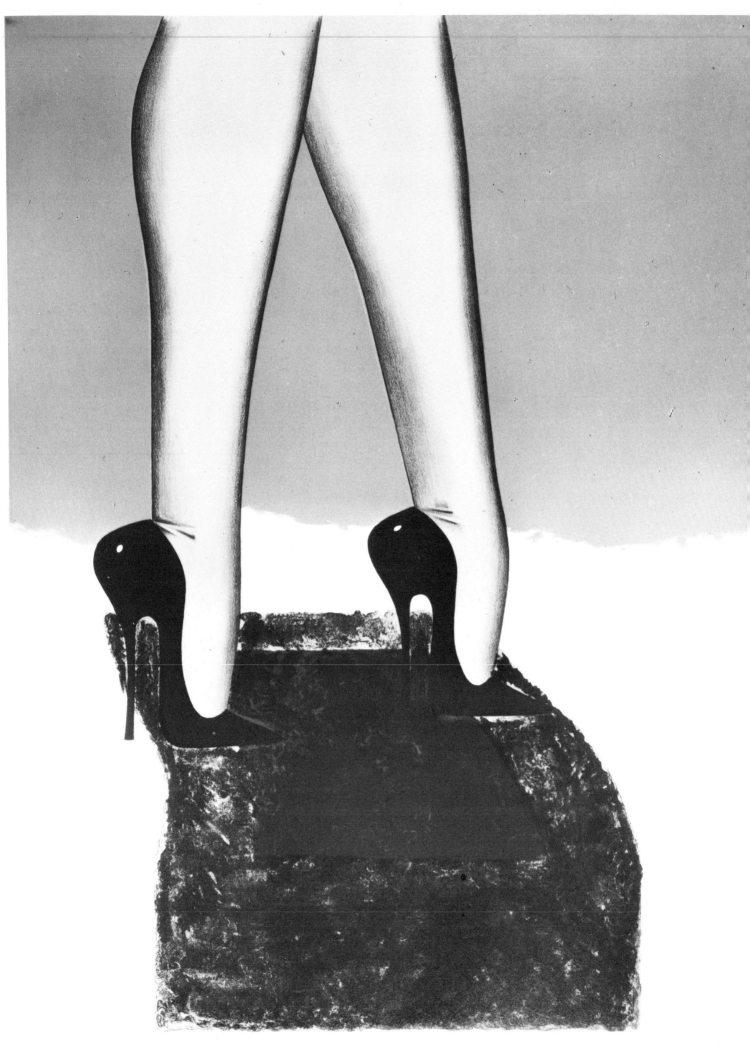

# 12
# THE EDITION

The editioning of a color print may be a long and difficult operation, but also a valuable one, since the printmaker may find it necessary (on both aesthetic and practical grounds) to perform for himself those technical functions most likely to foster his personal vision. An artist of national reputation, however, with the financial support of his dealer, can afford to shift the burden onto the graphic studio of a professional printer. In this case, the artist has only to prepare the blocks or plates and achieve a correct pull, or proof, taken from them. When photo-screen printing or photo-lithography is the chosen process, the artist's work is even further simplified, since the printer should be able to work directly from a graphic maquette, a collage, or some other form of "original" supplied by the artist.

When I began editioning, I found myself very frustrated. I had no press, and I used to print by putting the inked block on the floor, with paper and a board on top, and standing on it, I stamped with my foot to produce enough pressure to take an impression. Slowly, however, the necessary pieces of equipment came into my possession. One day I bid successfully for an Albion press at a printing works auction, and the chief tool of my profession became the main feature of the studio. From this point, I was able to edition images effectively, and I began at last to distribute them to the first few dealers attracted to my work. This gradual approach to the job of editioning must have been fairly typical of artists who began making relief prints fifteen or twenty years ago, and will still apply to amateur printmakers working in their improvised workrooms, wherever these enthusiasts are found.

For the American or English student, trained at the present time in one of the leading art schools or university art departments, these conditions will now appear almost comically primitive and remote. He will have all the advantages of highly sophisticated equipment, of teachers already experienced in their use, and of recently published documents on print-making. Thus, the experience we acquired with so much effort will be gained by the student of today very much more easily.

A New Perspective on Floors,
*lithograph (30" x 22"), by Allen Jones.*
*The buyer is able to open and fold the sheet*
*to form a three dimensional object.*

212

Handling sheets. *When editioning is done, the sheets are handled with cardboard clips. The printer keeps the little finger and thumb on the near side of the sheet, the three other fingers on the far side. This enables him to position the sheet accurately in the register stubs.*

## Setting up the Work

In planning an edition of fifty or more prints — often a long and difficult operation — the artist will want to consider the effort and cost involved, breaking this down in terms of materials used (paper and ink) and time spent at the press (his own or his assistants'). In the case of a mixed media image, the print may also need special processing by a method not covered by the artist's own studio facilities: the preparation and printing of a halftone photo silkscreen for example. This will entail sending away the paper required for the edition, together with a positional tracing, showing the exact position of the photo screen relative to any other blocks employed. Careful instructions should also be given with regard to the method of registration to be employed.

When work is carried out in the artist's own studio, the cost of editioning is obviously much lower than if outside facilities are used. In the case of color prints, the cost of professional editioning may be restrictive to the point where only artists of wide acclaim find the use of professional printers at all practical, as already indicated.

For studio printing, one of two methods is suggested. The sheets can be printed in batches, say three sets of twenty for an edition of fifty, giving five artist's proofs and five sheets to waste, above the edition number, in case of printing errors. On the other hand, the whole edition can be processed in sequence. The first method is recommended for an artist working on his own, the second when trained assistance is available. In the latter case, each color is put down in turn on all the sheets to be printed. If a block takes more than one color, the appropriate inks are set out, and the block is inked and printed at one operation with the various colors intended.

When a long run of sheets is wanted, the usual practice is to put a paper slip, projecting beyond the pile, every ten sheets. In the case of a miscount — or for quick reference — this method saves a good deal of time.

Paper is laid face down, in readiness for printing, as near the press as possible. If the sheets are handmade, with a natural deckled edge, the left hand corner and a section of the bottom edge are trimmed with scissors to fit the register stubs. When paper from a roll is used, the

sheets are cut to size a day or two before the material is needed. After cutting, they are laid face down, with a board and heavy weights on top, to allow the curved paper to straighten. If the roll has stood in stock over a long period, the curve will be difficult to correct. In this case, the sheets should be wound over a cardboard tube, rolled the opposite way to the original curve.

Atmospheric humidity causes paper to expand. Normally, the effects of expansion are too slight to interfere with the work of editioning; but violent change, between hot sunny conditions and cold damp ones, may well cause some distortion of the registration. In using large sheets of soft paper, in humid conditions, this may be noticeable. Where distortion occurs the aim is to attain accurate register in the central portion of the image by adjusting the corner of the paper to overlap the stubs. When printing is done in different weather conditions, this should be helpful.

In editioning for color, the pace of ink drying is programmed to the sequence of work. Normally, the first color should dry before the second goes down; but when slow drying ink is used for the first block, driers are added. This is to avoid any unnecessary holdup in printing. In hot weather, on the other hand, or for work in a well heated workshop, a slow drying vehicle such as oil of cloves or poppy oil is added. This is to make sure that the ink will remain fluid and workable throughout the working day. Both time and materials are wasted when ink crusts on rollers and ink slab within a few hours.

Any given run of prints is likely to show a good deal of variation in color, definition, registration, and so on, caused by the remixing of ink, variations in block inking, and many other factors. When images are printed in separate sets, this is particularly noticeable; but when the printing operation is continuous, and a large run undertaken, the differences from print to print will always diminish. Set procedures tend to produce their own feedback in terms of a repeatable performance standard.

## Use of Assistants for Editioning

At the end of their courses, a number of trained, or partly trained, printmaking students leave the art school or university every year. Some of them will already have had a good deal of practice in printing and some will be

London Knees,
*1966,*
*by Claes Oldenburg.*

London Knees, *giant lithographic postcard, 1966,* Claes Oldenburg.

looking for ways to extend this experience. To call on their help as trainee assistants, when printing is to be done, is one of the few practical ways for the professional artist to produce editions of his own. If the artist himself has any reputation, he should have no difficulty in finding likely recruits. An ambitious student is generally anxious for a chance of working with a printmaker of experience; he is quick to recognize that this not only helps him towards high professional standards, but gives him valuable insights into workshop routine, insights that are likely to assist him later in setting up his own graphic workshop.

The work routine that has taken shape in my own studio is no doubt typical of other such places. Two assistants make up the printing team. Between them, at the start of each run, the division of work will be decided; one of them may handle the sheets and operate the press; the other undertakes the inking and registration of the block. To work with full freedom of movement, they should stand opposite each other, at either side of the table. The table itself should be approximately 36" wide; if it is wider than this, the far side is beyond the reach of the printer. In all cases, the color to be used is mixed by the artist himself and tested for accuracy against the working proof. He also works in turn with each assistant in establishing the printing procedure to be used.

The first sheets to come off the press are placed beside the proof for direct comparison, using paper eyeholes cut from small pieces of white paper to check the color. If the work has been set up properly, a correct printing should normally be achieved after three or four trial pulls; five or more pulls should be considered exceptional. Once the edition is under way, and the assistants are working on their own, the color of the sheets is checked against the original proof at frequent intervals, generally at every five or six impressions taken. When any problems arise, the artist is immediately consulted, and together with his assistants, work procedures are carefully checked over to discover the cause of difficulty. If a solution cannot be found, and a particular color appears impossible to match, for example, the run is halted, the ink slab and rollers cleaned, and another part of the work is taken up instead. Coming back to the job the next day, or after an interval, the work

is again started. But this time a solution is generally found; perhaps an ingredient of the wanted color is found missing, the color that appeared so impossible to match on the previous day!

It is understood by the assistants that the artist is entirely responsible for any edition undertaken. It is for him to demonstrate correct procedures, and to check any work done before the sheets are allowed to leave the studio. Should printing faults occur, the artist should always regard himself as finally answerable.

Personally, I find the days of editioning with the help of assistants particularly happy ones. A bond of work is quickly established, and the habitual quiet of the studio, where normally the artist works alone and in silence, comes suddenly alive with the sounds of active movement and discussion. The plan of my own studio, with its separate but interconnected creative and workshop areas, forms an ideal arrangement. I can pursue my own work in a separate part of the studio, while keeping in touch with the assistants busy at the press, when this becomes necessary.

## Hand Press and Power Press Printing Compared

All handcraft forms of printing are laborious, whatever the method used: whether burnishing with a wooden spoon, or rubbing with a baren or printing roller. Even printing on a hand press can be comparatively slow, and whatever advantages this method offers in terms of close personal control are largely offset by the time needed for its accomplishment — time employed, moreover, in repetitious work, entirely withdrawn from further creative effort. If you work alone in your own studio, aiming to take a large edition in color, you will know how much care and patience — and even endurance — the job will need.

The advantages of the handcraft method lie in the warmth and presence of the resulting image. But where these qualities are not sought, and the print is to be processed to exactly programmed instructions, then more highly mechanized methods are clearly appropriate. The powered proofing press runs with absolute precision, producing exactly matched effects each time its cylinder

Sphinx No. 2,
*screen print on metal*
*(16" x 13"), 1967,*
*by Richard Smith.*

passes over the print. In this case, success depends on the tight programming of the job, and on clear instructions given to the printer. Ideally, the artist should be present at the start of each operation; for once the color and the first impressions have been carefully checked (and approved) the work is likely to go smoothly to the end of the run.

Any powered press will obviously reduce the labor of printing, but in the case of the powered combination press, such as the Meeker McFee, the inking of blocks will still need to be done by hand.

A hand operated proofing press (the Harild Super Speedi) is used in the excellent workshop run by Trevor Allen in London. For effective operation, the press needs a team of two. The printing paper is carried on a 30" cylinder, which rotates over the inked block. To give "squash" and resilience, where ink is to be taken from more than one level of the block, a blanket is fastened round the cylinder below the sheet to be printed.

## Restrike

The term, *restrike,* is used when prints are taken from a block at a date much later than the original run. This term clearly does not apply to images printed in sets as a method of editioning, but only when blocks are used again, to pull a fresh series of images, when the declared edition has already been completed.

## Inspection of Finished Prints

Once the edition is complete, and the ink has dried, the sheets are taken down from the drying racks. In the case of large sheets, this is done as soon as possible, since some distortion of the sheet may occur at the point where the paper is held by the ball-clip in the rack. The prints should be sorted through in strong, clear light, and the most evenly matched put aside for the edition.

Where many colors have been used, the sheets will have received repeated handling, and may have become marked or damaged. Damaged edges can be fractionally re-trimmed, though this is impractical if the natural deckled edge of the sheet is to be preserved. Small creases are ironed out with an ordinary household iron. The damaged area in this case, should be placed between sheets of slightly moistened blotting paper, and the iron

used should be set at low or medium temperature. On European or Japanese handmade paper, any mark on the white margin, surrounding the image, may be difficult to remove. A piece of masking tape, pressed lightly on the blemish, and pulled gently away may serve to erase it. However, like scraping with the edge of a razor blade, this is likely to leave a roughened area that will need burnishing to smooth out the paper.

## Numbering and Recording

Assuming the number of sheets (above the edition) has allowed for artist's proofs, the original working proofs will still remain an integral part of the production. These are sometimes of special value. They are often imperfectly crafted, with dirty fingerprinted margins, but they remain a unique and special record of the original work sequence. I recommend you to sort them through, and preserve the best; mark them as working proofs, and number them in the order of printing.

Numbering the edition in the actual printing order is generally practical only with a black, or one color image. In this case, the prints can be numbered as they come off the press, or are taken from the drying rack; but when separate colors have been put down on all the sheets in turn, or on a series of sheets if the edition has been processed in sets, such numbering is clearly impossible and would, in any case, be meaningless. Its function, here, is to indicate to the dealer — or to the artist himself the total size of the edition and the stage of distribution reached.

Numbering and marking are normally recorded in the left hand corner of the margin; the signature is written in the right hand corner. Artists' proofs, which should not exceed 10% of the edition, are numbered as such; strictly speaking they should be marked with roman figures (1/10, 11/10, 111/10, etc.) or with the distinguishing letters, A, B, C, and so on (the figure following the stroke is the total number of such proofs). Finally, the edition sheets are numbered: 1/50, 2/50, the figure following the stroke representing the total of the edition excepting both the artists' and the working proofs.

Under present conditions, the numbering of prints remains a useful protective device, helpful for artist, dealer, and purchaser alike. It allows those concerned to judge the scarcity of the print (or otherwise) or the comparative uniqueness in the case of working proofs. When an edition sells out and a further demand for the image remains, the artist should resist the temptation to overrun the edition, or to project a second run, using an altered color scheme. It is always best to respect the declared ceiling of the edition to protect the chain of goodwill between artist, dealer, and buyer. This goodwill is also violated when the dealer himself uses devices to extend the number of saleable prints outside the accepted pattern of distribution. It is alleged, for example, that certain dealers in Paris have issued sets of artists' proofs, in addition to those normally allowed, by using arabic as well as Roman figures for numbering a second set. As a matter of fact, the trend today is to simplify the system of numbering. Some artists merely put the number of the edition (such as "Edition 50") in the left hand corner of the margin, or of the image. In this case, there is no reference to the printing order, and the artist shows a healthy unconcern for established tradition.

## Artists' Proofs

Some years ago, it was quite usual for collectors to choose artists' proofs in preference to a numbered copy taken from the edition. This preference arose from the following circumstance. In nineteenth century Paris (the birthplace of the print revival in the west), it was normal practice for the printer to submit a series of pulls, taken from the original blocks or plates, for the artist's approval; the one most to his liking was signed by the artist, and the printer aimed to match this particular copy throughout the run of the edition. Since the artists' proof was the example which the printer sought to copy, there were certainly good grounds for considering it a version of special value — the most truthful and perfect interpretation of the artist's original work on the block, plate, or lithographic stone.

This viewpoint, however, will remain valid only when the work of editioning proceeds on this particular pattern, namely the artist/printer relationship established in the workshops of Paris. But when the artist editions his own images as often happens today, it is clearly unreasonable to attach any particular value to the artist's proof. In this

case, copies produced at the end of the run may be more perfectly printed than those at the beginning, since the logic of the operation may favor experience gained in the actual process of printing: the register may have been tightened; a block may be modified to receive ink from the roller more perfectly; the press packing may be adjusted to give greater transparency, clarity, or depth of color, as the case may be.

For the artist, however, a set of proofs still carries one practical advantage; should he sell an edition outright to the dealer, he may have to accept only a small sum for each print, one third or one quarter of the selling price to the buyer, or sometimes even less. In England, and no doubt elsewhere, it is normal practice to reserve for the artist the right to sell his proofs, and working proofs, directly to his clients. Or should he sell them to other dealers or galleries, he may part with them on the more favorable terms normally offered: 50% on the outright sales, or 33 1/3% or 40% for sale on a consignment basis, known as "sale or return" in Britain.

I have never, myself, attempted to keep track of all the numbered prints in each edition; but there is certainly an argument for doing so. A record of prints sold is of considerable interest in the case of purchase by a museum, or even by one of the group of committed collectors on whom the survival of the artist partly depends. The artist should also attempt to keep at least one copy of each print for his personal collection. These examples are not only of great potential value in relation to future exhibitions and loans, but may also prove irreplaceable in the event of a retrospective show.

Some artists, Edvard Munch and Leonard Baskin among them, have preferred to produce prints that remain unnumbered. This follows an honored tradition. The images of Rembrandt, Goya, and other artists who produced their work before established patterns of commercial print distribution became recognized, bore no numbers in their margins. As a matter of fact, with the arrival of multiples in unlimited editions — such as vacuum formed reliefs, or three dimensional screen printed metal forms such as those designed by Richard Smith — our attitude to a set style of numbering is likely to be altered.

Printmaking has a future alive with possibility. One can see the poorer countries developing the production of manually made prints on an enormous scale, much as Mexican pottery or metal work today. One can also see highly sophisticated and brilliantly engineered multiples being marketed to a large public, with any general increase in prosperity and cultural involvement.

## Protection of Prints

One of the consequences of sending prints to a dealer on consignment, or "sale or return," is that the artist may find his unsold prints considerably damaged through inexpert handling by customers and occasionally by careless gallery staffs. He may even find that damage to his print makes it impossible either to send it out to an exhibition, or to place it with a second dealer. A great deal of the artist's stock can be wasted in this way. At the moment, no device exists for his protection, though possible damage is always reduced if the dealer places the print behind a plastic sheet with a suitable cardboard backing.

## The Future of Printmaking

What of the future? If we are now witnessing a convulsion of interest in printmaking media — particularly those susceptible to the impact of photo-technology — what are the forms most likely to emerge in the years ahead? This will depend, in some part, on how the resources of patronage are used. To reach full maturity, printmaking needs centers of research: workshops where the artist can operate effectively on the already narrow strip between technology and art; places where the equipment denied the individual artist, through high cost, will be made freely accessible to him.

It is obvious that many print forms are unlikely to remain permanently trapped behind sheets of glass, or between the covers of the collector's portfolio, as they are today. Printmaking media are highly adaptable. Constructional relief prints, vacuum formed images, and various types of multiples have appeared already, as well as see-through images, and prints boxed with metal and plastic "extras"; a wealth of new methods and materials are being turned to entirely novel uses in the graphic workshop. It is certain that the emergence already begun will now move forward with increasing momentum.

# INDEX